Dark Lens

The University of Chicago Press Chicago and London

Dark Lens

IMAGING GERMANY, 1945

Françoise Meltzer

The University of Chicago Press, Chicago 60637
The University of Chicago Press, Ltd., London
Published 2019
Paperback edition 2021
Printed in the United States of America

30 29 28 27 26 25 24 23 22 21 1 2 3 4 5

ISBN-13: 978-0-226-62563-8 (cloth)
ISBN-13: 978-0-226-81685-2 (paper)
ISBN-13: 978-0-226-62577-5 (e-book)
DOI: https://doi.org/10.7208/chicago
/9780226625775.001.0001

The University of Chicago Press gratefully
acknowledges the generous support of the
Division of Humanities at the University of
Chicago toward the publication of this book.

Library of Congress Cataloging-in-
Publication Data

Names: Meltzer, Françoise, author.
Title: Dark lens : imaging Germany, 1945 /
Françoise Meltzer.
Description: Chicago ; London : The University
of Chicago Press, 2019. | Includes bibli-
ographical references and index.
Identifiers: LCCN 2019005348 | ISBN
9780226625638 (cloth : alk. paper) | ISBN
9780226625775 (e-book)
Subjects: LCSH: World War, 1939–1945—
Destruction and pillage—Germany. | World
War, 1939–1945—Germany—Aerial opera-
tions, Allied. | World War, 1939–1945—Ger-
many—Influence. | World War, 1939–1945—
Germany—Psychological aspects. | World
War, 1939–1945—Germany—Photography. |
World War, 1939–1945—Germany—Art and
the war. | Ruins, Modern—Germany. | Ruins
in art. | Civilians in war—Germany. | World
War, 1939–1945—Moral and ethical aspects.
Classification: LCC D810.D6 M38 2019 | DDC
700/.458405343—dc23
LC record available at https://lccn.loc.
gov/2019005348

♾ This paper meets the requirements of ANSI/
NISO Z39.48-1992 (Permanence of Paper).

for Dianne Levitin and
for Raquel Scherr

Contents

Color plates follow page 80

What I Remember

My mother was a French woman, married to my father, an American in the State Department. But it was in Germany that I spent my childhood, so that I grew up speaking three languages: my father spoke only English to me, my mother only French, and Marta, our housekeeper, only German. It was, I suppose, rather an odd way to grow up—particularly given the postwar situation in Germany. At the end of the war, there was still a great deal of anger in Germany at the Allies (Russians, British, French, Americans). For many Germans, there was anger, too, at the loss of the war. And there was anger among those Allies who, for one reason or another, were obliged to live in Germany and were less than happy about it. As children, we sensed this anger from all sides, but without knowing what was motivating it.

When I was three, in Bad Nauheim, we lived in a large house that had been requisitioned by the United States government. An important Nazi had lived in it. One day, some German kids who were from the neighborhood threw me into a bed of rose bushes. I emerged with thorns all over my body. I remember sitting on my mother's lap, crying, while she, plied with tweezers, angrily removed the thorns from my flesh. "Sales boches" ("dirty Krauts"), she muttered with every extracted thorn. I didn't know what that meant, but I knew she was furious. There was something about her anger that I didn't really understand; it seemed to go beyond what had happened and was in no way directed at me.

When I was six, in Frankfurt, some friends of mine and I went trick-or-treating on Halloween. There, we lived in an American apartment complex, but there were a few Germans also in the building. When we knocked at one door, the window at the top of the door was opened by a German woman. We couldn't see her, but could hear her irritation when she asked us what we wanted. "Trick or treat!" we yelled happily, but I remember we weren't sure she had understood. "Just a minute," she said in German, and closed the window. A few minutes later, the window was opened again and a pail full of what must have been raw sewage (including excrement) was thrown at us. We were drenched in stench, compelled to return home. That was the end of our Halloween that year. The incident remained a mystery to me for a long time; we had been so shocked by her intense anger (and the smelly water). Years later, I realized how spoiled, costumed little American children excitedly demanding candy must have seemed to that German woman, who clearly would have had no idea what American Halloween was.

From around the age of five, I had a recurring dream for many years: I'm in a small German town and I'm lost. The town is gray, dark, and full of ruins. I wander around trying to find some street I recognize, but I can't. Finally, I sit down on a curb in the middle of the town square. A nice German lady approaches and asks, "Are you all right, little girl? Do you need help?" "I'm okay," I tell her (we are speaking German). "I'm just waiting to wake up. I know this has to be a dream." I must have frequently felt lost, between three languages, three cultures, and the tension that seemed, even to me at that young age, palpable everywhere. The dream seemed to be saying that if I waited long enough, there would be an explanation, or at least an escape.

Hunger was pervasive in the German populace. Our gardener in Bad Nauheim kept taking our vegetables, telling my mother in sign language (since she didn't understand German) that the rabbits had eaten them. She pretended to believe him. Around the age of four, I found a homeless man and struck up a friendship of sorts with him. He was hungry, he said,

so I brought him home. "You said we had to help the poor," I said to my mother, "and he needs food. You have to feed him and give him a bedroom." Years later she told me how difficult it was to explain to me that this man couldn't move in with us. She did give him food, but Marta was yelling at him to go away.

Marta, a Berliner, had been working for a French family in Brazil before the war. When Hitler put out a call to "ethnic Germans" abroad to return to the Fatherland, Marta answered that call. She returned to Berlin and was caught in the bombing, but managed to survive. When I was born, my parents hired her to take care of me because she spoke fluent French. As I got older, she became our housekeeper. In the meantime, it had become clear that I was speaking French with a German accent. My mother then told Marta to speak German to me. "At least she'll speak that with the proper accent," my mother is reported to have said.

Marta often took me with her into the German town next to the American compound. The town was dark and gray, and there were still many ruins (a town, in other words, like the one in my recurring dream). Marta bought bread there (far better than the bread at the PX), and liked to chat with friends and other nannies. One time, she met a friend and told her that she was sure there was another war coming. "No, no," said the woman, "I don't believe that." But Marta was clear on this: "You can be sure," she said quite fiercely, "that there will soon be another war. I know it." I couldn't figure out how she could know that, but I always believed everything she said, so it frightened me. "Why will there be another war?" I asked her. "Because there just will be," was her unhelpful (but firm) response.

Of course, it wasn't all about anger. In Bad Godesberg, on Sundays (her day off) Marta often took me for walks along the Rhine. She told me about the Rheingold, and we dug around for it. She also took me to her (German) church, and I sometimes sang in the choir there. Marta was furious with me one Sunday, as I stood in the front row of the choir, because I didn't know the words to the hymn we were singing; I pretended I did,

mouthing them enthusiastically any which way. But I had humiliated Marta in front of her friends. She must have been proud at first to show off her American charge, and I had greatly embarrassed her.

Searching for the Rheingold with Marta was one kind of digging; but whether in Bad Nauheim, Frankfurt, or Bad Godesberg, we children seemed always to be digging. We dug among the ruins (which we were, in fact, forbidden from entering—but did anyway); we dug around the American apartment complexes where we lived; we dug in fields and in the forests. Children were more easily able to play outside without adult supervision in those days, so sneaking off to the ruins was always possible. What were we looking for? Surely, we didn't know anything about the bodies lying beneath the ruins, and presumably we wouldn't have found any human remains in the American compound. Digging was a constant activity, as if we suspected that under all that rubble, or even in the cellar wells of our apartment houses where we dug, something was there, latent (to use that word in the sense of Hans Ulrich Gumbrecht). I thought of all that digging when I looked at Kiefer's paintings for the first time. But he is the creator of the underneath, which he then layers over with paint. As a child, he used the bricks from the bombed-out building next door to build houses and towers. We just dug. It was, I think, an attempt to find something—anything—that would explain the strange atmosphere in which we were growing up; to unearth what we assumed was a secret that no adult seemed willing to divulge. Our digging was fre-*

* See Hans Ulrich Gumbrecht, *After 1945: Latency as Origin of the Present* (Stanford, CA: Stanford University Press, 2013). "When I speak of 'latency,'" writes Gumbrecht, "instead of 'repression' or 'oblivion,' I mean the kind of situation the Dutch historian Eelco Runia calls 'presence,' which he uses the metaphor of the stowaway to illustrate. . . . And because we do not know the identity of the latent object or person, we have no guarantee that we would recognize this being if it ever showed itself." (23) This is precisely what we felt as children in postwar Germany—that is, that something was present but hidden, something that we wouldn't recognize even if we managed to see it, but that was nevertheless pervasive.

quently punctuated by the boys in our group, who often ran around with their arms extended, pretending to be airplanes and shouting happily, "Bombs over Tokyo!" Most of us had no idea what "Tokyo" meant. The war was in our vocabulary and our daily lives, though most of us were born several years after it had ended and had little idea of what it had been about.

While with my parents, things were culturally French and American, with Marta I was steeped in German culture and tradition—not all of it very reassuring. For example, Marta read Der Struwwelpeter *to me, probably the worst (and most engrossing) children's book ever produced. It was written in 1845 by Heinrich Hoffmann, who apparently couldn't find any children's books for his three-year-old son, so he created his own. The book has been favorably viewed for its vivid illustrations (produced by Hoffmann himself), but these are (at least for children) quite terrifying.* Der Struwwelpeter *comprises ten "object lessons" for children—bad things that will happen to you if you don't behave. For example: a boy refuses to stop sucking his thumb. One day, as the boy is happily sucking away, a terrifying bogeyman jumps out of the closet and cuts off his thumb with a huge pair of scissors. Dripping blood is bright red and prominent in the graphic illustration of the stub on his hand. There's also a boy who won't eat his dinner. The illustrations show him growing thinner and thinner, till he is swept out the window by a gust of wind (presumably never to be seen again). Then there is the Struwwelpeter himself, who refuses to cut his nails or hair, and so is left to stand, arms and hands stretched out, hair wild, and unable to eat or do anything. The illustration for that boy famously serves as the cover image for the book. "If you don't eat your dinner," Marta would say to me, "you'll blow away just like that boy in the* Struwwelpeter." *Somewhere I still have that book. There was also a book about a monster who crept into a little girl's bedroom at night and sat on her bed.*

My mother had no idea that Marta was reading me these things (such readings took place upstairs, in Marta's room, well away from our apartment). Maman started figuring it out when, during a parental cocktail

party, I was found banging on the front door to get in. When my mother appeared, I frantically explained that Marta had told me that if I didn't come in from playing outside by 6:00 p.m., a man all in black, driving a black carriage drawn by six black horses, would swoop down out of the sky and kidnap me. It was just six o'clock, and I was terrified. My mother glared at Marta, who looked down in embarrassment.

At Christmas time, Saint Nicholas went from door to door in our (largely American) apartment complex. Dressed in dazzling white with gold trim, and with a flowing white beard, he wanted to know if we had been good. He had a big book—also white and gold—with the names of good children in it. With him came schwarze Peter, a frightening-looking man in blackface, dressed in black clothes. The visual contrast between him and Saint Nicholas was very dramatic. If you hadn't been good, schwarze Peter would see to it that you got lumps of coal instead of presents on Christmas morning. He also had a book, which was black and contained the names of bad children. He read from it and informed me in detail of several bad things I had done that year, and it unnerved me that he knew these things. What I didn't know was that he and Saint Nicholas would first go to the back doors of the apartments and extract information on a child's naughtiness from whomever was back there. Marta had given them plenty of specifics on my misbehavior. (The racist implications of schwarze Peter were, I realize in retrospect, staggering.)

Continual changes added to the confusion we children felt. For example, German money was constantly being replaced by different currency. Every few months, a new paper currency would appear, in different colors and sizes from the previous ones, displaying portraits of men, usually not the same as the ones before. The cityscapes changed, too: ruins were hauled away, and new buildings appeared almost overnight, or so it seemed to us. Our school in Bonn, the American School on the Rhine, had teachers who came and left all the time. All of us came and went as well, since our fathers were with the State Department or the army, and were required to move regularly. The longest my family stayed in any German city was two years; usually, it was eighteen months. The State Depart-

ment put us up in furnished apartments; impersonal spaces that were boring and neutral.

In Bonn, I had one bout of tonsillitis after another, largely, I was told, because of the three huge chimneys in our neighborhood, spewing black smoke from the coal. I was skinny, pale, and had dark circles under my eyes. At the dinner table, I constantly heard "Mange!" (Maman); "Eat!" (my father); "Iss!" (Marta). There was so little sunlight in Bonn because of the pollution that several of us were taken weekly by our mothers to a place with sunlamps. We were all vitamin D deficient, it seems (Marta thought this was all ridiculous). My mother took me to France every time there was a school vacation. In the French countryside, I gained weight, got the color back in my cheeks, and was well. But, as soon as we got back to Bonn, I got sick again. My mother seemed to take this as some sort of justification for her negative feelings about Germany.

Unlike my friends' families, we never went to the US for vacations. My father was disgusted by McCarthyism. And, apart from my grandparents (with whom my father wasn't close), I had no American family. My father had broken off all contact with his large German American family, because most of them had supported Hitler before Pearl Harbor. Moreover, in 1932, when my father was a student in Berlin, his German American uncle and aunt (by marriage) visited him there. He proudly told them that he'd written an article about how fascism was creeping into children's textbooks. The article had been accepted by Time, and he was making his final revisions before sending it off to the magazine. His aunt denounced him to the authorities. The manuscript was confiscated, and my father was told to leave the country. He went to Paris, and that's how he met my mother.

By Way of Beginning

This is a book that centers on the ruins of Germany at the end of the
Second World War, on their textual and painterly depictions, and on
a series of photographs taken shortly after the bombs fell. One ques-
tion here is the extent to which we can read descriptions of disas-
ter, or gaze on paintings of war ruins, or finally see the photographs
shown here for what they are—largely unmediated images of recent
disaster. Is it even possible to view these images and photographs
in their raw state, without having recourse to some kind of repres-
sion? Do aestheticization, voyeurism, or a historical perspective, in-
formed though they may be, occlude actually *seeing* the war ruins
depicted? These are questions of ethics: what are the multiple ways
in which war ruins can be described and subsequently viewed? Then
there is the matter of suffering: what are the debates and questions
concerning the "acceptability" of suffering under certain circum-
stances of war (such as when the victims, as here, are viewed as the
undisputed enemy)? Can catastrophe be persuasively represented?

The photographs considered here were taken by my mother,
Jeanne Dumilieu, in 1945, with a Zeiss. They have never been pub-
lished, and have been hidden away in a trunk of family photos since
they were taken. Most of them were taken in Berlin, but some also
in Bremen, Düsseldorf, and other cities. Because I don't know the
exact location of all the photos, I have not attempted to locate most
of them geographically.

My mother, who was French, had been in the Resistance in Paris during the war. I never learned this from her (I found out from her friends, and by accident, in my late twenties); nor did she speak much about the occupation of Paris. The only thing she talked about was how hungry she and the Parisian population were throughout the war. When I asked her why she had never told me that she was in the Resistance, she retorted with some contained anger, "Today, everybody was in the Resistance. I have nothing to say about it." But it must be said that this was a particularly tight-lipped generation: my father never spoke of having been in the London *Blitzkrieg*, nor my uncle of surviving Buchenwald, nor my aunt of having hidden my mother, and thus having put my aunt's own life in jeopardy. I found out after my mother's death that she hid from the Gestapo for six weeks in a cellar. My cousin Jean-Claude, only eight years old in 1943, left for school every day with a package. He was instructed, with no explanation given, to drop the package, without stopping, in the window well of the cellar where (unbeknownst to him) my mother was hiding. He never learned until years later what he had been delivering nor why; it was food and water.

My mother married my father, an American, in 1945. He was in the State Department and serving in France. But upon marrying, he had to leave that country, given that his wife was a French national and thus posed a security risk—she might be a spy. He was thus transferred to Germany. My mother consequently found herself living in Berlin amid a population and in a country that she detested. Moreover, State Department rules stipulated that the wives (there were, after all, no State Department husbands then) were not permitted to work. Unhappy at being forbidden to work (she had had a successful career as a businesswoman in France), she told me that she began taking photographs to keep herself busy, and because the ruins were so portentous a presence, everywhere around her. She also said this: that the entire time she photographed the ruins, she was constantly

torn between a feeling of "Serves you right, bastards!" and a profound humanitarian response to the suffering of which the ruins were stark witnesses. Photographing the devastation, she said, was completely exhausting, precisely because of these extreme, conflicting responses.

I should add that, though my mother spent ten years in Germany —we left, in 1956—*Maman* had consciously learned only one word there: *gemütlich*. Otherwise, she had a German vocabulary left over from the Occupation. Occasionally, she would recite these words in a loud voice (imitating German soldiers), but with her strong French accent: *Heraus! Schnell! Halt! Papiere!* From the age of three, I translated for her into French whenever I could.

The German population after the war was desperate and starving, trying to emerge from the rubble, straining to return to some version of normalcy, reeling from the disasters caused by Nazi rule and ideology, stunned by the defeat of the Reich (for many, a defeat met with disappointment and incredulity), and assaulted by the brutal invasion of the Red Army (the vast number of raped women is still undocumented today). To this was added the immense loss of lives and homes caused by the continual Allied bombing, the (literal as well as psychological) shell-shock produced by trying to survive with constant fear in the ubiquitous destruction, and the presence of death everywhere. The German population, at the end of the war, was utterly traumatized.

My mother thus took these photos with profoundly contradictory emotions. It is tempting to think that this dialectic of sorts is discernible in the photographs. But I suspect that without knowing the "backstory," it is not discernible; and knowing the story, it is easy to superimpose, or to read, that dialectic into the photographic images. While that dialectic, as I am calling it, was forcefully experienced by the photographer herself, the context of the photographs is such that other viewers, too, may feel the same conflict of responses. It will

also be noticed that most of the images keep their distance from the populace photographed, as if my mother was willing to record, but not engage with, any of those she captured on film.

The photographs, as I noted earlier, have never been published. They are in black and white, and the photographer was an amateur. Any self-respecting professional photographer will see immediately that a nonspecialist eye has informed the quality of the images. And yet, audiences to which I have shown these photopraphs have frequently commented on their strange, unembellished beauty. They do not produce a narrative; they are, rather, a series of disparate shots, but always with ruins looming in each frame.

Aestheticizing catastrophe has, of course, its own dangers, as Adorno and Rancière (among others) have forcefully demonstrated. And yet, here again is an antinomy of sorts, much like my mother's conflicted response to the "ruinscapes": the images are both grim and stark; at the same time, they are oddly pleasing in some undefined manner. Moreover, decades after the fact, these images do not elicit much Schadenfreude; but there is still a bit of what Burke discerned: "a degree of delight, and that no small one, in the real misfortunes and pains of others."[1] I will try to disentangle these possible responses to the images.

Though I was born several years after the war, I, too, along with many other German children, grew up playing among the ruins. Like Joel Agee,[2] I remember seeing the remnants of staircases, different wallpaper for various (and now open) rooms, lighter patches on the wallpaper where a picture had hung, ripped-apart plumbing, hanging wires, and broken pieces of furniture. The ruins were for me an enticing playground, though I remember once seeing a dead man who had hanged himself, with a handwritten sign pinned to his

1 Edmund Burke, *A Philosophical Enquiry into the Origin of Our Ideas of the Sublime and the Beautiful* (Oxford: Oxford University Press, 2015), 39.
2 Joel Agee, *Twelve Years: An American Boyhood in East Germany* (Chicago: University of Chicago Press, 2000), 30.

chest. An older boy, who could read, told me it said, "I am hanging here because I could not feed my wife and children." Another man was removing the dead man's shoes, and then put them on his own feet. The "playground" could be sinister indeed.

Ruins were thus the scenery, as it were, of my childhood. When we landed in New York Harbor in 1956, the first question I asked my mother was, "Where are the ruins?" I could not imagine a world without them. The present study on the description of such ruins, then, is deeply embedded in my personal history. It is a book I came to realize that I *had* to write—no doubt to come to terms with these stark images of my childhood, which have never receded. My hope is that the issues this study raises, however, triggered though they have been by my past, transcend the personal and begin to probe the question of how to image catastrophe, and what it means to target civilians in war—any civilians. Clearly, this is a particularly pertinent question in our present era of drones, suicide bombers, smart bombs, rockets, terrorist attacks, nuclear missiles, and any number of other highly sophisticated devices and undertakings intended for the specific purpose of killing civilians.

I have remarked here that my mother's generation was tight-lipped—most of them did not talk much about their war experience. Some of my readers, when this book was still in manuscript, noted an uncharacteristic stylistic reticence of my own. I have come to realize that such reticence on my part is symptomatic of what Nicolas Abraham and Maria Torok call "transgenerational haunting." I am indeed haunted by the generation that witnessed these events—the events on all fronts of World War II—of which this book examines only a very partial aspect; and I seem here to have inherited some of that generation's reserve.

I have tried to overcome this discomfort, or restraint, by including a few childhood memories at the outset of this study. But my point in producing these is not primarily autobiographical; rather, it is to convey the atmosphere of a devastated Germany, as experienced by a child. There was much that I did not understand, but

also much that I continue to carry with me. I have tried to choose memories that tell at least as much about the time, about the feel of Germany in the late 1940s, as they do about me personally and my parents. If I am still haunted by my memories, I am further haunted by the attempts to record the horrific results of bombings—in texts, paintings, and photographs. I have to admit that I hope that this haunting is contagious, and that the reader will thus join me in witnessing images of catastrophe.

The present work does not try to add to the study of ancient ruins, nor even to the subject of ruins qua ruins. Rather, I am here questioning to what extent, and by what means, ruins and the devastation that caused them, can, in fact, be described and thus *seen* by the viewer. Thus the first chapter here will consider texts that give an account of the bombed-out towns of Germany in the last years of the war—journalistic communiqués, novels, and witnessing (autobiographical narratives). I then turn, in the following chapter, to the paintings and the endeavor to describe pictorially the horror of bombs on the cities and towns of Germany, and the scars that remain incised in the landscape. In the third chapter, I introduce the collection of my mother's photographs, and try to glean the degree to which the ruins of war can be better assimilated, and their context more fully taken in, *because* they are photographs. Is there something about the medium of photography that allows for a more concrete reality, more of a direct hit on the viewer, as it were, resulting in seeing more or more completely? Many critics have argued on both sides of the issue in answering this question. I try further to stake out my own position in the fourth chapter. This last chapter is followed by an appendix, displaying more from my collection of photographs. I hope the reader will by then see these images of ruins differently.

My choices of texts and paintings may appear to be random, but they are not. The choice of the artist Karl Hofer was initially driven by the fact that he was still painting in Berlin when my parents moved there in 1945. My parents knew him, visited his studio often, and

bought three of his paintings. Hofer and his wife occasionally had dinner at my parents' house. Family lore has it that he was taken with my mother and was painting an oil for her of a young woman carrying a large sunflower. Hofer's wife found out, and demanded that the painting be hers. Hofer acquiesced, but gave my mother a lithograph of the same image. It hangs today in my library. Similarly, the choice of Anselm Kiefer was initially personal. In 1979, I went to an exhibit of his work in Chicago. I had never seen his paintings before. At the exhibit, I asked my husband how old Kiefer was. "He must be in his sixties," replied my husband. I retorted that I was sure that Kiefer was around my age, because the vast landscapes he produced made me feel as though I were looking again at Germany through the eyes of the three- or four-year-old child I was then. Kiefer, it turns out, is two years my senior. I discovered at that exhibit that it is possible to know things that one is not always aware of knowing. It was an odd realization.

But there is a more important reason underlying the choices of Hofer and Kiefer: Hofer painted ruins before and during the war, while Kiefer produces work that consistently alludes to war devastation. Painting in the immediacy of the war and of the bombing, in juxtaposition to painting out of memory, provides a way of forcing my question: how does one represent and depict war ruins and destruction? How does one's relation to the events change the perspective?

So, too, my choice of texts may seem equally arbitrary. They are not meant to be an exhaustive list of German and other texts inspired by the war. They are, rather, selections that have helped me to question how catastrophe is textually depicted—including in fiction. Again, odd juxtapositions (such as Hannah Arendt and the Texan folklorist and journalist J. Frank Dobie) allowed me to find similar assumptions about the German population in the postwar era.

My hope is that in considering the context of Germany after the war, the larger issue of targeting civilians in modern warfare can be more immediately seen for what it is—deliberate murder (I am not

alluding here to the euphemistically labeled "collateral damage," since in such cases, the targeting of civilians is purportedly accidental). I mean the verb "seen" in two senses: visualizing, but also understanding, absorbing. I have chosen Germany at the end of WWII, not only because of my possession of these photographs, but also as a willfully provocative example of civilian casualties. When the Allies bombed Germany, mainly during the last two years of the war, Germany and Germans were seen as the mortal enemy that not only needed to be defeated but, according to some, also made to suffer.

I turn now to a brief discussion of how ruins were viewed in the past, in order to help prepare, for lack of a better word, the viewer's gaze on the ruins of war.

A Brief Recounting of Gazing on the Ruins of the Past

In the West today, we are easily mesmerized by the remnants of disaster; we scrutinize images of modern ruins—whether they be the remains of the Twin Towers, villages and towns entirely collapsed in present-day Lebanon, Palestine, Detroit, or Syria, or other such architectural wreckages and human horrors of war. And we have ourselves had sufficient "natural disasters"—floods, hurricanes, earthquakes, tornados, wildfires, and tsunamis, for example—to know the irresistible lure of seeing devastation, and of witnessing nature's increasing destructive capacity in the face of climate change. All of this may be viewed from "a safe place," as Burke and Kant put it; for example, from the comfort of an armchair and in front of a television or computer screen.

Earlier epochs had their own armchairs for viewing ruins, such as the landscapes surrounding the ancient ruins of Greece and Rome. And ruins have always provoked reflections on mortality to some degree—hardly surprising, given that they are material vestiges of what has been lost. Greek authors under Roman rule nostal-

gically reimagine the unified and glorious Greece of old. Pausanias, Pseudo-Longinus, and Dio of Prusa attempt to rebuild, through ruins, the totality of a lost Greek past. "So transient and frail are the affairs of men," writes Pausanius as he contemplates what is left of Arcadia. All men are subject to fortune's mutations, for "her resistless force sweeps them along at her will."[3] Thucydides imagines future digs of Lacedaemon and Athens in ruins, but for the purposes of properly estimating their former power. For Petrarch, ruins elicit a collective memory, a perspective fairly common for his era. The fifteenth century measures and studies ruins and worries about transforming them into monuments. One century later, the topographer and engraver Étienne Dupérac makes an album of Roman monuments in ruins, with imagined reconstructions (including the famed Baths of Diocletian).

The great event in the history of ruins in the West happens in the sixteenth century: the discovery of Pompeii and Herculaneum, as well as a few other ancient cities near Naples. But archaeological digs were to begin only in 1748. Fifteen years later, Winckelmann publishes his famous book on the discoveries of the ruins. The Grand Tour—that interesting manner, in the upper classes of combining culture with a certain discretion (after all, one doesn't want to see newlyweds in society for at least a year)—is once again all the vogue because of these archaeological finds. Swarms of well-to-do travelers descend on Italy and Greece to admire the ancient remainders.

3 On the reception of Pausanius in the eighteenth and nineteenth centuries, including his notion of the sublime, see Jás Elsner, "Picturesque and Sublime: Impacts of Pausanias in Late Eighteenth- and Early-Nineteenth-Century Britain," *Classical Receptions Journal* 2, no. 2 (2010): 219–53. For a much fuller discussion of Pausanias and ruins, see Elsner as well, "From the Pyramids to Pausanias and Piglet: Monuments, Travel and Writing," in *Art and Text in Ancient Greek Culture*, ed. Simon Goldhill and R. Osborne (Cambridge: Cambridge University Press, 1994), 244–52ff.

It is at the end of the eighteenth century that one begins to see a nascent Romantic gaze. This is a century obsessed with ruins; it is very "in" to build fake ruins in your garden;[4] they are all the rage.

It was the French *philosophe* Diderot who coined the term "poetics of ruins," emphasizing the theme of sorrow. Ruins, he writes, inspire a "sweet melancholy." He ponders a painting by Hubert Robert (1733–1808), the great painter of ruins, and complains that there are too many people in it, too much noise and movement. Diderot advises Robert to study Claude Vernet, the "greatest landscape and marine painter of the age," writes Michael Fried.[5] "Learn from him how to paint," scolds Diderot, who adds,

and as you've committed yourself to the painting of ruins, be advised that this genre has its own poetics; you're completely innocent of it, acquaint yourself with it. You have the technique, but you lack the ideal.... A solitary man, who's wandered into these shadowy precincts, his arms across his chest and his head inclined, would have made a greater impression on me.... Monsieur Robert, you still don't understand why ruins give such pleasure, independently of the variety of accidents they manifest.[6]

One might argue that, for Diderot, the ruin elicits the future of a new genre more than it evokes the past. We remain alone when we contemplate ruins, writes the philosopher turned art critic, "sole remnants of a generation that no longer exists; *and here is the first*

4 For example, Hagley Hall in England, was built in the mid-eighteenth century to look like a ruined medieval castle, and the Parc Monceau in Paris, the classical colonnade, was built in 1778 to look like a ruin, and can still be admired today.
5 Michael Fried, *Absorption and Theatricality: Painting and Beholder in the Age of Diderot* (Chicago: University of Chicago Press, 1980), 122.
6 John Goodman, ed. and trans., *Diderot on Art II: The Salon of 1767* (New Haven, CT: Yale University Press, 1995), 198.

line in a poetics of ruins."[7] The ruin has here already attained the status of a poetics, complete with a demand for solitude and an ideal. And (we might add) the ruin has arrived as well at its Romantic representation—textual as well as painterly—soon to become a predictable series of clichéd depictions.

From Petrarch forward, the theme of the ruins is a constant one. But beginning at the end of the eighteenth century and throughout the nineteenth, the ruin theme expands exponentially and varyingly. Every major (and minor) Romantic thinker in France, the German states, and England (to name the most obvious) writes about ruins, as if a landscape of the traces, heaps, and rubble of previous civilizations provided furniture for the installation of meditative solitude. Artists and painters generally in the nineteenth century not only follow suit, but are frequently the torchbearers of romantic ruin obsession, and the malaise and bittersweet pleasure that undergird it.

Ancient ruins are often taken to engage what Longinus, Burke, Kant, and others call the sublime—a greatness without calculation or, as Žižek puts it (echoing Lacan), a material object elevated to the status of an impossible Thing.[8] Ancient ruins are not, in fact,

7 Roland Mortier, *La poétique des ruines en France: Ses origines, ses variations de la Renaissance à Victor Hugo* (Geneva: Librarie Droz, 1974), 93. Emphasis Mortier's, translation mine. This is a good and thorough study of the ruin in France from what Mortier calls "the origin of the ruin theme" to most of the Romantics, ending with Hugo. It is Mortier who argues that, for Diderot, ruins evoke the future more than they do the past.

8 Longinus is normally held to be the first to define the sublime, although, as James Porter notes, "Longinus in no way holds a unique patent on the concept." See James I. Porter, "Ideals and Ruins: Pausanias, Longinus, and the Second Sophistic," in *Pausanias: Travel and Memory in Roman Greece*, ed. S. E. Alcock and Jás Elsner (Oxford: Oxford University Press, 2003). See also Kant's *Critique of Judgment* (1790), and his earlier work, *Observations on the Sublime and the Beautiful* (1764).

"impossible"—there they are, in front of us. And yet in a sense they are impossible, for they speak of a past that will never be present again, materially enacting the passing of time and reminding the viewer of mortality. One need but look at the landscape paintings of Caspar David Friedrich to see how wedded the sublime remains to the Romantic vision. Piranesi, for his part, is no doubt the greatest ruins artist of the early Romantic era. His dark depiction of ancient ruins, like his *carceri* drawings, demonstrate an iconology that anchors ruins in a void; a proximity to an abyss such that seeing itself is ineluctably tied to some sort of ocular transgression.

Many writers of Romanticism and post-Romanticism (although one can question whether or not we are in fact "post" the Romantic gaze) note that a textual description itself is powerless in the face of ruins. By what linguistic method could ruins possibly be described, ask ruins scholars? Always by way of a simile, they conclude, for ruins can only be depicted "by a detour"—analogy, comparison, metaphor. Benjamin Constant writes that it is impossible to define the wind groaning among the ruins. Philosophy, he adds, is incapable of conveying this phenomenon through language. Freud compares memory to the layers of ruins that underlie the city of Rome— each layer revealing another ancient city, another civilization in fragments. But Freud, too, abandons the analogy: "There is clearly no point in spinning our phantasy any further, for it leads to things that are unimaginable and even absurd."[9] He dreamily adds that stones speak: *Saxa loquuntur*. There is also the fascinating conviction of Freud's that Judaism has survived because the ruins of the temples cannot be seen and must thus be kept only in the mind's eye. In a letter Freud writes, "The invisible edifice of Judaism became possible only after the collapse of the visible Temple."[10]

9 Sigmund Freud, *Civilization and Its Discontents*, ed. and trans. James Strachey (New York: Norton, 1962), 17.
10 Letter to Martha Bernays, July 23, 1882.

It is not, obviously, that ancient ruins cannot be depicted textu-
ally; it is, rather, that the peculiar combination of melancholy and
pleasure produced by ruins, and the meditation on mortality that
ruins elicit, are somehow deemed too elusive to describe, too myste-
rious to capture fully. Even Walter Benjamin's famous remark about
ruins is itself a simile, and a less than obvious one at that: "Allegories
are in the realm of thought what ruins are in the realm of things."[11]
Moreover, the reconstruction of actual ruins seems to add to melan-
choly rather than to dissipate it. "No one knows how sad one had to
be," writes Flaubert, "to reconstruct the ancient city of Carthage."[12]
The philosopher and sociologist Georg Simmel, in his 1911 essay
"The Ruin," puts all of this murkiness this way: the "ruin strikes us
so often as tragic—but not as sad—because destruction here is not
something senselessly coming from the outside but rather from
the realization of a tendency inherent in the deepest layer of exis-
tence of the destroyed." The ruin is a tragicomedy, he adds: "Every
ruin [is] an object infused with our nostalgia.... When we speak of
'returning home,' we mean to characterize the peace whose mood
surrounds the ruin ... purpose and accident, nature and spirit, here
resolve the tension of their contrasts." Ruins "signify this coming
together of all contradictory striving."[13]

 Ruins can also inspire a prospective viewpoint. Diderot and Rob-
ert, contemplating ruins, anticipate the future as if they were ghosts
in the present; Robert goes so far as to paint the great gallery of the
Louvre in ruins (shown at the Salon of 1796). Some thirty-five years
later, Joseph Gandy produces his famous painting, *Bird's Eye View*

11 Walter Benjamin, *The Origin of German Tragic Drama*, trans. John Osborne
(London: Verso, 1977), 177-78.
12 Letter to Ernest Feydeau, November 29-30, 1859, in *Correspondance: Gus-
tave Flaubert*, ed. Giovanni Bonaccorso (Saint-Genouph, France: Nizet, 2001)
3:59. My translation.
13 Georg Simmel, from "Two Essays," trans. David Kettler, *Hudson Review* 11,
no. 3 (Autumn 1958): 379-85.

of the Bank of England (1830). Soane's new bank is first drawn in all of its splendor, and then reimaged as a magnificent ruin for future ages to admire.

There is a chilling aspect to projecting edifices of the present as ruins of the future. Albert Speer, Hitler's architect (and later, minister of armaments and war production), developed what he called a theory of "ruin value." If buildings of a great empire are to inspire future generations, argued Speer, they need to be made of stone and not of iron (the latter looking ugly once in ruins). In keeping with the "principle of this 'law of ruins,'" writes Speer, he had "a romantic drawing prepared" for Hitler. The drawing showed the prospective *Haupttribüne* as an ivy-covered ruin, "walls crumbling here and there." Speer's model was the Parthenon, the ruined splendor of massive stone blocks that so inspired Flaubert. Hitler called Speer's ruin theory "a bridge to tradition," declaring that hundreds of years from the present, the Thousand Year Reich would thus produce ruins as beautiful as those of antiquity. Speer's vision, quite distinct from the political horror of which it is a part, shares the Romantic view of antiquity as aesthetically pleasing—beautiful in its crumbled stones, and suggesting a great wholeness, even as it is remaindered in fragments. "By using special materials," writes Speer, as he reminisces in his autobiography, "and by applying certain principles of statics, we should be able to build structures which even in a state of decay, after hundreds or (such were our reckonings) thousands of years would more or less resemble Roman models."[14]

We have seen such a future-oriented approach to ruins before: Simmel's gaze is as if from a time to come that sees the present in ruins. He, along with Diderot, Robert, and Gandy all partake of what Svetlana Boym calls "ruinophilia"—the prospective dimension of nostalgia, one that is "reflective rather than restorative and dreams

14 Albert Speer, *Inside the Third Reich*, trans. Richard Winston and Clara Winston (New York: Macmillan, 1970), 56.

of the potential futures rather than imaginary pasts."[15] Speer's ruin
theory, paired with Hitler's "bridge to tradition," is similarly future
oriented. But rather than attempting to remind the viewer of the in-
evitable expiration of every civilization and its structures, Speer and
Hitler want to postpone expiration and structure everything—even
the gaze of future generations—in viewing future ruins.

At this point, we may consider the obvious: not all ancient ruins
are created by the gentle erosion of time, or by the returning claims
of nature, with its curtains of ivy and brambles. The Lisbon earth-
quake of 1755, for example, was such a total devastation that it is
frequently seen as having put an end to the optimism of the first half
of the eighteenth century, and prepared the way for Romanticism.
One year later, Edmund Burke put out his *Philosophical Enquiry into
the Origin of Our Ideas of the Sublime and Beautiful*. If Thucydides
had worried that a future archaeologist might misunderstand the
power of city states, judging as he or she would only from the rem-
nants, Burke, in his study on the sublime, is on a different tack: he
wants to show that we have Schadenfreude: "a degree of delight,
and no small one, in the real misfortunes and pains of others" (1803,
39). In his drive to demonstrate our morbid fascination with disaster,
Burke—like Thucydides and Speer—imagines the future destruction
of a city; in this case, London. And although he does not name it
directly, the Lisbon earthquake of the previous year is clearly very
much on his mind. What if, he asks, London were destroyed "by a
conflagration or an earthquake"? If such a catastrophe were to occur,
he continues, "what numbers from all parts would crowd to behold
the ruins, and amongst them many who would have been content
never to have seen London in its glory?" (46) Catastrophe, of which

15 Svetlana Boym, "Ruinophilia: Appreciation of Ruins," in *Atlas of Tranforma-
tion*, ed. Zbynek Baladrán and Vit Havránek (Zurich: JRP Ringier, 2011), http://
monumenttotransformation.org/atlas-of-transformation/html/r/ruinophilia
/ruinophilia-appreciation-of-ruins-svetlana-boym.html.

ruins are the traces, are of far greater fascination than the ordinary vistas of the everyday; and while Burke believes that "no man is so strangely wicked" as to desire that the city of London be destroyed, he knows that they will certainly flock to see it if it ever were to lie in ruins.

Derrida himself is not immune to the lure of ruins. The contemplation of ruins, he argues, predetermines the gaze to a great extent. In *Memoirs of the Blind*, he connects ruins to a skull's empty eye socket (a common theme, it should be added, among those who try to describe ruins). For Derrida, the ruin is neither a spectacle nor a theme, nor something in front of us, nor a love object; it is experience itself: "Ruin is, rather this memory open like an eye, or like the hole in a bone socket that lets you see without showing you anything at all, anything of the all."[16] The inability to see "anything of the all" is reminiscent of the Romantic focus on the fragment: some sort of totality haunts in the fragment, a memory of an all that (as Hegel points out) is only superficially belied by the view, among the ruins, "of *change at large*."[17] Death becomes here a dark divinity of sorts, or at least an absolute that, much to Derrida's apparent consternation, cannot be negotiated and of which ruins are the augury.

Derrida's text becomes a kind of epistemological recusatio: it performs what it professes to contest. And though Derrida, unlike Simmel, does not hold that "a new entirety" emerges from ruins, his reading of the skull's empty sockets is less radical than Walter Benjamin's view of the skull, or death head, and his view of ruins as allegory. The skull (common, Benjamin reminds us, in the staging of baroque drama) for him shows "the complete subjugation of man

16 Jacques Derrida, *Memoirs of the Blind: The Self-Portrait and Other Ruins*, trans. Pascale-Anne Brault and Michael Nass (Chicago: University of Chicago Press, 1993), 69.
17 G. W. F. Hegel, *The Philosophy of History*, trans. J. Sibree (New York: Dover, 1956), 126.

to death." For death is that which "most deeply incises the broken line that demarks the limit between physical being (*Sein*) and signification." The ruin is the allegory of this perspective; it allows for escaping the false affirmation of the symbol. A ruin can, through the intervention of such a gaze, accomplish what Benjamin calls for: a shock that will unveil history in time and "make the continuum of history explode."[18]

Ruins, then, have long been peculiarly alluring, as if they were a siren-like scaffolding for the abyss, or the bemused handiwork of death. For a reason that eludes me, ruins have been of particular fascination in the last decade. In the US, this is perhaps the effect of 9/11—repetitively shown, visually seared in the mind of the American populace. Those ruins were the first in modern memory to be created on American soil. Or perhaps this fixation stems from the "ruinscapes" in the daily paper in places such as Afghanistan, Lebanon, Syria, and Palestine—to name just a few. Nevertheless, the number of books, articles, exhibitions, and other installations on ruins today is fairly surprising, particularly since a majority of these studies return to ancient ruins, and not to the present-day work of drones, explosives, and other technological devices of destruction.

We begin, then, by considering various textual attempts at describing the devastatingly successful bombing of Germany by the Allies at the end of the Second World War. One unspoken question underlying this first chapter is to what extent the reader will be able to ward off the seductively pervasive romantic gaze. As Rancière remarks, there is not always politics, but there are always forms of power.[19] There is, he continues, such a thing as an ethics of images (2004, 43). Even images, I would add, that are mentally stimulated by texts.

18 Walter Benjamin, "Theses on the Philosophy of History," XV, in *Illuminations*, trans. Harry Zohn (New York: Schocken, 1969), 261.
19 Jacques Rancière, *Malaise dans l'esthétique* (Paris: Galilée, 2004), 40.

Physical characteristics Berlin — Holes in pavement, broken glass everywhere, tank blocks, many telephone wires, slips paper pasted indicating where people moved to; flowers in memoriam on heaps of ruins; destroyed tanks, cars, guns.

Story of Karstadt bldg.? Kottbusdamm ent., Hermannpl. Subway flooding — canal near Anhalter Bhf. Train of wounded soldiers in tunnel.

In final days of Berlin battle Nazis identified the capital with Europe as a whole. "Europa wird nicht russisch." There was the grain of truth, i.e., that western allies did not fully understand the Soviets & what they threatened.

April 29 — Russ approaching Potsdam pl.
More than 1/2 mill. foreign slave laborers in Berlin.
Hitler said he wd. fight until 5 mins past 12.

More detail about an air raid shelter. Baggage, etc. Bad air.

Street signs: "Führer, wir folgen Dir."
"Volk ans Gewehr."
"Wir kapitulieren nie."
"Sieg oder Sibirien."
Kolberg — city of 40,000, plus 60,000 refugees. Nazis said defend to last. SS left in chg. 20,000 supposedly drowned in attempt evacuation by sea.

Breslau — Nazis built airport in middle of city — under artillery fire. Burnt & dynamited bldgs, then leveled area. Check.

People in line at water pumps. (old, never thought would see.)

1 When Words Fail

WRITING DISASTER

"You have also been told to love your friends and country, although you may hate your enemies and foreigners. But I say, if you cannot love your enemies, at least respect the humanity in them." HEGEL, paraphrasing Jesus[1]

How do texts attempt to describe and convey the catastrophe that flattened the German cities in the last years of the war? How do writers evoke an image of total destruction, of ruins, and of a German population left reeling (clearly from a variety of disparate reasons) once the war has ended? In the immediate postwar era, texts produced by the Allies and survivors of the Nazi terror are largely (and unsurprisingly) driven by anger, revenge, scorn, or contempt—or all of these. An enemy of unimaginable evil has been vanquished, and any recognition of the suffering the enemy population endured is of little or no import; indeed, by some lights, such suffering is deserved, and taking it into account is unethical. It was not until several decades after the war was over that some writers began, cautiously, to consider the Allied bombing of German civilians, and the

1 Hegel, "The Life of Jesus," in *Three Essays, 1793–1795*, ed. and trans. Peter Fuss and John Dobbins (Notre Dame, IN: University of Notre Dame Press, 1984), 112.

extent to which the German cities and towns had been reduced to ruins, leaving behind an immense number of people dead, maimed, or homeless in the rubble. That project had its own pitfalls, its own hazards, as we will see.

We begin by considering two texts, chosen from among many others, written a few years after the war's end. The first by the philosopher Hannah Arendt, and the second by J. Frank Dobie, a folklorist and journalist. They do not immediately make for an obvious pairing, to say the least; but a similarity of assumptions emerges as their reports are considered.

In the winter of 1949–50, Hannah Arendt visited Germany in her capacity as Director of the Commission on European Jewish Cultural Reconstruction. Though her primary goal was to retrieve lost or stolen Jewish objects, while there she also wrote "The Aftermath of Nazi Rule: Report from Germany." She begins by noting that while the rest of the world is horrified by "the sight of Germany's destroyed cities and the knowledge of German concentration and extermination camps," the Germans themselves are lacking in any response. "Nowhere is this nightmare of destruction and horror less felt and less talked about than in Germany itself."[2] Is this, she wonders, a half-conscious refusal to yield to grief, or is it a genuine inability to feel? She notices that the Germans are feverishly busy, "a greedy craving for something to do every moment of the day." Whereas many other writers of the period describe Germans as near-ghosts, shell-shocked in every conceivable way, Arendt decides that their chief defense against reality is busyness. She watches the Germans "busily stumble through the ruins of a thousand years of their own history, shrugging their shoulders at the destroyed landmarks or resentful when reminded of the deeds of horror that haunt the whole surrounding world." (249)

2 Hannah Arendt, "The Aftermath of Nazi Rule: Report from Germany," in *Commentary*, X/10 (1950): 248–69, at 249.

Amid the ruins, continues Arendt, the Germans "mail each other picture postcards still showing the cathedrals and market places, the public buildings and bridges that no longer exist." The "standard reaction to the ruins," declares Arendt, is only a sigh followed by "Why must mankind always wage wars?" Moreover, she notes, her conversations with Germans, once they learn she is Jewish, are not filled with sympathy, nor with questions such as, "What happened to your family?" Rather, the Germans she talks to produce "a deluge of stories about how Germans have suffered," thus cancelling out the suffering of others since everybody has suffered and so "we may as well proceed to a more promising topic of conversation." Germans suffered, too, she admits: "True enough, of course, but beside the point." (249)

J. Frank Dobie, the American folklorist and newspaper columnist, went to a vanquished Germany two years before Arendt, in the winter of 1946–47. He wrote of his time there in a long article that appeared in *National Geographic*. The article, "What I Saw Across the Rhine," tells a story similar to Arendt's; of the Germans' inability to come to terms with what they (and their Nazi regime) had done. In a German store, Dobie meets two people who begin—uninvited, as Dobie notes—"crying on [his] shoulder about hard times." He adds, with a combination of wonder and anger, "Neither seemed to have the slightest realization of the fact that they and their people have merely reaped what the Germans sowed."[3] Months later, Dobie leaves Berlin for Paris, thoroughly delighted to be getting out of Germany. Paris, he writes, seemed to have a "kind of brightness" and appeared to belong "to another world from Germany, where for months I saw on nearly all human countenances only heaviness, secretiveness, depression, surliness, and often hate." (86) The hate, of course, was directed at the American GIs and other Allied forces—

3 J. Frank Dobie, "What I Saw Across the Rhine," *National Geographic* 91, no. 1 (January 1947): 57–86, at 83.

the conquerors. When Dobie finally reaches New York, he writes that "the color intensified the profound and almost unrelieved grayness that in some ways seems to me to sum up Germany today." (86)

Unlike Arendt, Dobie is not a philosopher, and Arendt is certainly not a folklorist. But both writers attempt, through their differing prose, to capture the "atmosphere" of postwar Germany. Dobie resorts to light and color metaphors—brightness for Paris, and intense color in New York, which contrast sharply with the unrelieved grayness that for Dobie is the dull hue in which all of Germany is steeped. For Arendt, what stands out is the German's lack of affect, again in sharp contrast to "the whole world" that is horrified by a destroyed Germany and knowledge of the camps. Dobie, too, notices what Arendt dubbed "busyness." The Berliners, he says, "all seem to walk somewhere for some purpose, or jam into the trains or streetcars.... Many carry briefcases or some other kind of bag." (63) As we will see in the photographs in chapter 4 of this study, in the midst of the bombed-out landscape, many people are indeed shown, either carrying a briefcase, pushing a grocery cart, or with bags attached to their bicycles. Dobie does not seem to realize that these parcels can be attributed to the black market (hiding the goods in a bag), or to the general foraging for food, or to carrying one's belongings when homeless.

Busyness, of course, also helps in repressing the fact of calamitous surroundings, and helps as well in erasing the memory of the trauma, attempting to restore some sort of normalcy. Arendt ignores this reaction of self-preservation, and rather scornfully refers to busyness, it will be recalled, as "a greedy craving for something to do every moment of the day." While it is indeed a strange sight— people purposefully rushing about in a landscape of near-complete destruction—there is more to this "greedy craving" than Arendt's perspective will allow. There is, apart from repressing the physical and psychological effects of the war, the food shortage, which

results in frantic searches, bartering, dealings with the black market, and foraging. Moreover, there is the search for a job, for help in reconstructing, for putting a roof over one's head, for fulfilling the bureaucratic requirements of the occupying forces, for searching for lost relatives, and so on.

Both Dobie and Arendt's descriptions of postwar Germany, then, interpret German defensiveness, hostility, and lack of response as indicative of "the German problem." The reporting of both, in other words, is informed by an understandable anger of their own, manifested textually by an annoyed sarcasm and generalizations: Why don't the Germans shoulder their guilt; recognize their role within the Nazi rule; feel *something*? Why are they crying on peoples' shoulders "about hard times," in the words of Dobie, when it's in fact all their fault? Arendt remains coolly political: a ruined Germany, she concludes, is "an object lesson for the consequences of totalitarianism." (269) For Dobie, the German people have "merely reaped" what they have sown; they should accept this. But Arendt's informed political perspective does not work to differentiate her greatly from Dobie's more anecdotal commentary. Both are convinced that the Germans are escaping their responsibility; that they brought all of this upon themselves; that they have no affect; that they, in fact, annoyingly refuse responsibility. Thus both essentialize the German population: "The Germans" think and do this or that. While this lack of nuance is quite understandable in considering the atrocious enemy that was the Third Reich, the Germans were not, obviously, monolithic in their attitude toward the regime. The journalist Stig Dagerman, to whom we will soon turn in this chapter, had a much more complex view of the German population at the end of the war, as did other writers, some of whom we will consider here.

Neither Dobie nor Arendt take into any significant account, then, the extent to which most of the German population is traumatized at the war's end. Is suffering ever "beside the point"? Even of an enemy,

or of Nazis? Is it impossible to feel compassion for the German civilians? Should one feel compassion, or empathy?[4] To this is added the fraught problem Arendt mentions at the outset of her report: that in referring to their own suffering, the Germans are attempting a zero-sum game, wherein the suffering of one side cancels out the other. This is an unacceptable point of view, needless to say. While any suffering is never beside the point, attempting to erase the barbaric acts of the Third Reich cannot be canceled out by anything. Thus, there is a fine line to be walked here, between the undeniable suffering of the German civilian population during the war, on the one hand, and the moral depravity and murderous agenda of the Nazi machine, on the other. This fine line, this balancing act, informs many texts describing the horrors of the bombing raids in Germany. But the first to write directly on this problem is W. G. Sebald in 1999.

In his controversial book on the bombing of Germany, Sebald, like Arendt and Dobie, comments on the tabula rasa that seems to characterize the German mind after the bombings, and after the defeat. The destruction, he writes, "seems to have left scarcely a trace of pain behind in the collective consciousness; it has been largely obliterated from the retrospective understanding of those affected."[5] He retells the story of a man who insists on speaking about what happened; the audience turns on him and kills him "for the deathly

4 In using the term "empathy," I do not mean professing to share the feelings or misfortunes of others, but rather to recognize them. On how viewing photographs of ruins created a "politics of pity" early in the Cold War, see Stefan-Ludwig Hoffmann, "Gazing at Ruins: German Defeat as Visual Experience," *Journal of Modern European History* 9(30):328–50 (November 2011). Hoffmann considers how German and Allied visual experience of the postwar diverged. For similar questions, see Robert G. Moeller, "Germans as Victims? Thoughts on a Post–Cold War History of World War II's Legacies," *History and Memory* 17, nos. 1–2 (2005):147–94. Moeller's account discusses how many Germans are attempting now to mourn their dead and come to terms with the horrors of World War II.
5 W. G. Sebald, *On the Natural History of Destruction*, trans. Anthea Bell (New York: Modern Library, 2004).

chill he spreads." Most survivors are spared this fate, he adds, be-
cause "their trade is less dangerous than dealing in concrete mem-
ory." (52) Sebald's book is controversial precisely because it deals
with this thorny issue: in recognizing German suffering during the
war, it is too easy, as we saw Arendt note, to equate that suffering
with the Holocaust and other victims of the Nazi regime.

Outing memory is indeed dangerous (hence, the recourse to
busyness), because it too often results in unwanted guilt, or breaks
down the defenses of repression. György, the fourteen-year-old
protagonist of Imre Kertész's novel *Fatelessness* (1975) survives the
death camps.[6] But when he gets home, he finds that the two elderly
neighbors he'd known before his deportation, neighbors who had
somehow escaped the camps, cannot understand his experience
and furthermore don't want to. They don't kill him, as in the story
told by Sebald, but they angrily resent his insistence on speaking of
what happened to him. "What?" shouts one, "So it's us who're the
guilty ones, is it? Us, the victims?" (260) György finally lapses into
silence, realizing that those who survived the camps cannot convey
the experience to those who were spared from being sent to a camp.
He even found "happiness" in the camp, he says; something he will
no doubt never be able to explain. But someday, he decides, he will
try again to tell his story, "If indeed I am asked. And provided I my-
self don't forget." (262) *Fatelessness*, even as it narrates György's ex-
perience in the concentration camp, also narrates the inability to
recount the experience; the inability of those who were not sent to
the camps to visualize, or otherwise comprehend, the experience.
Trauma, as innumerable writers on the subject have noted (begin-
ning with Freud), does not lend itself to that most basic of human
undertakings, narration; and memory will work ceaselessly, out of
self-protection, to erase the events—"provided I myself don't forget."

Writing like so many other journalists who went to Germany
immediately after the war, Stig Dagerman tries to understand the

6 Imre Kertész, *Fatelessness* (New York: Random House, 2004).

silence that envelopes the civilian population. The people, he writes in his remarkable *German Autumn* (1947), "became significant perhaps not in spite of their silence but because of it, for nothing can be expressed with such a charge of menace as that which is not expressed."[7] As the foreword writer to his book puts it, Dagerman's "extraordinary gift was his ability to empathize." (ix) We will return to Dagerman shortly.

The photographer and reporter Margaret Bourke-White also went to Germany immediately at the end of the war and photographed, for *Life Magazine*, both the liberated camps and the destroyed cities.[8] The juxtaposition is telling, and Bourke-White has no difficulty with description. She interviews (among many others) Hildegarde, a young German woman and fervent Nazi, who believes that the war was started by England—or maybe it was Poland or Russia. Hildegarde continues, "We always thought you didn't really want to bomb us. We always had the impression you wanted us to fight Russia." (7) To this Bourke-White comments, "I was to meet this kind of thinking in one form or another again and again in Germany." Her photographing of the death camps has left her little sympathy for the Germans, but she interviews them without divulging her revulsion. Hildegarde, for example, speaks openly about her continuing anti-Semitism to Bourke-White, who produces a vivid verbal image of the ruins that surround the Nazi woman: Hildegarde "stood out incongruously against the background of devastation. Her kitchen, hanging insecurely, open to a panorama of wildly tossed ruins just beyond, gave the feeling of a small stage against which someone had lowered the wrong backdrop." (8) Bourke-White's descriptions of the bombed-out cities are as declarative and uncomplicated as

7 Stig Dagerman, *German Autumn*, trans. Robin Fulton Macpherson, foreword by Mark Kurlansky (Minneapolis: University of Minnesota Press, 2011), 5.
8 Margaret Bourke-White, *"Dear Fatherland, Rest Quietly": A Report on the Collapse of Hitler's "Thousand Years"* (New York: Simon and Schuster, 1946).

her photographs. In her foreword to the book, she is explicit: "This book is a description of Germany as I saw it in defeat and collapse. Perhaps because I am primarily a photographer," she continues, "I have tried to give a candid picture rather than to suggest solutions to the problems I found there." And indeed, her descriptions and images of ruined cities are candid, if candid is taken to mean blunt. Upon viewing the flattened town of Hamburg, she photographs the rubble that pervades in that city and adds the somewhat ironic caption: "Not enough was left of Hamburg to make an impressive ruin." She photographs the destruction of Cologne and notes, "Cologne was the first great German ruin that I saw. It measured the magnitude of the disaster which overtook the Nazis." In Bremen: "Bremen was a desert. A few landmarks told you it had been a city." Bourke-White, who is not a writer of literature, makes no attempt to assert a personal style, unlike Gertrude Stein, as we will see shortly. But the photographer and reporter certainly has a style of her own: her verbal descriptions of the ruins are precise and matter-of-fact.

Not so her photographs, captions, and comments on the liberated death camps, however. In these, Bourke-White is openly angry and horrified by the Nazi war crimes and genocidal camps, and by the Germans' collaboration with Hitler's murderous agenda. The captions read as continuous, and frequently sarcastic, condemnations. "Fräulein," reads one caption to a photograph of a pile of dead, emaciated bodies, "you who cannot bear to look, did you agree about the Jews? Will you tell your children that the Führer was good at heart?" This sarcasm is addressed to a woman in a photograph that shows Germans being forced to view the horror that is what remains of Buchenwald. The caption for another photograph of this "visit" reads, once again sarcastically, "It was George Patton's idea that Buchenwald's good German neighbors should visit it." A caption for a photograph of a young boy reads, "This boy is dying in the Buchenwald murder factory." The very title of her book is one of forceful sarcasm: *"Dear Fatherland, Rest Quietly"*—a sort of mockery of a

graveyard eulogy (although this title too may have been provided
by *Life*). What is clear from Bourke-White's account is that Germany
has died, and she was there to record the final death throes.

At the same time, however, she is aware of the deadly totalitarian
machine that bears down on all of the population. The caption for
the photo of a Buchenwald crematorium reads: "A child's denuncia-
tion, a neighbor's spiteful whisper, a man's belief in his own God or
in democracy, or anyone's sly malice might start one on the path to
which this was the awful terminal." In the foreword, Bourke-White
thanks her editor at *Life* "for his fine captions." They are not all her
captions, then, but many are taken from Bourke-White's text. On
the other hand, *Life* uses captions for shock value, and to keep the
reader's attention. Just such a *Life* caption describes a young boy
averting his face from the dead bodies on the side of the road near
Bergen-Belsen: "Shortly after Germany's defeat in 1945, a child
walks past the corpses of hundreds of former inmates of Bergen-
Belsen concentration camp, laid out along a country road. Like most
adult Germans in the postwar years, he averts his gaze." We will re-
turn to this photograph in a subsequent chapter of the present study.

Perhaps Bourke-White's decision to give a "candid picture rather
than to suggest solutions" helped her to produce a plain-spoken text
as well as plain-photographed account of what she heard and saw
from the German population. But it is worth noting that the Ameri-
can conquering gaze, let us call it, is encouraged, and that it informs
as well as manipulates readerly response—through the photographs
and the text itself, but also through that small textual addendum to
photographic reporting called the caption. The horrors that Bourke-
White reports from Buchenwald are gripping and difficult to read
about, and even more so to view. But the captions are not only infor-
mative of the horror Bourke-White records; they are produced by
Life and thus molded into its sensationalist discourse that trains the
eye to see in a specific manner.

The fact that Bourke-White deals at the same time with *both* the
death camps *and* the bombings is to some extent the perspective,

and problematic, of the present study. But Bourke-White's photographs, captions, and text, in their *Life* context, frequently have the unhappy result of commodifying her subjects, who either provide the reader/viewer with horrific images of victims in the liberated camps, or with the German populace, produced as the enemy that deserves to suffer. Both perspectives lead to a fascination with suffering, however, and both serve to fuel the fire of hatred for the enemy. Bourke-White's "candid" descriptions and extraordinary photographs are organized by the magazine to titillate and to sell copies, at least as much as to situate the political drama unfolding in Germany 1945.

Descriptions of the bombed-out cities and towns are not always so "candidly" produced. Indeed, some journalists who witnessed the destruction of Germany were themselves overwhelmed, and frequently wrote that they could not, in fact, describe the scenes. The journalist Jacob Kronica writes from Berlin on May 4, 1945, "Today's walk gave us more disturbing impressions of the Berlin battlefield. The devastation is impossible to describe in words. The entire city center . . . is utterly destroyed. The streets are littered with the burned-out wreckage of cars, tanks, motorcycles, cannons, and so on."[9] The reporter Theo Findahl, in Berlin on May 8, 1945, writes in a similar vein: "This is the first time I've come this far into the city, where the appalling destruction defies all description." (351)

Dagerman, on the other hand, refuses to resort to the word "indescribable," and insists that the destruction can in fact be described. He sardonically repeats the word "indescribable" only to reject it: One could "describe the 'indescribable' wanderings" of the children . . . and then give a series of 'indescribable' pictures of their "classroom activities" in the high piles of rubble. "At the same time," writes Dagerman, "it would be proper to describe the 'indescribable'

9 Oliver Lubrich, ed., *Travels in the Reich, 1933–1945: Foreign Authors Report from Germany*, trans. Kenneth Northcott, Sonia Wichmann, and Dean Krouk (Chicago: University of Chicago Press, 2010), 348.

activities with which those who stay at home in their water fill their day";[10] or the "indescribable" feelings of "the mother of the three hungry children." His is a sad task, writes Dagerman, but as his comments about the "indescribable" attest, he will in fact describe daily life in war-torn Germany and any anecdotes he deems instructive. Dagerman's is a didactic book, and his clear rejection of other reporters' style and his descriptive record of the state of things is something that in his opinion "has to be done." (9)

Dagerman seeks to remove collective guilt that has been leveled on the entire German population. On the one hand, says Dagerman, the cruelties practiced by Germans inside and outside Germany are incontestable. But, he adds, "it is another matter to ask if it is now right, if it is not indeed a cruelty, to regard the sufferings of the Germans as justified on the ground that they are the undoubted results of a German war of aggression that failed." (11) Dagerman aims to describe the suffering of the German people in order to persuade the Allied forces to do something about it. His anecdotes and descriptions are detailed and compelling; throughout his text he rigorously continues to refuse the "indescribable" to which his colleagues so frequently succumb. Dagerman himself was as if a victim of his efforts at describing the suffering of the Germans. A few years after writing *German Autumn*, he could no longer write anything at all. A novelist and playwright, Dagerman had been a rising star in the Swedish literary scene by the time he was twenty-three. At the age of thirty-one, he took his life.

Around the same time as Arendt's and Bourke-White's trips to Germany, another famous writer went to see the devastation there and to write about it. Gertrude Stein and Alice B. Toklas set off for Germany in the summer of 1945; Stein had also promised *Life* a reportage on the subject. The resulting piece, with several photo-

10 The text states "in their water" as their homes were flooded with sewage, or had flooded because of burst pipes.

graphs, appeared in the magazine on August 6, 1945. The title alone
is vintage Stein: "Off We All Went to See Germany: Germans Should
Learn to be Disobedient and GIs Should Not Like Them No They
Shouldn't."[11] Stein, whose relationship with the Vichy government
has often been described as overly cozy, says she had a great time
on this trip, but only because she loved being with the American
GIs. "It was a wonderful experience" are her first words. She con-
tinues, paradoxically enough, "and I really pretty well forgot about
Germany and the Germans in the enormous pleasure of living inti-
mately with the American Army." (54)

Stein's prose takes no prisoners, as it were (nor does it stoop to
standard punctuation). Her descriptions are, typically for her, crisp
and repetitious: "We all went to see Germany, we had seen it ru-
ined from the air and now we saw it ruined on the ground. It cer-
tainly is ruined, and not so exciting to look at." (54) She, too, lapses
into generalizations about "the Germans"—they are too obedient,
and there's the problem. To General Osborne, she quips, "the Japs
and the Germans are the only really obedient people on earth and
see what happens, teach them disobedience, confuse their minds,
teach them disobedience, and the world can be peaceful." (56) She
does become somewhat pensive about ruins when she gets to Co-
logne, which "was the most destroyed city we had seen yet, it is nat-
ural, of course it is natural to speak of one's roof, roofs are in a way
the most important thing in a house, between four walls, under a
roof, and here was a whole spread out city without a roof." The ca-
thedral, too, captures her attention: "There was the cathedral but
it looked very fragile as if you pushed it hard with your finger your
finger either would go through it or it would fall over." In Munich
she remarks, "One would suppose that every ruined town would

11 Gertrude Stein, "'Off We All Went to See Germany': Germans Should Learn
to Be Disobedient and GIs Should not Like Them, No They Shouldn't." *Life*, Au-
gust 6, 1945, 54–58.

look like any other ruined town but it does not." (57) She sees under-nourished men, and easily admits, "Was I pleased to see it, well a little yes." (56) With several GIs, she and "Miss Toklas" (as Stein refers to her) go to Berchtesgaden and visit Hitler's mountain retreat. On the balcony, she finds a radiator that she wants to bring home (and put plants in), but is discouraged by its weight and leaves it behind. Her friend-of-the-Vichy-regime reputation is not helped by the photograph showing Stein and the GIs on Hitler's balcony, all with arms raised in a playful Hitler salute.

Stein is clearly not given to empathy for the Germans, except somewhat indirectly (the houses without roofs; the cathedral at Cologne). Her style does not attempt to accommodate a journalistic, rather than literary, perspective. Her pseudo no-nonsense tone, the repetitions and lack of normal punctuation, the frequently poetic rhythm, the random anecdotes (Hitler's radiator, meals with the soldiers, discussions with the army pilot)—all betray a rather mischievous and ironic stance. This, combined with her statement at the outset that she was able to forget all about Germany and the Germans, makes for a jarring contrast with the devastation that surrounds her, and with the texts of other journalists, overwhelmed by the devastation. There is only one moment in the piece when Stein sounds intensely political. In talking with the GIs, she learns that they "like Germans better than other Europeans," and she lectures them quite forcefully. The Germans, she tells the soldiers, are obedient and flatter them, but they should not be fooled. "You don't like the Latins or the Arabs or the Wops, or the British, well don't you forget a country can't live without friends, I want you all to get to know other countries so that you can be friends, make a little effort, try to find out what it is all about." The sergeant complains that she has "confused the minds of his men." (58)

Stein's piece in *Life* is surrounded by ads for cigarettes, soft drinks, washing machines and new kitchens. The other stories in the

issue concern Truman's first one hundred days; how to defeat Japan; Marlene Dietrich kissing a GI; Churchill's recent replacement; fall hats; tourists returning to Coney Island; and a story about an army bomber who, lost in overcast skies, crashed into the Empire State Building (the photograph of which reads like an eerie presaging, on a much smaller scale, of 9/11). But if the purpose of the piece was to *describe* a ruined Germany, it was unsuccessful—with the possible exception of the Cologne cathedral. And if the prose was to be journalistic, Stein studiously avoided such diction. The playfulness of the piece is rather off-putting, given the circumstances, though at times it is quite amusing. It reads like a contrarian response to the descriptions that were expected of her; it manifests Stein's unwillingness to train her gaze with any real attention on the catastrophe that was Germany in 1945.

These five reports from Germany that we have considered, then— those of Arendt, Dobie, Bourke-White, Dagerman, and Stein— comprise five different approaches to writing about the German devastation and obvious suffering of the German populace at the end of the war. From Arendt's politico-philosophical analyses, to Dobie's folksy tone and metaphors of color versus grayness, to Dagerman's graphic account of the cruelty of daily life among the ruins, to Bourke-White's "candid" report, to Stein's tongue-in-cheek wanderings and raves about the wonderful GIs, we have different modes of describing. And, as we have seen, there are many others. The purpose of journalism, one might safely assume, is precisely to describe, to recount, to record. Even so, as we have seen, variations in styles and perspectives prevail. But narration, it is to be noted, always inserts and asserts itself. What happens, then, when the attempt to describe catastrophe is produced as autobiography, or diary entries, or even fiction?

Autobiography

Memoirs are never more than half sincere, however great the concern for
truth may be: everything is always more complicated than we say it is.
Perhaps we even come closer to the truth in the novel. ANDRÉ GIDE

Gide is already onto the problem: autobiography is not necessarily
the truth—at least not all of it—and fiction is frequently closer to the
truth than is autobiography. For Philippe Lejeune, perhaps the most
famous theorist of autobiographical texts, the definition of that
genre is as follows: autobiography is a "retrospective prose narrative
written by a real person concerning his own existence, where the fo-
cus is his individual life, in particular the story of his personality."[12]
Although Lejeune admits that "the chronicle or political history can
also be a part of the narrative," the subject must be *primarily* (Le-
jeune's emphasis) individual life, the genesis of the personality. (5)

The chronicles we are about to consider do not fall neatly into
Lejeune's definition. To begin with, they are autobiographies that
have elements of fiction, or historiography, or journalism in their ac-
counts. They do not primarily have an individual life as a primary
subject; they rarely discuss the genesis of personality. They are first-
hand accounts, most of them, of the bombing raids and/or growing
up under the Third Reich. On the other hand, the narrator is also the
principal character, which is central to Lejeune's definition of the
autobiographical genre. I have chosen several firsthand accounts of
the war, all of which describe the bombings and the ruins.

Let's begin with Irmgard A. Hunt's *On Hitler's Mountain: Over-*
coming the Legacy of a Nazi Childhood, because it is the most conven-
tional autobiographical account, following most of Lejeune's rules
for the genre. Irmgard Hunt grows up in Obersalzberg, a small town

12 Philippe Lejeune, "The Autobiographical Pact," in *On Autobiography*, trans.
Katherine Leary (Minneapolis: University of Minnesota Press, 1989), 4.

in Berchtesgaden, the mountainous region Hitler chose as his alpine retreat. Her childhood is a happy one, at least for her first five years (1934–39). "Silently," she tells us, "my father and mother held on to their delusion that indeed a happy future lay ahead in our cheery home with Hitler's red wax portrait watching over us."[13] Hunt's narration is written through the lens of retrospection: as she writes, she inserts knowledge of the horrors of the Third Reich; knowledge that she did not have during the childhood she relates. When a year before her birth, her newly married parents decide to live in Berchtesgaden, Hunt writes that their apartment was "on the very mountain that Hitler had chosen . . . and from which he unleashed his madness on the world." (32) The present, in other words, provides a retrospective corrective onto Hunt's past. When Hunt recalls that a child with Down syndrome was taken away by the Nazis, and then declared to have died in hospital of a cold, Hunt adds, "What I did not know and what the adults refused to believe or face, was that Hitler's euthanasia program, while still shrouded in secrecy and as much as possible hidden from the general public, was up and running." (67)

At the age of five, when Hunt goes with her father to Nazified Salzburg, she looks on that childhood event from the present: "But the shadows were lengthening and the clouds were losing their light. The Nazis had taken over our mountains, and soon most of Europe's ancient cities would be in ashes. Bombs would fall on the great dome of the Salzburg cathedral." (96) This narration of the past from the perspective of the future turns the book into a proleptic alarm system of sorts, transforming every ordinary act of daily life into a warning of what lies ahead under the Nazi regime. When Hunt's father dies in the war, the Görings, who live nearby, give Hunt and her sister dolls. But Hunt adds, "Nineteen-forty-one was the year my world shattered," and follows this with a reminder to the reader of the over

13 Irmgard A. Hunt, *On Hitler's Mountain: Overcoming the Legacy of a Nazi Childhood* (New York: Harper Collins, 2006), 35.

fifty million dead who were to fall beginning in that year. (116) Her retrospective lens, in other words, inserts itself into the narration by recounting aspects of the war that she could only have learned later. The closer Hunt gets to the bombings, however, the more she is descriptive of the present within the time narrated.

By 1943, writes Hunt, "the hours we spent in the town shelter had increased dramatically, due mostly to overflights by Allied bombers going after strategic targets to the South." (131) On the "deceptively clear spring morning" of April 25, 1945, the bombs have arrived, "like a final thunderclap after a violent storm. British warplanes came swooping into the valley. First they tried to bomb the Eagle's Nest on Kehlstein but then emptied their loads on Obersalzberg." (193) Hunt and her school friends run for cover:

The hellish explosions were followed by an enormous storm-like wind that would have blown me off my feet had I not gripped the rough bark of the nearest spruce and pressed myself against it. We had not been warned that the detonation of each of the six-hundred-kilogram bombs that were dropped from an estimated three hundred British planes that day would cause intense air pressure.... The earth shook, and the air was filled with the rumble of airplane motors, the whistle of the falling bombs, the detonations, and the wind that followed. (193)

She and her family take refuge in their cellar at midnight, when the bombs fall again. When Hunt, who is now eleven, walks to school the next day, she is met with the results of the bombing:

Then, as Obersalzberg came into view, we saw the devastation. The plateau had become a chaotic brown-and-black mess of tree stumps resembling charred matchsticks, irregular dark craters, and ruins that still smoked. "It's all gone," I said to no one in particular. (195)

The dead are buried in a mass grave, and the local newspaper proclaims, "We had the hope that there would be a limit to the satanic

deeds here in the high and elevated beauty of nature's creation ... [but] the terror of enemy bombs forced its way into our sacred Alpine world." (197) The author leaves the incredible irony (and horrifically self-righteous kitsch) of this passage aside, but upon hearing the local Nazi give a speech (the Führer was suffering with each and every one of his people, the heroic dead had died so Germany could live, and so on), Hunt comments as if an adult, not the child she is purported to be: "Less than ten days from the end and a few days before Hitler's suicide, we were still expected to tolerate such humbug from an officially sanctioned voice." The chapter ends with a reference to "the new West Germany that arose from the rubble." The last part of the book, "Bitter Justice, Or Will Justice be Done?," covers 1945–48, and describes the author's move to the United States. Her Nazi childhood, however, has left her disoriented, a feeling that she couches in topographical metaphors: "The terrain that lay ahead now was dark and unfamiliar; I was not sure there was a path, even the beginning of a path, to take forward. Everything behind us had been wrong, and everything before us was uncharted." (221) The author continues: "The guilt of genocide would be upon us for generations. Nothing could undo what had happened."

Hunt's story is thus written in hindsight, and crafted as a way of coming to terms with a Nazi childhood. It tries to understand how Hitler could have seduced an entire nation: "Who had we become under the Nazi regime," she asks, "and how was it accomplished?" (239) In a sense, *On Hitler's Mountain* spends most of its cerebral time trying to answer that question. The past is always presented in the light of the present. The descriptions of the bombings are fairly unsurprising; the story is rather of a psychological and political coming-of-age, with the reader and the author looking at each other knowingly as they view the naïveté of Hunt's parents voting for Hitler in 1933, and then growing increasingly disillusioned with what they should have known was pure evil to begin with.

But this "should have known" is somewhat akin to what the noted Austrian-born literary scholar Michael André Bernstein calls

"foreshadowing." At its extreme, writes Bernstein, "foreshadow-
ing implies a closed universe in which all choices have already been
made, in which human free will can exist only on the paradoxi-
cal sense of choosing to accept or willfully—and vainly—rebelling
against what is inevitable."[14] Bernstein is particularly concerned
with the Holocaust in his use of foreshadowing: the victims of the
Holocaust, foreshadowing would argue, "should have known" and
rebeled, fled, or otherwise saved themselves. In the case of ordinary
Germans under Hitler, the possibilities of escaping that closed uni-
verse were limited but not absent. Hunt's narrative tries to find the
crack in the Nazi armor—a crack that might have saved her family
from believing in, and cooperating with, the Nazi regime.

There is always a counter-story, writes Bernstein. It is worth re-
membering, however, as Arendt points out, that under totalitarian-
ism, all conscious decisions become equivocal. The alternative, she
continues, is no longer between good and evil, but "between mur-
der and murder." Hunt's book tries to explore how Hitler could have
happened and what a counter-narrative might have been. Signifi-
cantly, however, the book seems to assume that the bombings, for
example, were an inevitability. Hunt's book accepts them, even as
she (briefly) describes the damage and the fatalities. This accep-
tance is born, I think, of the sense, among many Germans, of the
collective guilt that Hunt says will last for generations. In assuming
collective guilt, in saying "we" to describe the German's sympathy
(certainly initially; less so as the war progressed) for the Nazis, Hunt
paradoxically undermines her own search for a counter-narrative to
the rise of the Third Reich. If the guilt is collective, if a way out was
unimaginable, if all choices were, more or less, excluded once the
initial one of joining the Nazi party was made, then we are squarely
in foreshadowing mode with no exit. The narrative, in other words,

14 Michael André Bernstein, *Foregone Conclusions: Against Apocalyptic History*
(Berkeley: University of California Press, 1994), 2.

asks questions to which there is no answer because the answer is already in the narrative: there was no other way; there was no hope for escaping.

The genre of diary, we can agree, is not quite an autobiography since it is comprised of frequently random entries rather than a continuous narrative. Moreover, in principle, diaries are not meant for publication. The diary is nonetheless a cousin of the autobiography, and with respect to the devastation by the Allied bombings, there are many diaries producing descriptive accounts of devastation as the war progressed.

One of the best-written testimonies of the paranoid isolation wrought by the totalitarian state is perhaps Friedrich Reck's *Diary of a Man in Despair*.[15] Reck despises the Nazi regime, and attempts to survive the war by keeping his views to himself, which he does with more or less success. His diary is filled with his loathing of the regime. In June of 1942, he writes,

But I, on this summer night, hot as cobalt, have lost myself. The distant worlds are enclosed in icy separation. . . . My life is loneliness, and the growing awareness that it must be so—loneliness among a people whom Satan has overcome, and the awareness that only by suffering can the future be changed. Isolation, with one last chance given one in this life: the chance to affirm truth by one's death. (153)

Reck witnesses his first bombing from a hotel room in Munich, where he had gone in the fall of 1942 to do research on his book:

I heard in the distance the muffled booms, and it was calculated that since the bombs were dropping eighty kilometers away, it had taken

15 Friedrich Reck, *Diary of a Man in Despair*, trans. Paul Rubens (New York: New York Review of Books, 2013). First published in Germany as *Tagebuch eines Verzweifelten* (Stuttgart: Burger Verlag, 1947).

three minutes for the sound to carry—three minutes during which the victims at the scene had been gasping and gagging and dying. Finally, the whole of the sky to the west was a gigantic sheet of fire. (154)

Five days later, "people were still being dug out ... wedged in among fallen beams and rubble, where they had been unable to move. And then there were the dead, whose faces still bore the marks of their last agonies."

One year later, Reck witnesses his first air attack by American planes in Regensburg, near his "quiet valley." A plane is shot down, and Reck drives to Seebruck to see the wreckage: "Burning oil bubbled in a crater fourteen feet deep at the wreckage. The engines had bored so deeply into the ground that no attempt was being made to dig them out. Around the crater, pieces of the human body were scattered—a foot, a finger, an arm. The remains were carried off in a small potato sack." (182) Reck has heard about Hamburg: "The news from Hamburg is simply beyond the grasp of the imagination—streets of boiling asphalt into which the victims sank and were boiled alive, veritable cities of ruins, which cover the dead and surround those still alive like some jagged stone martyr's crown. The talk is of 200,000 dead." (182) Reck describes shattered windows in his own home caused by air pressure from the bombings, even though he is ninety kilometers away. He describes another "silver bird," shot down by the Germans, spiraling down "like a leaf made tired by the coming of autumn." In other words, Reck has no difficulty with description, even as he notes that the devastation is beyond the grasp of the imagination. When he fears he will lose all of his cherished possessions—"the library, the medieval statuettes, the candelabra from the Middle Ages, the drawings"—he cries out, "Ah, have you ever looked about you at the possessions of a man on his deathbed, knowing that all of it would soon be scattered to the four winds?" (187)

What undercuts the bombing horrors that Reck sees and hears about is his conviction that Germany has brought all of this upon

itself, and his own brand of sarcasm concerning the Third Reich and Germany's "gigantic psychosis" in supporting it. The night of the bombing of Munich, Reck tells us, "Herr Hitler" happened to be there. But before the alarm sounded, Hitler was "already safely tucked away in a private shelter complete with rugs on the floors, baths and, reportedly, even a movie-projection room. Thus," Reck continues sardonically, "while hundreds and hundreds of people buried under the rubble struggled horribly to breathe, he might well have been watching a movie." (155) For Reck, the horror that is Hitler began with Bismarck, and there are in any case two Germanys: "If by 'Germany' is meant that gigantic heresy of Bismarck's which is today in extremis, if it is forgotten that before that there existed a Reich which was the cradle and focus of the great ideas ... then we are bad Germans!" (178–79) The mistakes of the last decades could still be corrected by the "immediate indictment of all the generals responsible for the continuance of war." Not a bad beginning, he adds, "though not without hyperbole." (178)

In December of 1944, Reck was finally arrested for "insulting German currency" (224) and sent to Dachau, where he died of typhus in February of 1945—a few short months before the end of the war.

Another diary of the period is that of Marie Vassilichikov, a "White Russian princess," as the blurb describes her, who spent most of the war working in Berlin at the German Foreign Office, and then as a nurse in Vienna.[16] She was also in on the plot to kill Hitler in July of 1944, and hid her diary in a filing cabinet in her office. Her parents had left Russia with their children in 1919, and so, as Vassilichikov's brother notes in his introduction to the diary, she grew up as a refugee between France, Lithuania, and Germany. In 1940, "Missie" (as she is known in the diary), who was twenty-three, went to Berlin with her sister to look for work, and found it there. Her point of view in describing the bombings and other extreme hardships is unusual because Missie "belongs" to neither side in the war. Although

16 Marie Vassilichikov, *Berlin Diaries, 1940-1945* (New York: Vintage, 1988).

involved in the July 20 Plot, for which many of her friends were exe-
cuted, she sees both warring sides as barbaric. "He belongs to a more
civilized world," she writes of a friend, "something, alas, neither
side does." (170) The constant bombings, in other words, do little
to ingratiate the Allies to her—she is bombed out of several homes
during the Berlin air raids, and has to flee Vienna at the end of the
war, narrowly escaping death. The other unusual aspect of her nar-
ration is that she comes from Russian royalty, and (especially at the
beginning of the diary, when things are still semi-normal) spends
a good deal of time going to very fancy receptions, dinners, parties
and so on. The contrast between the rubble and devastation that sur-
rounds her and her group of friends trying to assassinate Hitler, on
the one hand, and her friends among European nobility (and their
palaces, to which she has free access), on the other, makes for an at
times uncanny and fascinating narrative. For example, Missie goes
to a concert with her friend in May of 1944:

In the evening, Mozart's *Entführung aus dem Serail* with Percy Frey.
Then a late snack at the Adlon.... He escorted me home on foot through
the Tiergarten and was staggered by the ruins around our house. We
had to climb over hillocks of rubble and he was quite fascinated. I am
not. It has been too uncomfortable too long living like rabbits in a war-
ren. (170)

The following day, Missie manages to exchange Percy Frey's ex-
pired meat coupons against "a big sausage." At the office, she auc-
tions off the sausage in return for "valid coupons," which she then
will give to Frey. These juxtapositions—the Mozart concert and the
late snack at a fancy place, versus the sausage, the ruins, and the
rubble she has to climb over to get to her door—are jarring. Despite
Missie's often terrifying and harrowing experiences, the voice of the
diaries relates things in an unsentimental fashion, without once fall-
ing into self-pity. In an entry dated May 7, 1944, Missie reports on
the bombings in Berlin:

There was much smoke and many new craters, but American bombs—
the Americans come during the day, the British at night—seem to cause
less damage than English ones. These explode horizontally, whereas
the former go deeper, so that the neighboring buildings collapse less
easily. (172)

Her courage is quite striking: she consoles others in the air raid
shelters by trying to make small talk; and on June 15, still 1944, she
writes calmly, "An air raid is in full swing. The usual mines which I
fear far more than the bombs, although they drop only about eighty
each time." (179) By July, Missie is "getting more and more nervous
during air raids. I could not even chat with Tatiana, as *Sprechen ver-
boten* was plastered all over the walls, probably so as not to use up
oxygen should we be buried alive." (183) The truth, she writes,

is that there is a fundamental difference in outlook between all of *them*
and me: not being German, I am concerned only with the elimination
of the Devil. I have never attached much importance to what happens
afterwards. Being patriots, *they* want to save their country from com-
plete destruction by setting up some interim government. I have never
believed that even such an interim government would be acceptable
to the Allies, who refuse to distinguish between "good" Germans and
"bad." This, of course, is a fatal mistake on their part and we will proba-
bly all pay a heavy price for it. (189–90)

Indeed, Missie believes that the July 1944 plot to kill "the Devil"
failed in large part because the conspirators could not get help from
the Allies, convinced as the latter were that there was no such thing
as a "good" German. She had danced for joy at the first reports that
Hitler was dead; later she waits while hearing that, one by one, her
friends in the conspiracy are being executed. She finally leaves Ber-
lin when she is warned that her own life is in danger.

Gordon A. Craig of the *New York Times Book Review* calls Missie's
diary "neither a set of reflections nor a philippic, but a record.... The

best eyewitness account we possess of the bombing of Berlin." The historian John Kenneth Galbraith notes Missie's even-tempered perspective: "One of the most remarkable documents to come out of the war," he writes, "and nothing will ever quite match its calm and grace in utterly hideous circumstances." Missie's grace is not only her prose style; it is also that it's political. As I noted earlier, as she is not one of *them*—on either side—this allows her a different viewpoint, one that considers both sides as barbarous war-mongers, with the suffering German civilian population, and the soldiers on both sides, victims of the conflict. As in Kertész's *Fatelessness*, it is Missie's matter-of-fact, descriptive prose that makes the horrors stand out all the more, and gives the textual images their power. The reader is able to *see* the destruction and suffering with such diction, far more than in the prose of the generation that came home from the war. Members of that generation, Sebald writes with obvious disgust, "were so intent on their own wartime experiences, described in a style constantly lapsing into maudlin sentimentality, that they hardly seemed to notice the horrors which, at that time, surrounded them on all sides."[17]

One recent example of the description of bombing during the Second World War is not by a German, but by a popular Jewish American author. Jonathan Safran Foer's novel *Extremely Loud and Incredibly Close* (2005) is narrated by a nine-year-old boy, Oskar, who lives in New York. His father has died in the World Trade Center on September 11th, and his grandfather survived the bombing of Dresden. In all, four war atrocities are brought up in the novel: September 11th, the Dresden bombing (February 1945), the dropping of the nuclear bomb on Hiroshima (August 1945), and the Holocaust. The first two of these are central to the novel; the Holocaust is alluded to several times; and Oskar gives a report in his class at school on Hiroshima. By collocating these war atrocities, a strong call for

17 Sebald, *On the Natural History of Destruction*, 9.

pacifism emanates from the novel. Further, these atrocities dena-
tionalize (for want of a better word) the hideous war machines that
humans have invented. The grandfather at one point writes about
his experience during the two days of the Dresden bombing. Foer's
description (we have been trying to consider description) is devas-
tatingly vivid. Here is part of it, narrated by the grandfather:

Everyone was losing everyone, the bombs were like a waterfall, I ran
through the streets, from cellar to cellar, and saw terrible things: legs
and necks, I saw a woman whose blond hair and green dress were on
fire, running with a silent baby in her arms, I saw humans melted into
thick pools of liquid, three or four feet deep in places, I saw people
crackling like embers, laughing, and the remains of masses of people
who had tried to escape the firestorm by jumping head first into the
lakes and ponds, the parts of their bodies that were submerged in the
water were still intact, while the parts that protruded above water were
charred beyond recognition, the bombs kept falling, purple, orange
and white, I kept running, my hands kept bleeding, through the sounds
of collapsing buildings I heard the roar of that baby's silence.[18]

The run-on sentence (and I have produced only part of it here)
puts together a montage of differing horrors, connected by commas.
Moreover, the work is a graphic (or imaged) novel and, in this in-
stance, the passage is corrected by red pen, like an editor gone mad
with proofing that makes no sense. The illogical markings mirror
the incomprehensibility of logic for the Dresden population under
the firebombs. In the passage, some phrases are circled in red, and
many gaps between the commas and the following word are circled
as well. From a short distance, the pages look as if they are covered
in small drops of dried blood, as if the horror of the event were being

18 Jonathan Safran Foer, *Extremely Loud and Incredibly Close* (New York: Mari-
ner, 2006), 211–13.

revisited with pages that "were there." The red pen thus emphasizes the distance between one scene and the next, at once insisting on the murderous array of pandemonium-soaked images, described as a continuous flow of chaos, and leaving the reader as perplexed as to the logic of the red ink marks as to the reason such catastrophic destruction would be visited on anyone. The horror is all the more palpable, and the mental images conveyed by the text all the sharper, not only by Foer's strong and willfully nonsequential description, but also by the red ink. Fiction, in other words, can sometimes be more graphic than photographs—or, at least, as graphic.

But Foer's novel is still fiction, and the author was never a witness to the destruction of Dresden. "What is the distance," asks Dagerman, "between literature and suffering?" He concludes that "simply to suffer with others is a form of poetry, which feeds a powerful longing for words."[19] There is here a powerful longing for words indeed; the irony is that, in Foer's novel, the deadly event, narrated by the grandfather, results in his becoming gradually mute—he is unable to speak, though he can "write." For the grandfather, there are no more spoken words after the disaster of Dresden. Foer manages, in his description of the Dresden apocalypse, vividly and almost tangibly to convey the bombings of total war.

Sebald (to return to him again) cites an essay by Elias Canetti on the diary of Dr. Michihiko Hachiya, who survived the bombing of Hiroshima. When asked what it means to survive such a vast catastrophe, Canetti writes that "the answer can be gauged only from a text which, like Hachiya's observations, is notable for precision and responsibility. If there were any point in wondering what form of literature is essential to a thinking, seeing human being today, then it is this."[20] Sebald argues forcefully that "the ideal of truth inherent in its entirely unpretentious objectivity, at least over long passages, proves itself the only legitimate reason for continuing to

19 Dagerman, *German Autumn*, 111.
20 Sebald, *On the Natural History of Destruction*, 52.

produce literature in the face of total destruction." This seems a par-
tial response to Adorno's famous dictum that to write poetry after
Auschwitz is barbaric. Adorno was arguing there against engaging,
through writing, in the very culture that produced the Shoah. In a
similar vein, Sebald argues with Canetti for "precision and responsi-
bility" after a vast catastrophe. That is why, in his own work, Sebald
rants against "kitsch." One writer's style is described in a scathing
critique as "citing all manner of horrors as if to show that he does not
shrink from depicting the reality of destruction in its most drastic
aspects." Even so, he continues, "an unfortunate tendency towards
melodrama remains dominant." In such melodramatic renditions
of tragedy, Sebald writes, "I do not see what is being described; all
I see is the author, eager and persistent, intent on his linguistic fret-
work." (58) Foer's novel would no doubt escape Sebald's disgust, if
for no other reason than Foer's description of the Dresden bombing
is precise and responsible, and tells us nothing about the author, but
rather brings to life the reality—and therefore the mental imaging
—of scenes that should never be repeated. That is one purview of
acceptable literature, I would suggest, after Auschwitz.

Literary critics have long characterized description itself as an in-
terruption in a given narrative, particularly in the realist novel. Bal-
zac begins every work with a meticulous description of the surround-
ings where the action will unfold. Before any character can speak,
a precise description of the general scene is produced. The classic
example is his *Le père Goriot*, which opens, filmlike, with a descrip-
tion of a neighborhood in Paris, then a street; next it pans to the fa-
cade of the Pension Vauquer in which the novel begins. The "cam-
era" proceeds to move slowly inside the shabby pension, and finally
to Mme. Vauquer herself (with a lengthy description of her clothing,
tattered slippers, and physiognomy). Balzac is quite aware that de-
scription is an interruption, but he engages in it even when he prom-
ises his reader to eschew it. At the beginning of the novel, when he
is introducing us to the Vauquer pension and its furniture, he writes:
"To explain to what extent this furniture is old, cracked, rotten, shaky,

gnawed, half-blind, one-armed, invalid, expiring, one would have
to produce a description that would overly delay any interest in this
story, and which people in a hurry could never forgive."[21] A mag-
nificent description has been managed, complete with a catalog
of anthropomorphic and humorous adjectives depicting the furni-
ture, while the narrator insists that he won't burden his reader with
description!

In 1880, Zola had written on description, from his naturalist point
of view.[22] The novelist, he argued, is simply a natural scientist, pick-
ing up insects and then collecting them as facts to be described. By
the time Roland Barthes wrote on the subject in 1968 (the heyday
of French theory), structuralists had taken over and things had (un-
surprisingly) gotten much more complex. The list of theorists who
engage in the question of description is a lengthy one, and I will not
enter into it here. But Roland Barthes's notion of the reality effect
(*l'effet du réel*) is worth considering because he raises the question
of the relationship of narrative to description. Description itself, he
argues, has no real purpose, and further has many unnecessary and
superfluous aspects.[23] The question of the "real" was to grow in di-
mension: to what extent, theorists asked, does a text engage reality?
To what extent is description a valid vehicle to whatever is deemed
real? Philippe Hamon, one of the leading theorists of description,
argues that the term itself is at best imprecise and hard to define. On
the other hand, he admits, readers seem to have no difficulty recog-
nizing a description, even if only for the purpose of skipping it to get
back to the plot: "Every description presupposes a narrative system,
as elliptical and unsettled as it may be."[24] Michael Riffaterre, for his

21 Honoré de Balzac, *Le père Goriot* (Paris: Garnier-Flammarion, 1966), 29 (my
translation).
22 Émile Zola, "De la description" from *Le roman expérimental*, in *Œuvres com-
plètes*, vol. 10 (Paris: Cercle du Livre Précieux, 1968), 1299-1302.
23 Roland Barthes, "L'effet du réel," *Communications* 11 (1968): 84-89.
24 Philippe Hamon, "Qu'est-ce qu'une description?" in *Poétique* 12 (1972):
465-85.

part, argues that description is inextricable from narrative and vice versa,[25] thus evading the structuralist argument (Barthes and Genette,[26] for example) on that connection (or dialectic).

Of course, all of this literary/critical discussion works particularly well with respect to the novel of the nineteenth century—whether realist or naturalist. The texts we have been considering here, however—fiction, autobiography, diaries, or reportage—have a specific peculiarity: the descriptions of the firebombs and other horrors serve as the major protagonists (as it were) of their texts. In other words, the descriptions function, not as interruptions, but as display; as a contextualization meant to force the reader into remembering the events through textual images that graphically convey the scenes of destruction. And this is true whether the style (another fraught literary term) strikes the reader as affectless (parts of Bourke-White), empathic (Dagerman), willfully eccentric (Stein), full of foreshadowing (Hunt), politically analytic (Missie's diary), personal and reflective (Reck)—or any other combination of these. In Foer's *Extremely Loud and Incredibly Close*, for example, the detailed description of the Dresden firebombing (difficult as it is to read and contextualized as it is in a fictional account) juxtaposed with 9/11, Hiroshima and the Holocaust, serves if nothing else to show the reader that all war atrocities are just that—atrocious. Foer's pacifist beliefs push him to demonstrate to the reader, and to teach him or her, how catastrophic any war—on any side, and for any reason—can be. In this Foer is reminiscent of Ernst Friedrich's 1924 multilingual *War on War*. Friedrich thought that by showing photographs of the First World War's devastation, no war could ever erupt again. In this sense, showing photographs or producing vivid descriptions serves the same purpose: an effort to illustrate a given

25 Michael Riffaterre, "Descriptive Imagery," *Yale French Studies* 61 (New Haven, CT: Yale University Press, 1981), 107-25.
26 See Gérard Genette, "Frontières du récit," in *L'analyse structurelle du récit* (Paris: Éditions du Seuil, 1981), 158-69.

event and its meaning through a visual or textual context. But Friedrich's book was a failure, of course. As Susan Sontag notes in reference to Friedrich in *Regarding the Pain of Others*, "For a long time some people believed that if the horror could be made vivid enough, most people would finally take in the outrageousness, the insanity of war."[27] But, of course, even with graphic and horrifying descriptions and photographs, "most people" have not taken in the horror of war.

Description belongs to the larger economy of representation; it attempts (quite literally) to present again what is otherwise absent. Absence itself has many roles to play in a text: it can serve to illustrate an event that has been forgotten or unseen (or unheard), or to bring to life a lost era and its particular events, or to memorialize, record, depict, or otherwise image what is not before the viewer's eyes, so as to make it mentally visible. Descriptions, as we have noted, are in one manner or another didactic, teaching or arguing through showing. Certainly, this would describe a work such as Alexander Kluge's *Air Raid*, with its almost scientific elucidation of how and why the town of Halberstadt was bombed, and the horrifying consequences.[28] The same could be said of Hans Erich Nossack's *The End*, about the 1943 bombing of Hamburg.[29]

27 Susan Sontag, *The New Yorker*, December 9, 2002. Susan Sontag, *Regarding the Pain of Others* (New York: Farrar, Straus and Giroux, 2003), 14.

28 Alexander Kluge, *Air Raid*, trans. Martin Chalmers (New York: Seagull, 2014). Kluge witnessed the bombing of this, his hometown, when he was thirteen years old. Such a restrained account as Kluge's, avoiding emotional or angry responses, and purporting thus to provide an objective witnessing, is often labeled a "minimalist style." It is more usually applied to Holocaust narratives (Kertész, for example), but I would argue that Kluge is of the same stylistic school. On this choice of style, and the critical discussion surrounding it, see Carolyn J. Dean, *Aversion and Erasure: The Fate of the Victim after the Holocaust* (Ithaca, NY: Cornell University Press, 2010), 105–11.

29 Hans Erich Nossack, *The End: Hamburg 1943*, trans. Joel Agee (Chicago: University of Chicago, 2004).

Descriptions are also never innocent of ideology: for example, again in Balzac's *Goriot*, the description of Mme. Vauquer ends with, "Finally, all of her person explains the pension, just as the pension implies her person." (30) Here the depiction of the pension evokes social class; the implied narrator is addressing an implied reader who shares his or her horror of the vulgar, shabby, and taste-less lower middle class. Both narrator and implied reader "look at" Mme. Vauquer, not only as tawdry and ill-dressed, but also as met-onymic of the social structure that is Paris in the July Monarchy. But descriptions such as Balzac's of classes and their surroundings are no doubt easier to "take in" (to return to Sontag's term) than are de-scriptions of human catastrophes.

Bourke-White's photographs and text (and captions) of a de-stroyed Germany are not aimed at the same response in the reader as is Nossack's *The End*. The first describes destroyed German towns and cities with a certain unapologetic Schadenfreude. The second, Nossack's account of the Hamburg bombing, strives to show the horror and inhumanity of war. It also quite openly con-demns not only the crime of targeting a civilian population, but also the extent to which the British and the Americans were guilty of war crimes in their leveling of populous areas. The same ruins are de-scribed with different political and ideological lenses. Even Stein's cryptic and ironic remark "We all went to see Germany, we had seen it ruined from the air and now we saw it ruined on the ground. It certainly is ruined, and not so exciting to look at . . ." is born of an ideology: one of showing off her famous style, on the one hand, and of demonstrating that she has (for good reason) no interest in the suffering Germans, on the other. Stein "looks" without seeing ("And I really pretty well forgot about Germany and the Germans"); and describes the ruins quite off-handedly (Germany is "not so exciting to look at," or the nearly dismissive "One would suppose that every ruined town would look like any other ruined town but it does not"). This is description that, by virtue of refusing to describe, produces

an ideological lens (Stein is on the side of the Allies, and she loves the American Army), even as it is also a demonstration of the famous Stein style.

A different example of describing the ruins in Germany is by Joel Agee (son of the writer James Agee), who spends twelve years after the war in East Germany. He views (and describes) the ruins through the eyes of a boy: "I actually rather liked looking at the ruins," he reminisces. "You could see the lineaments of the lives that had once been sheltered here: flowered wallpaper imprinted with pale rectangles where pictures had hung, staircases, windows, sometimes a rag of a curtain still stirring in the breeze."[30] The young Agee sees in the ruins the lives that "had once been sheltered" in them; he does not "see" the ruins as broken reminders of devastation and death.

Description, then, partakes of historiography—including, to some degree, when the account is fictional. History generally likes to work from the premise that *this happened* and "You Are There" (as the radio program of the late 1940s, and the spin-off television show of the 50s, put it). History starts with the assumption that a represented event really took place; fiction starts with the assumption that a represented event *could* have happened. Even if the notion of history as chronological has been largely dismissed in contemporary theories of historiography, even if (as Walter Benjamin noted) history is only written by the victors, even if historical discourse can only signify the real and not actually present (or represent) it, even if (in reaction to the historiography of the nineteenth century) history is no longer expected to provide a sequential, orderly narration—many readers gravitate toward realist novels, diaries, autobiographies, biographies, and documents because they give them the illusion of being there. Perhaps, since Freud, we have become so obsessed with the individual mind that any autobiographical passage fascinates. Or perhaps we have witnessed enough wars,

30 Agee, *Twelve Years*, 30.

genocide, and atrocities that the orderly telling of events, such as
the nineteenth-century historian Michelet wrote, no longer seems
sufficiently realistic in showing the calamity that technological war
machines produce.

We can continue to ask, then, how one represents catastrophe.
The texts we have considered here try to do so, in varying ways; they
can be considered to have captured at least some sense of the dev-
astation. But how is the gaze structured when viewing a painterly
image of catastrophic ruination? And how can we, some decades
later, take in images of bombed-out towns and cities in a defeated
Germany? Perhaps if we turn to pictorial representation we can get
closer to how to look upon the ruins of this war. Art describes and
represents differently, and its frequently abstract and nonfigurative
perspective yields yet another means of showing catastrophe. And
so we will try to capture how the gaze is constructed—or, at least,
how the gaze is meant to be constructed—when it looks on art that
represents or remembers Germany, circa 1945.

2 Ruination in Painting

MAKING THE UNSPEAKABLE VISIBLE

Bombardments are impersonal; bombarded people, however, die *personally*. ... Both points of view are correct in their way, and the space between them—the impersonal view from above, the personal anger and pain from below—is the space of the ultimate contradiction of war. ALESSANDRO PORTELLI[1]

If morality can only be powered negatively, where there can be no such thing as beneficence powered by an affirmation of the recipient as a being of value, then pity is destructive to the giver and degrading to the receiver, and the ethic of benevolence may indeed be indefensible. CHARLES TAYLOR[2]

In the article from which the first citation is taken, the Italian oral historian Alessandro Portelli makes a distinction, with respect to bombing raids, between the view "from above" and the one "from below." The bomber planes fly from above, seeing little of what they

1 Alessandro Portelli, "So Much Depends on a Red Bus, or, Innocent Victims of the Liberating Gun," *Oral History* 34, no. 2, War Memory (Autumn, 2006): 29–43, at 30–31.
2 Charles Taylor, *Sources of the Self: The Making of Modern Identity* (Cambridge, MA: Harvard University Press, 1989), 516.

are targeting: "The top down, outside, emic view from above," he writes, "possesses a *superior* (literally, higher) *power* to perceive the global context, the general picture." The bird's eye or bomber's radar view, argues Portelli, sees farther "and retains the wholesome detachment, the capacity for abstraction." (30) This is the narrative that usually prevails, and that engenders much historiography—the official version, in other words. The view from below, on the other hand, "is narrowly focused, irretrievably bound to the detail, to the concrete . . . immediacy of material experience, and is inevitably twisted into and limited by the personal, emotional identification and involvement." (30) Portelli, who is using the 1943 bombing of Italy by the Allies as his working example, and is intent on oral history, believes that the two narratives should be combined. A culture, he argues, "is a machine that allows us to reconcile the irreconcilable and to live with ambivalence." (35)

The problem, however, as Portelli points out, is that one side tends to dominate the other, "while the other is sunk into silence and irrelevance." In interviewing Italians who experienced the Allied bombings of Italy, Portelli hears two major narratives: resentment of the Americans, because they killed innumerable civilians and destroyed homes; and the contrary belief that the Americans liberated Italy from the yoke of fascism. "Can't we consider both," he asks, "each in its own dimension? It is as though seeing one horror prevented acceptance of the existence of the other. . . . One need not equate Dresden or Hiroshima with the Shoah in order to realize that this contradiction reveals the implicit Manichaeism of war narratives." (40)

Portelli has articulated here one of the central questions we are considering in the present work as well: the extent to which seeing one horror precludes seeing another. Portelli adds that many civilians are personally innocent yet "they are 'guilty' as Italians, and suffer a death sentence without benefit of trial, for the crimes of the regime and the state." (32) The same can be said, I have suggested,

of the civilian German victims of Allied bombing, and indeed the civilian victims of *any* bombing. But in this instance (to repeat), the German civilians were not "collateral damage"—they were targeted. So, too, the Italian civilians suspected that the Allies were not just trying to bomb industrial plants, bridges, munitions plants, and so on—they were aiming at the civilians as well. Criticism of the American bombers becomes sharper, writes Portelli, "when considering another form of aerial warfare, the strafing of civilians in the streets by low-flying aircraft, in which intentionality appears to be beyond doubt." (37–38)

Karl Hofer's painting *Frau in Ruinen* (1945) (plate 1), to use Portelli's term, is clearly the view "from below." It is the work of an artist who was a German expressionist (though he never affiliated himself with any of the expressionist groups) and lived through the war in Berlin.[3] Openly hostile to the Nazis, in 1934 Hofer was fired from his job as director at the art school of Charlottenburg and ordered to cease painting. He was also forbidden from showing his work, and from selling any of it. Over three hundred of his paintings that were privately owned were seized by the Nazis. Some of those were displayed at the infamous "Degenerate Art" (*entartete Kunst*) exhibition, organized by the Nazis in 1937, in Munich.[4] Hofer's work was displayed there as an excellent example (among many others, of course) of decadent and corrupt art. He went from being one of the most famous painters in Germany to being shunned, degraded,

3 As of 1907, Karl Christian Ludwig Hofer began signing his canvases "CH." Thus he is often referenced as "Carl Hofer" as well as "Karl Hofer."

4 On Nazi views on art, see Berthold Hinz, *Art in the Third Reich* (New York: Pantheon, 1979); and Henry Grosshans, *Hitler and the Artists* (New York: Holmes and Meier, 1983). See also Donald Kuspit, "Diagnostic Malpractice: The Nazis on Modern Art," in *Artforum International* 25 (1986), 90–98. Kuspit suggests that Hitler's vituperative hatred of modern art as madness also betrays his own fears of himself lapsing into mental illness. Hitler was afraid, according to this view, that the "pathology" of modern art mirrored his own instability (94–95).

and in constant danger of arrest. How he survived the war is any-
body's guess—and inexplicable to Hofer himself: "I was not careful
with what I said," he writes in an autobiographical text, "and today
it seems like a miracle to me that I am still alive."[5] In 1943, during
one of the first massive bombings of Berlin, his studio and all of his
work (he kept painting despite the prohibition against it) went up
in flames. He continued to paint in a small room in his apartment
when, the same year, bombs burned the building in which he lived
to the ground, along with the new art he had produced. In 1944, the
Nazis confined Hofer to a sanatorium "as punishment for his gen-
eral recalcitrance."[6] In 1946, he displayed portraits he had done of
Nazis who had escaped responsibility. During and right after the
war, he painted several works depicting the ruins that the bombings
created.

Hofer's work, particularly during and after the war, is often (and
unsurprisingly) described as melancholic, with a strong undercur-
rent of alienation. *Frau in Ruinen* is clearly the result, and depiction,
of trauma. Painted in 1945, the piece shows an old, lone woman
who stands in exhaustion and disbelief, her head in one hand and
her eyes closed, as if to make the scene somehow disappear. She is
leaning against a wall for support, but the wall is itself leaning, as if
close to collapsing. Her other hand is lifted and half closed, as if to
gather something to herself, though nothing has been left standing
except her. Or perhaps she is starting to cover her mouth, signaling
her mute despair. There are no words, the painting seems to say. In-
deed, one critic called this painting "an image of the unspeakable"

5 "Wenig vorsichtig war ich in meinen Äußerungen, und heute will es mir wie
ein Wunder erscheinen, daß ich noch am Leben bin." Karl Hofer, *Karl Hofer aus
Leben und Kunst* (Berlin: Rembrandt Verlag, 1952), 16 (my translation). Hofer's
first wife, Mathilde Hofer (née Scheinburger), was Jewish. She and Hofer di-
vorced in 1938. In 1941, Mathilde Hofer was denounced and sent to Auschwitz,
where she died the following year.

6 Grosshans, *Hitler and the Artists*, 80.

(*eine Bildwerdung des Unsagbaren*).[7] Her hands are positioned as if in a failed attempt at prayer.

The old woman is surrounded by broken parts of buildings, charred property, twisted iron bars, and splintered furniture. She is wading in the rubble, her feet not even visible, covered as they are by debris. Behind her, one can detect an almost cartoonlike sketch of a naked figure with dirty yellow hair. This barely discernible figure has whitish strands coming out around the lower part of her face. One would think it was blood, but it is the wrong color. It is like blood made of ashes, springing out of the figure's chin, reminding the beholder that what remains—including human remains—is burnt. Or maybe it isn't the corpse of another woman at all; perhaps it is a ghost. It is not clear. Nevertheless, if it is a female figure, her eyes seem to pop out of her head as if, again, seeing produced too much to believe. The white strands are like the navel of the painting, to use Freud's term for that part of a dream that is indecipherable. The navel here marks the place where the incomprehensible meets the chaotic horror.

In the immediate background, charred ruins appear, incongruent with what were once mainly the right angles and straight lines of city buildings. Behind the old woman, the sky is an angry orange, so we know that the city is still burning from the explosions. Indeed, one part of a structure, just over the woman's head and in the background, seems still to be in flames. The bombings, this painting tells us, have just stopped. But the burning sky over the blackened ruins is a reminder that the danger from that sky is far from over. It is an intensely precise depiction of the view "from below."

The old woman herself looks ashen and emaciated, her sunken cheeks attesting to the constant hunger that must be hers. She is wearing an old dress of no definable color; it has dark stains on it, no doubt from the blackened debris. One senses the dead lying

7 Adolf Behn, in 1947. Cited in *Grisebach* catalog, June 4, 2015, 43.

under the rubble. Hofer himself was obsessed with those who were
buried alive by the bombs. The artist actually believed, wrote his
friend Paul Ortwin Rave in 1956, that he owed it to the dead who
lay buried, "to hear their trembling heartbeats; and so he labored
to make all the unspeakableness graspable and visible."[8] Such an
effort is reminiscent of Dagerman's refusal of the "indescribable."
The old woman, further, can also be seen to stand in for all of the
casualties—German, Allied, and European—that were produced by
the military aspect of the war. She is something like an allegory for
the horrors that war visits on civilians. The painting, however, will-
fully transforms what is utter unspeakableness into the graspable
and the visible for the beholder, even as it shows how incomprehen-
sible the scene is for the old woman, who closes her eyes to erase the
sight. The beholder sees, then, both the extent of the ruins and the
old woman's despair, as if at once outside the woman (in the rubble
and devastation) and inside her mind (the despair that renders her
blind and mute).

What is the response to this by the beholder, particularly seen
through the lens of a much later time? If it is pity, motivated by
what one believes to be benevolence, we are in trouble, according
to Charles Taylor. What happens, he asks, when benevolence is
understood as a duty "somehow required by our dignity as ratio-
nal, emancipated moderns, regardless of the (un)worth of the re-
cipients?" When this is so, he continues, "how close will we have
come to the world Dostoevsky portrays, in which acts of seeming
beneficence are in fact expressions of contempt, even hatred?"[9] Pity,
as Hannah Arendt remarked more than once, is to be feared.[10] It is

8 Hofer: "Glaubte ihren zitternden Herzschlag zu hören und quälte sich ab, die
Unsäglichkeiten fassbar und schaubar zu machen." From *Grisebach* catalog, 43
(my translation).
9 Taylor, *Sources of the Self*, 517.
10 On Arendt and pity, and her insistence on the impersonal, see Adam Kirsch,
"Beware of Pity: Hannah Arendt and the Power of the Impersonal," *New Yorker*,
January 12, 2009.

demeaning to the ones pitied, and hypocritical of the ones pitying, since they feel self-righteously affirmed by their own benevolence. Pity allows one to view from a position of superiority; a stance that can easily transmute into contempt, as Dostoevsky showed so brilliantly. Or the viewer can submerge into his or her own pity in seeing images such as this one from Hofer. "With the current decline of the workers' movement," writes Luc Boltanski, "humanitarian action, which is the focus of most altruistic yearnings and is familiar to the vast majority of people only through the media, is also denounced for giving everyone the opportunity to cultivate themselves through absorption in their own pity at the spectacle of someone else's suffering."[11] Nietzsche is more derisive (as always): "Pity," he writes, "on the whole thwarts the law of evolution, which is the law of *selection*. It preserves what is ripe for destruction. . . . Schopenhauer was within his rights in this: life is denied, made *more worthy of denial* by pity—pity is *practical nihilism*."[12] Susan Sontag is more concerned with fear. She disagrees with Aristotle that, in viewing a tragedy, pity and fear will be purged by catharsis: "But pity, far from being the natural twin of fear in the dramas of catastrophic misfortune, seems diluted—distracted—by fear, while fear (dread, terror) usually manages to swamp pity."[13] Perhaps the viewing of catastrophic images allows for pity precisely because, as with the sublime, the viewer is in "a safe place" and is thus protected from fear. But this seems to me unconvincing and quite unhelpful.

How perverse, finally, is the beholder? If aestheticizing an image of human suffering serves to neutralize the catastrophe, a voyeuristic gaze on imaged disaster similarly erases the violence of the tragedy and transforms the gaze into fascination rather than recognition.

11 Luc Boltanski, *Distant Suffering: Morality, Media and Politics*, trans. Graham Burchell (Cambridge: Cambridge University Press, 1999), xiv.
12 Friedrich Nietzsche, *Twilight of the Idols and the Anti-Christ*, trans. R. J. Hollingdale (New York: Penguin, 1968), 118.
13 Susan Sontag, *Regarding the Pain of Others* (New York: Picador, 2003), 75.

Indeed, viewing from a safe place (and certainly years upon years after the Second World War provides such a place) may provoke a titillating pity based on the certitude of one's own security. The viewer then looks with lurid curiosity at what catastrophe looks and feels like for others. The voyeur is still leering—rather like the visual analogue of television "journalists" who ask questions such as, "What were you feeling when you saw your son being murdered?" The journalists know that disaster sells, and that morbid curiosity does as well. Finally, pity can easily mutate into an excess of feeling—sentimentality. And sentimentality, as Wallace Stevens remarked, is the absence of feeling.

So if we are to resist the totalizing dangers of the aesthetic gaze when viewing renderings of modern war ruins, and resist as well pity or prurient curiosity, what remains to construct our gaze?

———————

It wasn't safe to come out of the shelter until noon the next day. When the Americans and their guards did come out, the sky was black with smoke. The sun was an angry little pinhead. Dresden was like the moon now, nothing but minerals. The stones were hot. Everybody else in the neighborhood was dead.

So it goes. KURT VONNEGUT[14]

Hofer's painting *Mann in Ruinen* (Man in Ruins) (plate 2), is an analogue to the one we have been considering. Because it was painted in 1937, we might conclude, as many critics have, that it acts more as a warning of things to come, rather than as a description of what has already occurred (as in the case of *Frau in Ruinen*).[15] The man

14 Kurt Vonnegut, *Slaughterhouse Five* (New York: Random House, 1991), 178.
15 Except that the first sketches of *Mann in Ruinen* were done by Hofer at least as early as 1923-24. A lithograph and a chalk and wash drawing are from that

here is at least half naked and seems to be struggling to get out of the ruins. His nakedness and baldness lend him a stark humanity that seems to transcend national identity or even a specific war event. Picasso's *Guernica*, for example, painted the same year, has a title making the context explicit. *Mann in Ruinen*, on the other hand, is generic (as is *Frau in Ruinen*); the absence of articles in the German, as in English, here emphasizing the essential man.

The man is leaning on his right arm, suggesting both a pensive pose and also exhaustion, no doubt from trying to extricate himself from the pile of rubble that surrounds him. But we do not actually see much rubble here; mostly, the work shows ruined buildings in the background, looking as though they were cut out from cardboard for a stage set. In fact, the ruins in the background look like a Potemkin village gone wrong—showing, instead of hiding, reality. Light is coming from the man's left, but his eyes are dark. What is left of the buildings' windows, however, is lit up, as if the windows could see more clearly than the man. Fragments of the ruined buildings lie directly behind the man's left hand and torso; the fragments look like pieces of a puzzle waiting to be put back together. In this version of the image, the sky is yellow and dark purple, reminiscent of the first painting; the purple in the sky here matches the color of the ruins.[16] This is the description of an Armageddon in which the Good has resoundingly lost the battle to Evil.

The man's face is deeply and unalterably sad; hopelessness is incised in the lines on his face. On either side of him, boulder-like structures surround him; they in turn are streaked with something resembling blood, as is the flat surface on which he leans. His left

period and are clearly early drafts that served as models for the later, painted versions. In the early twenties, Hofer was responding, one may surmise, to the World War I bombings of Germany by the Allies. The 1937 painting, coming on the heels of the Guernica attack, would thus be a revisitation of the same theme in a different context of bombings. (Grosshans is wrong on this.)

16 Hofer painted several versions of this image, each with slightly differing hues.

arm looks as though it had been flexed, ready to try crawling out of the debris before fatigue took over. His hands have relaxed into what might be a brief repose. Or perhaps he has given up on attempting to crawl out; that, too, is possible.

This painting is more openly allegorical than the one with the old woman. Here, the man is simply man, and the ruins, products of any war machine. Unlike in the first painting, no possessions surround him, no clothing, no pieces of what was once home, no identifying objects. Is Hofer singularly prescient here, alerting the political powers to what war would look like? After all, 1937 was a year when Nazi Germany, growing ever more powerful, was only two years away from the invasion of Poland, and thus from the start of WWII. "The brown flood," as Hofer called the Nazis, had risen dramatically, and Hofer had already been fired from his job four years before and, two years later, would be prohibited from painting or selling his work.[17] Moreover, the Spanish Civil War was being fought, with regular reports of death and destruction coming from the fighting there; several Spanish towns, including Guernica, had been bombed.

Guernica, a small town in northern Spain (Basque country), was infamously bombed by Nazi Germany on April 26, 1937. Outraged, Picasso began painting on May 1st. It took him a little over a month to complete the famous mural *Guernica*. The work had originally been requisitioned in January of the same year by the Republican government (which would be overthrown by Franco shortly thereafter). It was to have been for the Spanish pavilion at the Universal Exposition in Paris. Initially at a loss for what to paint, Picasso had no difficulty finding his subject after the bombings.

Hitler, of course, had decided to side with Franco, principally because the civil war gave his soldiers battle experience (in this case,

[17] One of Hofer's self-portraits had been exhibited in the Kronprinzenpalais. In 1935, the painting was declared degenerate by the Nazis; in 1937, it was removed from the museum (along with several other Hofer works) and sold at auction (by representatives of the National Socialist government) in Lucerne, Switzerland.

dive bombing), and because the war in Spain deflected attention from the (staggering) Nazi arms buildup. On the day of the bombings, the Germans sent hundreds of Heinkel HE 111 and J52 Junkers to decimate the town with phosphorous bombs. They also killed many civilians with machine-gun fire. Out of a population of seven thousand, more than 1,650 civilians lost their lives and nearly one thousand were wounded. Picasso, horrified, said after Guernica: "No, painting is not to decorate apartments; it's an offensive and defensive weapon against the enemy."[18]

As against Hofer's image, Picasso's is filled with movement and chaos. The painting is too famous to describe in detail, but the juxtaposition of the two works by these two very different painters is worth considering. What strikes the viewer in comparing the two paintings is the brutal energy of the Picasso as against the crushing fatigue evident in the Hofer. In the Picasso, a horse is rearing, people are screaming and dying, and a bull is standing, as if perplexed, in the midst of it all. Other frightened animals are shown, and basically all hell is breaking loose.[19] In the Hofer, a solitary man pauses as he tries to overcome his exhaustion and immobilizing sadness in his attempt to crawl out of a similar hell. The difference in intent of the two works is made clear by Picasso's remark: painting is an instrument of war against the enemy. For Hofer, painting is more allegorical and didactic; it is a warning and a plea. Picasso's anger is

18 Quite a different opinion from the one Picasso famously espoused two years before, in 1935: "There ought to be an absolute dictatorship . . . a dictatorship of painters . . . a dictatorship of one painter . . . to suppress all those who have betrayed us." Picasso, in conversation with Christian Zervos, *Cahiers d'Art* 10, no.1 (1935): 173. The clichéd phrase "Be careful what you wish for" is grotesquely apt here.

19 One critic argues that Picasso was inspired in drawing the figures for *Guernica* (particularly the bull and the horse) by illustrations in the Biblia León, a tenth-century Mozarabic Bible. Exhibited in the Cathedral of León in 1929, Picasso would have gone to see it. See http://www.omifacsimiles.com/brochures/bib_leon.html.

as palpable as Hofer's despair. The German painter's solitary man stands in for the other wounded and dead civilians, in a time frame just after the bombs. Picasso, on the other hand, produces a painting that is meant to be *during* the bombing. His landscape under the bombs is reminiscent of Vonnegut's narrator describing Dresden immediately after the bombs: "Like the moon now, nothing but minerals. The stones were hot." One also wonders if "everybody else in the neighborhood was dead."

There were precedents for bombing civilians. Another Spanish town, Durango, had been bombed by the Germans in March of 1937, resulting in over five hundred deaths. It was to be bombed over and over again in April of the same year. The bombing of Durango marked the first civilian place to be attacked by the Luftwaffe, and this at Franco's explicit request. And between 1935 and 1936, during Italy's second colonial war with Ethiopia (then Abyssinia), the Italians used bombs to disseminate mustard gas. The Italian Royal Air Force also bombed a Swedish Red Cross Hospital, which constituted a war crime. Guernica, however, is the name that remains in memory. Sven Lindqvist wonders why Durango didn't also become a symbol of air bombing atrocity, since the number of civilian victims was as great as that of Guernica. The people of Durango today, writes Lindqvist, have a theory: "Guernica already had a special position as the capital city of the Basques, where they would convene under the holy oak. The destruction of Guernica became a symbol because Guernica was a symbol already."[20]

George Steer, a correspondent for *The Times* of London, is considered to have provided, along with Picasso's painting, another reason for which the bombing of the town of Guernica would never be forgotten. Steer witnessed firsthand the devastation of Guernica

20 Sven Lindqvist, *A History of Bombing*, trans. Linda Haverty Rugg (New York: New Press, 2000), 73.

and interviewed survivors there.[21] His report, in reserved and un-sensationalist prose, was published in the *Times* on April 28, thus two days after the disaster. Picasso, in Paris, read a translation of Steer's report in *L'Humanité*, and began painting his mural two days later. In "The Tragedy of Guernica," Steer describes the bombs. The object of the bombardment, he declares, "was seemingly the demoralization of the civil population" (which the British were later to call morale bombing) "and the destruction of the cradle of the Basque race." This was a new kind of warfare, writes Steer: "In the form of its execution and the scale of the destruction it wrought, no less than in the selection of its objective, the raid on Guernica is unparalleled in military history. Guernica was not a military objective."[22] The targeting of civilians was, in 1937, still shocking and incomprehensible, and the proliferation of photographs showing the charred ruins of the town could still be viewed with disbelief.[23]

21 Steer is careful to point out, however, that he arrived in Guernica the day after the bombings. He did not witness them.

22 See, along with George Steer's article in *The Times*, Nicholas Rankin, *Telegram from Guernica: The Extraordinary Life of George Steer, War Correspondent* (London: Faber and Faber, 2003). Rankin's entire chapter, "Gernika" (114–147), is a superb description of the horrific and total annihilation of Guernica. The chapter includes the reports of various writers (such as George Orwell) and journalists.

23 Rankin remarks that people knew that the bombing and destruction of entire towns could theoretically happen but, he continues, "as Sven Lindquist [*sic*] argues in *A History of Bombing*, bombing had till then been something mostly done in faraway places, often as a way of punishing rebellious colonial subjects. In civilized Europe in 1937, the bombing, burning and machine gunning of white civilians shocked people." (122) The racial assumptions in "civilized Europe" of 1937 are striking indeed. See also Steer's book on Gernika (the Basque spelling of the town), first published in 1938: *The Tree of Gernika: A Field Study of Modern War* (London: Faber and Faber, 2009). The recent edition also has an introduction by Rankin.

It was Colonel Giulio Douhet, in his famous book *Il dominio dell'aria* (1921), who was the first to argue that an enemy should be attacked by the air force in a manner so terrifying that response was impossible. Douhet saw the implications for civilians very clearly. By virtue of the advent of the bomber plane, writes Douhet, "No longer can areas exist in which life can be lived in safety and tranquility, nor can the battlefield any longer be limited to actual combatants. On the contrary, the battlefield will be limited only by the boundaries of the nations at war, and all of their citizens will become combatants, since all of them will be exposed to the aerial offensives of the enemy."[24]

The London Blitz was to follow three years later, Hitler having decided to teach the British a lesson. By 1945, the German town of Halberstadt—also not a military objective—suffered the same fate as Guernica, except that this time the perpetrators were the Americans. The targeting of civilians is an equal opportunity undertaking, as Colonel Douhet had coolly noted. Upon viewing the destruction of Guernica, Steer had written that this was a new kind of warfare. We need not be reminded of this in the present era, but, as Rankin notes, 1937 marks the beginning of the modern targeting of civilians.[25]

The comparison of Picasso's *Guernica* and Hofer's *Mann in Ruinen*, one might argue, is somewhat incongruous because of Picasso's tremendous fame and Hofer's modest one. But viewing Hofer's

24 See the English translation by Dino Ferrari, *Command of the Air*, with a foreword by Charles A. Gabriel (Washington, DC: Office of Air Force History, 1983), 9–10.

25 Rankin, *Telegram from Guernica*, 122. Rankin notes that "nowadays, this is normal practice. Modern war is largely directed at civilians.... In the First World War only 11 percent of casualties were civilians; in the Second, 53 percent. In the wars of the 1970s, 1980s and 1990s, the proportions were 68 percent, 76 percent and 90 percent respectively. This may be the true legacy of Guernica and Durango in 1937."

painting in conjunction with Picasso's offers two methods (among many, needless to say) of depicting, within the iconology of each artist, the horror of the death machines of modern war. These are thus painterly analogues of the novels and texts we considered in chapter 1. The paintings depict civilian slaughter from below, though as the result of what comes from above. If, as Portelli wrote, such is the space of the ultimate contradiction of war—that between the personal and the impersonal, the below and the above—it is a space whose contradiction and spatial metaphor are of little help in the tracking of the inhumane, or of the moral imperative to action.

With respect to Hofer and Picasso, one might also consider their separate circumstances, which, at first glance, seem quite different. To begin with, Hofer's enemy is entirely within; that is, the Nazis have taken over his country, and are also the perpetrators of the catastrophe in Guernica. For him, the notion of enemy is at once insidious and frighteningly familiar (one can be denounced by a neighbor, or even a family member, as we know). And Hofer, let us remember, spends from 1933 to the end of the war trying to avoid arrest, under surveillance, unable to display or sell his work, and confined, in the last year of the war, to a Nazi-run sanatorium. He is also continually threatened by the outside, "official" enemy—the Allies and their bombings—from which Hofer suffered directly, as noted earlier. Might we say that Picasso has a better sense of who the enemy is and where that enemy resides? It is true that the enemy for Hofer is everywhere, anyone, all the time; it is a ubiquitous and frequently invisible presence. Hofer was branded as a degenerate and an undesirable; Picasso was in Paris where, neither a Jew nor an open resister, he was, one might argue, in less immediate danger than Hofer. At the same time, however, occupied Paris provided its own possibilities for denouncing the Jew, the resistance fighter, or those who spoke against the Nazi regime. Although far from being in "a safe place," Picasso was less menacingly targeted in occupied

Paris than Hofer in Berlin; Picasso could still paint and sell his art privately, though it could not be displayed publicly.[26]

For Hitler, modern art was synonymous with madness, bolshevism, and the Jews—an argument he had already made in *Mein Kampf.* Hitler insisted that modern art (including that of the Weimar period in Germany) was an apocalyptic symptom of social despair; a deviation marked by blackness and fragmentation. The Thousand Year Reich, on the other hand, was to uphold unity and regeneration, with artworks filled with symbols of solidarity and power that would trumpet the *Volksgemeinschaft.* Across the street from the Degenerate Art Show in Munich, another art exhibition displayed new works by artists collaborating with the regime (thus basically propaganda, and decidedly mediocre, as even Hitler himself realized).[27] Whereas the Degenerate Art Show was housed in a dilapidated building, the

26 By some accounts, Picasso was protected by the Nazi occupiers themselves, who were (despite Hitler's fulminations on modern art) dazzled by the artist's work. But one of Picasso's biographers, Patrick O'Brian, writes to the contrary that the artist was in real danger in occupied Paris: "[Picasso] himself was not only suspected of being partly Jewish but was known to be the most notorious leader of the *Kunstbolschewismus* so abhorred by Hitler; his work, like that of the other degenerate artists, was proscribed in all territory ruled by the Nazis; he had taken an unmistakable and very public stand against fascism, and Hitler's friend Franco hated him; he knew and liked a great many Communists, and he was thought to be one of them." Patrick O'Brian, *Picasso: A Biography* (New York: Norton, 1994), 348. Indeed, when the Germans fled France in 1944, Picasso joined the Communist Party, an act that won him a certain amount of criticism and suspicion.

27 The art dictated by Hitler resembled, finally, that of second-rate, sentimental paintings of the nineteenth century—largely kitsch, in other words. Sax and Kuntz write that such art appealed primarily to the lower middle class. They add that "most of the cultural endeavors the Nazis encouraged as a replacement for all that they silenced, expelled, or destroyed were of a quality so inferior as to be embarrassing." See Benjamin Sax and Dieter Kuntz, *Inside Hitler's Germany:*

exhibit of "German" art was displayed in July of 1937 in the newly built—and glistening—House of German art. In his speech dedicating the new, palatial museum, Hitler thundered: "Works of art which cannot be comprehended are validated only through bombastic instructions for use ... from now on will no longer be foisted upon the German people!" Modern art, he continued, demonstrated artists who "clearly suffer from defective vision," because they have no sense of color nor of form. "There really are men who can see in the shapes of our people only decayed cretins; who feel that meadows are blue, the heavens green, clouds Sulphur-yellow." These "horrid disorders," said the Führer, are the result "of unashamed arrogance or of a simply shocking lack of skill."[28] These and other attacks on modern art by Hitler are notorious. His belief in his own ability to judge art and to be its visionary "protector" were motivated by his conviction that he himself had been an artist and understood art better than anyone else. Indeed, during his speech for the opening of the House of German Art, some spectators claim he got so enraged that he was foaming at the mouth. Thus Hitler's assertion that modern art was a symptom of the insanity of modern life was performed by his own insane comments on art. And, as previously noted, he may have also feared, as some historians suggest, that proximity to such art put his own (fragile) sanity at risk.

Karl Hofer had written, in 1922, that Germany should be proud of French and other European influences: "We are today the only nation whose art as a whole can stand up next to the French." But Hofer had quickly continued by explicitly rejecting nationalism as a motivation or standard for art: "Not through an attempt to present our nature in national specialties, but on the higher plateau of

universal forms in art."[29] Fifteen years later, Hitler would tolerate
only German works, and Hofer was thrown out of the Nazi pantheon
of art and declared degenerate and, therefore, un-German. But Hit-
ler's zeal to "purify" Germany of modern art clearly did not extend
as militantly to occupied France, where he no doubt felt that French
culture was beyond repair in its admiration for modern painters and
their works. However, and as is well known, Nazi officers and other
officials of the Reich confiscated a great many works of art in Paris;
artists' strongboxes in banks were looted of their contents (includ-
ing those of Picasso and Matisse). Though Hitler loudly proclaimed
that "degenerate" art was emphatically not to be exhibited or tol-
erated, this statute did not prevent a good many Nazi officials from
recognizing the value of modern artworks, and from stealing and
selling such work for their own enrichment.

29 Carl Hofer, "What Is German Art?" in *German Expressionist Art: The Rob-
ert Gore Rifkind Collection*, ed. Orrel P. Reed (Los Angeles: Frederick S. Wight
Art Gallery and University of California, Los Angeles, 1977), 146. It should be
added that in 1933, as Hofer was in increasing trouble with Nazi authorities, he
wrote a short article arguing that, unlike in music, theater, and literature, Ger-
man art had almost no Jews. Indeed, he wrote, only the German military had
fewer. The exception in art, Hofer continued, was the founder of German ex-
pressionism, Max Liebermann (whom Hofer calls "Master"). This was clearly a
desperate (and unfortunate, if well intended) attempt on the part of the embat-
tled artist to save modern art from the Nazi label of Jewish and degenerate. "Der
jüdische Kunsthandel," writes Hofer, "hat auf das Schaffen deutscher Künstler
keinen Einfluss ausüben können. In der bildenden Kunst sind die Verhältnisse
gänzlich anders gelagert wie auf dem Gebiet der Literatur, der Musik und des
Theaters." "Der Kampf um die Kunst," *Karl Hofer: Schriften* (Berlin: Gebr. Mann
Verlag, 1995), 218. For an account of Hofer's work, see Kirsten Muhle, *Karl Hofer
(1878-1955): Untersuchungen zur Werkstruktur* (Lohmar, Germany: Josef Eul Ver-
lag, 2000).

Our religion, morality, and philosophy are decadence forms of man. The
counter-movement: art. NIETZSCHE[30]

Cette obscure clarté qui tombe des étoiles. CORNEILLE[31]

In commenting on Nietzsche's sentence above, in the section "The
Will to Power as Art," Heidegger distills Nietzsche's view on the art-
ist into five statements about the essence of art. The fourth of these,
paraphrasing the one cited above, reads: "Art is the distinctive coun-
termovement to nihilism."[32] Heidegger goes on to explain that this
fourth statement can only be understood by assuming the fifth one:
"Everything hangs on the explanation and grounding of the *fifth*
statement: art is worth more than truth." (141) And to ask in what
the essence of truth consists, Heidegger reminds us, "is the prelim-
inary question of philosophy." The German painter Anselm Kiefer
has read his Nietzsche—or, at the very least, is of an apparently par-
tially similar mind. I say "partially," because Nietzsche (as indicated
in the last note) declares, in *The Case of Wagner*, all idealism to be a

30 Friedrich Nietzsche, *The Will to Power*, ed. and trans. Walter Kaufmann and
R.J. Hollindale (New York: Vintage, 1968), 419.
31 Corneille, *Le Cid*, ed. F. M. Warren (Boston: D. C. Heath & Co., 1909), 85, 4:3.
32 The first volume of Heidegger's study of Nietzsche bears the same title
as the section at hand in Nietzsche's *The Will to Power*. See Martin Heideg-
ger, *Nietzsche: The Will to Power as Art*, vol. 1, trans. David Farrell Krell (New
York: Harper and Row, 1979), 73. It should be added that, in *The Case of Wagner*,
Nietzsche distinguishes between an aesthetics of decadence and classical aes-
thetics, "beauty in itself," which Nietzsche dismisses as "just as much a chimera
as any other kind of idealism." *The Case of Wagner, Nietzsche contra Wagner and
Selected Aphorisms*, trans. Anthony M. Ludovici (New York: Gordon, 1974), 69.

figment of the imagination. And Kiefer possesses a distinctly ideal-
ist streak.

Kiefer, born in 1945, grew up in a war-torn West Germany that
was busily rebuilding itself, even as what had been the German
Reich was divided into two separate countries with rigorously con-
trasting regimes. On the night of Kiefer's birth, a neighbor's house,
directly next to his, was destroyed by a bomb.[33] Kiefer's early work
frequently shows him, often in his father's military uniform, taunt-
ingly assuming the Hitler salute (the *Heroische Sinnbild* series, from
the 1970s). A somewhat later series of paintings depicts landscapes,
heavily layered with paint and rubble. Stubbles of hay erupt on the
highly textured canvases, such as in *Die Milchstrasse* (plate 3). Later
installations include huge sculptures of burned books, tall and dead
flowers, paintings and sculptures inspired by the Kabbalah, Kiefer's
attic studio with its wooden slats and windows, figures from the He-
brew Bible, alchemy, heroes of Nordic mythology, German writers
and philosophers, forests, landscapes of sludge and ash, furrows in
muddied fields, and expanses brittle with hay. And that is, of course,
a very partial list. The artist uses, among other things, acrylic oil,
shellac, sand, emulsion, wood, cloth, metal, lead, and cinders to
achieve the intended abundant relief. His work performs the pa-
limpsestic, the written over, erasure, endless coatings; surfaces are
covered over with many layers and at times what lies beneath is
partially chiseled back into view. Kiefer also mistreats his paintings
(by his own admission—and volition), leaving them outdoors in any
kind of bad weather, or storing them for years away from sight.

The art critic Benjamin Buchloh grumpily refers to these tech-
niques, along with those of other neo-expressionist artists, as "ata-

33 Kiefer mentions this fact in numerous interviews, and in his series of lec-
tures at the Collège de France. See *L'art survivra à ses ruines; Art Will Survive Its
Ruins* (Paris: Éditions du Regard, 2011), 277 (bilingual). Kiefer scholars agree
that this bombing has had a profound effect on the artist's work.

vistic production modes," a fetishization of painting—all part of the
regressive return to expressionism and representation.[34] With art-
ists such as Kiefer, style becomes, in Buchloh's critical Marxian view,
"the ideological equivalent of the commodity" and a postulation of
history "as private property." Contemporary German artists such
as Kiefer, generally labeled postmodern and cutting edge, are in
Buchloh's contrary view above all regressive; they turn to past modes
of figural representation, to historical tropes (myths, legends, Teu-
tonic themes), and to nationalist nostalgia. The result for Buchloh
is a style of art steeped in marketing and commodification, with
history appropriated as a fetishized private property. There is some
truth to this view, I fear, though Buchloh's judgment of art such as
Kiefer's as "atavistic in production mode" is too reductive and omits
the searing brilliance—and disturbing quality—of Kiefer's work.

The French-Jewish philosopher Henri Bergson notes that we per-
ceive only the past, since the pure present is the "inaccessible prog-
ress of the past gnawing away at the future."[35] Perhaps this is at least
one way to approach the paintings of Anselm Kiefer. The past in-
deed inscribes itself on all of his work and, in his landscape paint-
ings in particular, receding lines often point toward the horizon—a
future of sorts—unattained and yet impending, just out of reach.
And though there are actual material ruins in Kiefer's work (partic-
ularly after 1985), all of his landscapes—with or without ruins—bear
traces of stress and laceration. Their very barrenness displays the
marks of a violence recently imprinted on the land. Railroad tracks,
paths, furrows, trenches, or piles of bricks create a mesh of crooked

34 Benjamin H. D. Buchloh, "Figures of Authority, Ciphers of Regression:
Notes on the Return of Representation in European Painting," *October* 16, Art
World Follies (Spring 1981): 39–68, at 59.

35 "Nous ne percevons, pratiquement, que le passé, le présent pur étant l'in-
saisissable progrès du passé rongeant l'avenir." Henri Bergson, *Matière et mé-
moire*, in *Henri Bergson, Oeuvres*, ed. André Robinet, intro. Henri Gouhier (Paris:
Presses universitaires de France, 1959), 291.

lines disappearing into the distance, running toward an uncertain horizon. *Die Milchstrasse* (1985–87), for example, is one such landscape. Kiefer's titles are often allusive, but also frequently vague. Street of milk, the title's literal translation, obviously alludes to the band of white, perpendicular to the other tracks, like a grid inviting the eye toward the horizon of the painting. What is milk doing in the stubbled field of plowed, almost geometrical rows?

In the painting, the white band of milk is echoed in hue by the receding and bright furrows in the field. These are, however, less starkly white. Above the part of the band that is offered to us to see, two cords on each side allow for the suspension of a shaft of sorts, which hangs above the white "street," as if to puncture the stretch of milk. In German, "Milchstrasse" also means Milky Way. The painting, however, is of the ground, and instead of a host of stars we see a field covered with stubbles of growth like so many inverted starscapes. At the painting's upper portion, the viewer can just barely guess at a cloudy and a starlit sky, with foggy clouds and smoke in the distance. The strip of white is as if the Milky Way, that arch thick with stars, had somehow fallen to the ground. Or is it the reflection of the Milky Way in a puddle on the field? That would make little sense in terms of perspective. And what is holding up the four cords with the shaft that hangs suspended above the puddle of white? The perspective there is equally confusing, suggesting that it has to be the sky itself, or some unseen towering structure, from which the cords are hanging. There is something at once menacing and playful about this shaft.

Is this white strip of milk, this inverted Milky Way, perhaps also an inverted allusion to poet Paul Celan's black milk? "Black milk of daybreak we drink it at sundown / we drink it at noon in the morning we drink it at night."[36] Kiefer has painted many works alluding to Celan's "Todesfuge." More than one painting refers to Shulamith's

[36] Paul Celan, "Todesfuge," in *Poems of Paul Celan: Revised and Expanded*, trans. Michael Hamburger (New York: Persea, 2002), 30–31 (bilingual).

ashen hair, and others to Margareta's golden hair. The reversed sky-scape could be a doubled mirroring of the white milk turned black in Celan's famous poem and then white again; of golden versus black hair turned to ashes. But Kiefer is also fascinated by cosmogony and the idea that the human body and the cosmos are related. He has dedicated paintings to the English Renaissance writer Robert Fludd (1574–1637). Fludd studied the occult, alchemy, the Kabbalah, astrology, mathematics, Rosicrucian thought, and cosmology (among other things). The influence on Kiefer is evident in the many works referencing the same areas of inquiry. One of Fludd's ideas is that "every plant had its equivalent star in the heavens. . . . The sunflower is transformed into a negative miniature of the starry sky, a veritable cosmos full of black stars."[37] So, too, *Die Milchstrasse* shows an inverted cosmos; the stubbles of plants are inverted stars, oxymoronic analogues of the sky. One sees this trend perhaps the most in Kiefer's series, *Sternenfall.*

Kiefer's landscapes, as I noted, often produce a horizon constrained by the grids moving toward it. The viewer's eye runs along the grids as well, until it bumps up against a sky that appears small and narrow because so little of it is offered. It is a sky, to return to Bergson's metaphor, that seems gnawed by the grids running toward a future. And yet one has the sense that if only one could see the whole sky in its magnitude, things would be different, freer, more expansive. Kiefer's paintings and installation, *Sternenfall,* on the other hand, produce larger-than-life ruins and surfaces ravaged by war. The exhibit emphasizes the earth: tunnels, sand, soil, straw, leaves, paths of brick, stone, decayed war planes and broken chairs, concrete walls with small openings, installations of twisted metal and broken war machines, and fragments of terra cotta. Kiefer's installations produce the very type of ruins that Speer, it will be recalled,

37 See Philippe Dagen's introduction to the catalog, *Anselm Kiefer: Sternenfall, Chute d'étoiles: Monumenta 2007,* ed. Philippe Dagen (Paris: Éditions du Regard, 2007). The exhibition was in 2006 at the Grand Palais in Paris.

strove so strenuously to avoid for the future. His theory of "ruin value," we remember, was to use only stone for building, avoiding metal and other materials that turn ugly (*dixit* Speer) when fallen into ruins. But Kiefer's canvases and sculptured installations fore-ground precisely the materials that Speer worked to shun: barbed wire, twisted metal, and heaps of broken concrete dominate in Kief-er's later work. The artist adds to this, as if insisting on the memory of the war's violence, dust-covered and grounded toy planes, land-locked warships in zinc bathtubs,[38] WWII bomber engines, and piles of rubble. As Philippe Dagen, the curator for the *Sternenfall* show puts it, "All these 'things' have three points in common: their con-siderable size, their rather advanced state of decay, and—this third feature inseparable from the second—their relationship to concepts of suffering and death, illness and war. In other words, their relation to a sense of tragedy."[39]

The tragedies alluded to are several; above all, the Shoah (the poets Ingeborg Bachmann and Paul Celan are referenced, as is the Kabbalah, Hebrew, and the Holocaust itself). There is also the Third Reich and its murderous politics: Kiefer makes leaden sculp-tures of huge books, blackened by fire, their heaviness crumbling in any space they inhabit. And it is the tragedy of the war itself: bro-ken, useless war machinery lies covered in powdery dust. The Nazi slogan of *Blut und Erde* (blood and earth) is, both in Kiefer's land-scape paintings and in his installations, an ironic allusion to that motto in painterly terms. Whereas for the Nazis, *Blut* signaled pu-rity of blood, and *Erde* a love of the Fatherland and its soil, in Kiefer these become signs of the savagery of war; of the traces it has carved and left on a scarred and blackened ground. His paintings of large architectural interiors, dedicated "To the Unknown Painter," reso-

38 Kiefer here is mocking the hygiene-obsessed Third Reich. During the re-gime, every German household was given a zinc bathtub.
39 Dagen, ed., *Anselm Kiefer*, 57.

nate bitterly and sarcastically to war memorials for "The Unknown Soldier"; painters, too, have been victims of the Nazi war machine. While the Nazis are the obvious villains here, the surfaces of lesions at the same time attest to the Allied bombing of the German soil and the destruction of buildings and houses the bombs have left in their wake. As a child, Kiefer's parents hid with him in the forest to escape air raids. The forest looms large in his work as a place of escape and frequently one of mystery and mythology. "I can't think of any forest that doesn't bear a mark or a sign of history," says the artist.[40]

Thus there is a certain ambivalence (or contradiction) in Kiefer's art. On the one hand, Hitler and the Reich are clearly targeted (one remembers the artist's sardonic pose in the Hitler salute that appears in many of his early paintings). Weapons of war and allusions to the Shoah are forcefully marshaled, and texts from Holocaust and Jewish writers are powerfully referenced with quotations scrawled across the paintings. At the same time, however, the cruelty and devastation of war itself—from all sides—is a major Kiefer theme. The enemy, in other words, is not only the Nazis; it is also the ability (and compulsion, one might argue) of human beings to wreak death and grotesque destruction. Kiefer's scarred landscapes are a testament to the ravages of war machines, and his corrosive surfaces and piles of rubble and abrasions bear witness to the results of warfare. Kiefer's work is not as literalized or as concretely contextualized as Hofer's; it is frequently more abstract, allegorical, and often gargantuan. But ruins are there nonetheless, and sometimes by their very apparent absence.

In Kiefer, the ground itself can be as much a site of ruins as buildings reduced to rubble. His landscapes often show the ruin, not by direct depiction, but rather by a perspective that renders the motif of destruction through visual and metaphorical extension. One of

40 Cited in *Anselm Kiefer, L'exposition/The Exhibition*, ed. Jean-Michel Bouhours (Paris: Centre Pompidou, 2015), 22.

Kiefer's series alludes explicitly to scarred ground: "Barren Land-
scapes" (*Unfruchtbare Landschaften*, 1969). At the same time, there
are also monumental installations and paintings of architectural ru-
ins in Kiefer's work. The ruin, both as landscape and as crumbled
edifices, is a recurring motif for the artist. "I like vanished things,"
the artist said to the art and music critic Martin Gayford in a 2014
conversation, "because I like things that are ruined. That's a starting
point for me."[41] Gayford calls Kiefer a "'post-catastrophic romantic';
that is, an artist working in the aftermath of the Nazi apocalypse."
This epithet, we might note, can be considered a positive version
of Buchloh's point about the neo-expressionist obsession with the
past—of painting, as well as of history.

*Self-destruction has always been the most deep-seated and sublime goal
of art, the vanity of which becomes obvious at this point. For whatever the
power of the attack—and even when it reaches its furthest limits—art will
always outlive its ruins.* ANSELM KIEFER[42]

Kiefer's *Innenraum* ("Interior") (plate 4) is enormous—nine square
meters. It is also Kiefer's allusion to Albert Speer. Speer designed
the huge Mosaic Hall of the New Chancellery as part of a project
that was to produce the Nazi world capital, Germania, on the site of
the city of Berlin. Mosaic Hall was Speer's largest completed project
for Hitler; it was destroyed by Allied bombing at the end of the war.
The painting, based on a photograph, resurrects the hall; the neutral

41 http://www.spectator.co.uk/2014/09/meet-everyones-favourite-post-cata
strophic-romantic-anselm-kiefer/. Gayford was talking to Kiefer before the
opening of a Kiefer retrospective at the Royal Academy of Arts in London.
42 *L'Art Survivra à ses Ruines; Art Will Survive Its Ruins* (Fayard, Éditions du Re-
gard: Paris, 2011), 189–90.

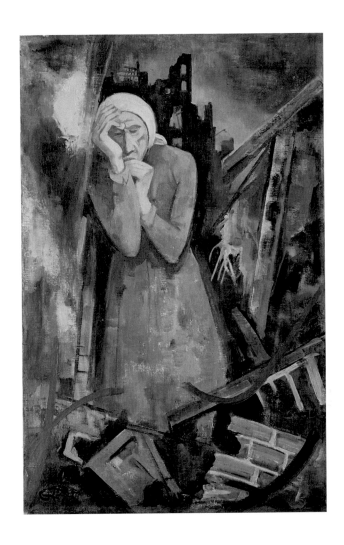

Plate 1. Karl Hofer, *Frau in Ruinen* (1945). Oil on canvas, 100 x 65 cm. © Artists Rights Society, New York / VG Bild-Kunst, Bonn. Photograph: © VAN HAM Fine Art Auctioneers / Saša Fuis, Cologne, Germany.

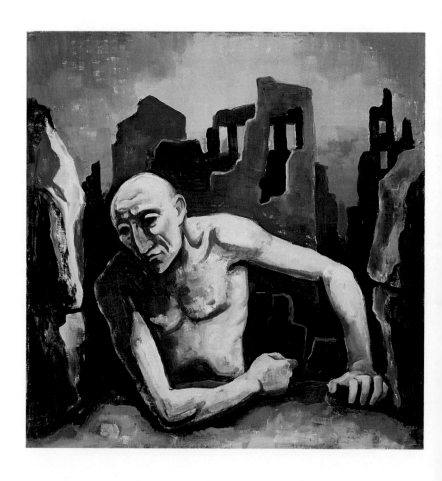

Plate 2. Karl Hofer, *Mann in Ruinen* (1937). Oil on canvas, 106.5 x 103.5 cm. © Artists Rights Society, New York / VG Bild-Kunst, Bonn. Photograph: bpk Bildagentur / Neue Galerie / Museumslandschaft Hessen Kassel, Germany.

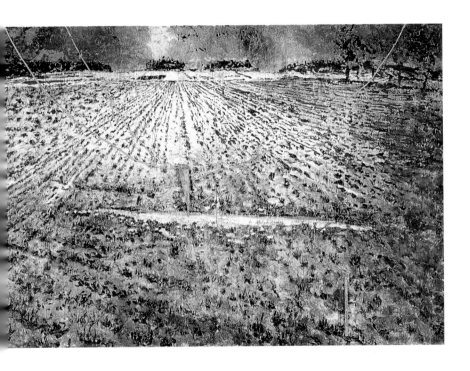

Plate 3. Anselm Kiefer, *Die Milchstrasse* (1985–87). Diptych: emulsion paint, oil, acrylic, and shellac on canvas, with applied copper wires and lead, (overall) 150 x 222 in. (381 x 563.9 cm.). © **Anselm Kiefer.** Photograph: Albright-Knox Art Gallery / Art Resource, New York.

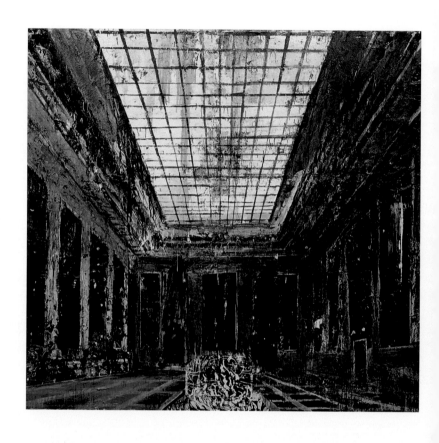

Plate 4. Anselm Kiefer, *Innenraum* (1981). Oil, acrylic, and paper on canvas. 113-1/5 x 122-2/5 in. (287.5 x 371 cm.). © **Anselm Kiefer.** Photograph: Collection Stedelijk Museum Amsterdam, the Netherlands.

title, "Interior," belies the deep implications. The hall stands, but as if eroded, dirty, and dusty. Note, however, the orderly, gridded sky-light with its geometrical lines, reminiscent of the other receding lines in Kiefer's landscapes that we noted earlier. Again, there is an ambivalence here: order as against erosion; monumental architec-ture as against dust and dirt.

At the same time that Kiefer's art shows the abominable scars of war, it also works toward redemption. This is another, contradictory and arguably problematic, part of the work. Indeed, everything is contradiction for Kiefer: "I'm full of contradictions," he says, "and every painting is the result of a struggle between different factions in my head."[43] Kiefer also believes that only art—and poetry—can lead to redemption. "The real world," writes the artist, "does not exist for me unless it is through an artwork or a poem categorically dis-tinct from life."[44] For him, art is impervious to attempts at destroy-ing it; indeed, Kiefer's 2010–11 lectures at the Collège de France are entitled "Art Will Survive Its Ruins." Like the ruin itself, something of art will always endure. Much in Kiefer is dual-valenced. Ash, so prevalent in his work, signifies the Nazi ovens, the Reich's burning of books, Shulamith's ashen hair, and the death camps. But ash is also that from which the Phoenix rises. For his 2014 exhibit at the Royal Academy in London, Kiefer hung crows from the ceiling. The crow or raven is a sign of death and ill omen; but it is also blessed by God in the Hebrew Bible. God chooses ravens to feed Elijah (Kings I, 17:5), and it is the first bird that Noah sends out from the ark. Young ravens are also cared for by God, who provides for them when they cry out in hunger (Job 38:41 and Proverbs 147:9). The raven is thus both protected by God and, conversely, on the list of birds that are an abomination and cannot be eaten (Leviticus 11:13, 15). Equally dual in valence is Kiefer's notion of straw. Kiefer writes that straw

43 Dagen, *Anselm Kiefer*, 65.
44 Kiefer, *Art Will Survive Its Ruins*, 258.

is synonymous with metabolism, "since it is transformed into dung in the stable." For him, continues Kiefer, "straw not only stands for Margareta's blond hair, it also embodies the effervescence of change."[45] Lead is the gray metal of war, but it also is the first element for the alchemist, when trying to transform base metals into gold. Sand is another such transitional material for Kiefer: on the one hand, it is the residue of decomposed rocks and minerals; on the other hand, "it too is a symbol of the notion of transition." (275) Transition for Kiefer is rebirth and renewal; resuscitation and redemption. Art is the way to all four of these. In reading a poem by Rimbaud, Kiefer writes, "for all its apparent illusoriness art is the only reality I can envisage." (244)

Perhaps the most problematic aspect in Kiefer's work is the move to reappropriate German cultural figures from their Nazi usage, with the declared goal of cleansing objects that are laden with Nazi associations. For example, he analyzes Christian Boltanski's thirty kilometers of railroad tracks, between Palavas and Montpellier; Boltanski placed small flags at regular intervals between the ties. "Nowadays," writes Kiefer, "indeed, any image of deserted tracks along which no trains will ever thunder again automatically brings Auschwitz to mind."[46] Boltanski often considers his own past in relation to the Nazi period, continues Kiefer. But he adds a caveat: knowledge of Boltanski's life "is by no means necessary to analyze and understand the present work. On the contrary, his biographical details could actually turn out to be a hindrance and could even be misleading." Kiefer decides that an effort should be made to see "something else in these tracks ... something other than what leaps to mind initially." (245–46) It is an odd comment from an art-

45 Kiefer, *Art Will Survive Its Ruins*, 275.
46 Kiefer, *Art Will Survive Its Ruins*, 245. Kiefer is referring to the 1971 exhibition in Montpellier, *100 Artistes dans la ville de Montpellier*, in which he also participated.

ist who puts so much of his own life into his work, and openly talks about his childhood and war. The New Critics of the mid-twentieth century would no doubt have applauded Kiefer's notion that using the artist's biography to understand a painting can be a hindrance and even misleading. Kiefer's idea, presumably, is that the artist's intention—or personal imagery—in the work is less important than what happens to the work in being viewed. Indeed, for Kiefer, the beholder provides 50 percent of the work's meaning.[47] Nevertheless, Kiefer admits, Auschwitz and Boltanski's relation to the Nazis do first spring to mind. It is as if, for Kiefer, those obvious referents had to be set aside in order for the "real" meaning of the painting to emerge (or at least the other half of it) from the beholder (to continue using Michael Fried's term); or, set aside in order to eradicate the Nazi affiliation. The artist's past is under erasure, as it were, so that the work can stand on its own, and be richer, once viewed. But under erasure or not, like Kiefer's layered paintings, the memory of the Nazi period lies latent, hidden from view in some works, blatant in others, but always undergirding his work.

Kiefer has his own railroad tracks, and here we return to the reappropriation of Germanic cultural icons. At some point during his career, Kiefer became obsessed with photographing a "derelict railway line."[48] With time, he decided that these tracks were Siegfried's path to Brunhilde resulting in a series entitled *Siegfried's Difficult Way to Brunhilde* (acrylic and emulsion on photographs of railroad tracks, 1977). The original English title of the series, writes Kiefer, internationalizes Siegfried, "freeing the hero from the misuse to which the adherents of National Socialism had put him when they co-opted

47 To Gayford, Kiefer remarked, "Paintings change in two ways. They change naturally, with time, and they change intellectually, because the artist is only half of the process, the other half is the spectator and every spectator creates his own painting." (See http://www.spectator.co.uk/2014/09/meet-everyones -favourite-post-catastrophic-romantic-anselm-kiefer/).
48 Kiefer, *Art Will Survive Its Ruins*, 252.

Nordic mythology for their own ideological purposes." Placing Sieg-
fried against the background of abandoned railway tracks, continues
Kiefer, puts the hero back in his rightful place: "He could become
Siegfried again." (255) Siegfried, now reappropriated by the artist, is
"a de-Nazified Siegfried who is now someone we can associate with."
Similarly, Kiefer photographs his studio as an "echo," as he puts it,
to the *Braune Haus*—headquarters of the Nazi Party. By introducing
the *Braune Haus* into his studio, explains Kiefer, by "appropriating it
in this superficial manner," he distances himself from it: "Connec-
tions exist everywhere, in other places, other periods. Thanks to this
artifice the dreadful *Braune Haus* is turned into just another medium,
like paint or clay." (232) Would, one might say, that it were so sim-
ple. This emphasis on national identity motivating the rather facile
denazification of German figures and myths is troublesome, to say
the least.

It is from the same perspective of reappropriation and cleansing
of the Nazi imprint, that we may also view the scrawled names of
great, nineteenth-century German thinkers and their portraits in
many of Kiefer's works (installations as well as paintings). Johann
Wolfgang von Goethe, Heinrich von Kleist, Johann Gottlieb Fichte,
Caspar David Friedrich, Friedrich Schleiermacher, Friedrich Höl-
derlin, Novalis, and G. W. F. Hegel, to name some of the most promi-
nent, appear like intellectual icons and visual cameos that, by virtue
of being celebrated in Kiefer's work, are writers "we can associate
with" again; they have been rehabilitated by Kiefer's art. The viewer
would be wrong, in other words, to assume that Kiefer is drawing an
inevitable line from Romanticism to National Socialism, as the 2013
exhibit *De l'Allemagne* in Paris was accused of doing.[49] On the con-
trary, he is obliterating the possibility of that line with his art. Kiefer
is not ironic here; he is performing reappropriation as overcoming
(in the literal sense, as well as in that of Hegel's *Aufhebung*): these

49 A fuller discussion of this controversial exhibit is in the conclusion below.

figures, taken over by National Socialism, are returned to their right-
ful place; erased from Nazism, preserved and lifted up from that us-
age, and reintegrated into German cultural history. It is that histori-
cal topography that Kiefer strains to restore, and it is this possibility
of renewed life that art can grant: "Are not all our actions," he asks,
"just make believe?" Kiefer's answer is that whereas some artists
demonstrate the absurdity of any action, "my action represents a
kind of restitution."[50]

For Kiefer, art does more than resuscitate and restitute. Art is
connected with a transcendental: "The visible," he writes, "is sim-
ply a support for the invisible, the emanation of a divine mystery."
(182) Hence Kiefer's spiritual bent and subjects: the Bible, the Kab-
balah, mythology, questions about a hereafter, alchemy, animism,
the Golem, Robert Fludd's work on the occult, astrology, cosmol-
ogy, and so on. To some extent, perhaps, we can consider Kiefer a
romantic. Philippe Dagen notes that Kiefer's use of vast landscapes,
his depictions of nature and the stars, his allusions to spirituality,
"indeed, mysticism—all add up to an underlying Romanticism that
fuels the contemplative side of his art."[51] Kiefer's larger-than-life
paintings are like a modern vestige of Friedrich's painterly sublime.
The latter's plunging ravines and awe-inspiring vistas are echoed,
if distantly, in Kiefer's images. Kiefer is a great admirer of Fried-
rich, and answers Friedrich's landscapes with heavily textured and
eroded canvases, as we have noted. In Kiefer, a palimpsestic sub-
lime yawns everywhere; moreover, there is less of a "safe place" in
viewing his sublime, since his installations and the very size of his
paintings enclose—even engulf and occupy—the viewer, who can-
not observe from a safe distance, and does not possess the security
of a proscenium to mark a reassuring separation from the work. In
Kiefer, the sublime is itself a transcendental, attesting to the spiritual

50 Kiefer, *Art Will Survive Its Ruins*, 241.
51 Dagen, *Anselm Kiefer*, 71.

capacity of art to lift beyond the real. "Only sheer will," Kiefer re-
marks, "is able to compel the earth to transcend the bounds of pos-
sibility and enter the field of the impossible. Art might be another
name for this."[52]

And yet, if we can say that Kiefer has a distinctly romantic sensi-
bility and a belief in a transcendent, and if he elicits a certain roman-
tic gaze in his viewer, he is emphatically what Gayford called a post-
catastrophic romantic. We might call Kiefer the post-ruins artist of
ruins. His sublime is embedded in the German past; Friedrich's ma-
jestic and terrifying ravines become, in Kiefer's work, allusions to
the Shoah, to the devastation of war, or to the horrors of the Third
Reich. These references lie beneath the layers of paint, sand, and
ash; or they are foregrounded, with a depth of lacquered and coarse
coatings around them. The economy of representation is altered
here. Description is produced by the figural, but is weighted by re-
curring themes that function like leitmotifs in music—recognizable,
their allusions comprehensible, but the performance of their impli-
cations covered in layer upon layer of images, words, time periods,
historical events, and coated reminders of trauma.

Kiefer's art has often been seen as militating against the German
collective memory of war. The removal of the ruins, and the rapid
rebuilding of Germany after the two World Wars, particularly in the
West, no doubt encouraged amnesia among the German populace.
Kiefer himself has commented that when he was in school, the Sec-
ond World War was hardly mentioned. But memory and amnesia
need not always be seen as diametrically opposed.[53] Monuments,
as has often been noted, serve, on the one hand, to keep memory

52 Kiefer, *Art Will Survive Its Ruins*, 285.
53 I take this point from Andreas Huyssen, *Present Pasts: Urban Palimpsests
and the Politics of Memory* (Stanford, CA: Stanford University Press, 2003). The
essays that constitute Huyssen's book, he writes, "read specific urban phenom-
ena, art-works and literary texts that function as a media of critical cultural
memory today." (6)

alive; on the other hand, the very fact that memory has been depos-
ited in a specific place allows for forgetting, for obviating remem-
bering. This is, in fact, a paradox similar to the one in the myth that
Plato famously tells concerning writing. In *Phaedrus*, it will be re-
called, the Egyptian god Theuth comes to the Pharaoh Thamus and
offers him "a recipe for memory and wisdom," which is called writ-
ing. Thamus replies that, on the contrary, writing will introduce for-
getfulness into the soul of those who learn it: "They will cease to
exercise memory because they rely on that which is written, calling
things to remembrance no longer from within themselves, but by
means of external marks. What you have discovered is a recipe not
for memory, but for reminder."[54]

The same can be said of any monument. Indeed, in the heart of
Berlin is the Teufelsberg, a *Schuttberg*—a huge hill made of the rub-
ble from war ruins. Underneath that mountain of bomb debris is the
Nazi military technical college, built by Speer though never com-
pleted. In the 1960s, the United States built a listening station on
top of the hill. The station closed with the fall of the Berlin Wall, but
the large radar domes and buildings remain. What to do with this
edifice now continues to be at issue in Berlin. This huge structure,
in other words, is as much of a palimpsest as one of Kiefer's paint-
ings, and equally rife with architectural and historical strata. But as
a looming, permanent landmark (and eyesore) in the city, its various
origins and purposes have long ceased being a site of active memory
by Berliners.

Memories of war's ruins function in strange ways in Kiefer him-
self. We have noted that the night Kiefer was born, the house next
to his parents' home was bombed and flattened. The artist, in his
lectures at the Collège de France, tells how when he was a child, "I

54 "Phaedrus," in *Plato: The Collected Dialogues*, ed. Edith Hamilton and Hun-
tington Cairns, trans. Lane Cooper (Princeton, NJ: Princeton University Press,
1973), 520 (275b).

used the scattered and thus liberated bricks from this house as building materials for small houses of my own several stories tall. Thanks to those bricks, this was my first involvement in constructing."[55] No surprise, then, that bricks are frequent in his sculptures and paintings. These works are variously titled *Heliopolis*, or *The Silk Road*, *The Ruins Women*, *The Form of Antique Thought*, and many others that feature bricks. One large painting is called *For Ingeborg Bachmann: The Sand from the Urns* (1998–2009) and is of a ziggurat (made of bricks) in a sandstorm. There is a long series on *Trümmerfrauen* (rubble women), who cleaned up the debris after the bombs fell. Kiefer expands the term to include women of catastrophe: Charlotte Corday, French queens, Bérénice. The she-demon of Jewish tradition, Lilith, is another figure of importance for Kiefer. In a German interview with the writer Christoph Ransmayr, Kiefer tells the writer that Lilith interested him because she was said to live in abandoned ruins. He adds, "For me, ruins are the most beautiful thing there is. You have no doubt already seen photographs and films of German towns after the war." "Constantly," replies Ransmayr, "ad nauseam." Kiefer retorts that he, on the other hand, can't stop looking at the ruins, that for him they are exalting. In the interview with Ransmayr, Kiefer again says that he spent his childhood playing with the bricks from the bombed-out house next door, and repeats his love of ruins: "It's extraordinary, because the beginning is situated there. Everything is possible. In fact, I played in the ruins, I had nothing but bricks."[56]

For Kiefer, ruins are a tabula rasa that allows for a new start, a rebirth and resuscitation—motifs that, as we have seen, are central to his vision. Ruins are, willfully on the artist's part, a positive ele-

55 Kiefer, *Art Will Survive Its Ruins*, 277. In 1989, Kiefer acquired—and surely not by coincidence—an old brick factory, where he worked and produced his installations.

56 *Anselm Kiefer: L'alchimie du livre* (Paris: Éditions du Regard, 2015), 244. This was the catalog for the Kiefer exhibit at the Bibliothèque nationale de France in Paris (October 2015–February 2016). My translation from the French version.

ment. Here is not the romantic viewing of the ruins with melancholic thoughts on mortality, the passage of time, the tragic beauty of fallen kingdoms. As if possessed by that romantic view of ruins, the catalog for the Bibliothèque nationale exposition sees Kiefer's work as suffused with "the motifs of melancholy and the ruin." (57) But this is not what Kiefer told Ransmayr; he rather explained that ruins thrill and exalt him.

Kiefer is the artist of ruins (including those of the mind), of the German landscape, of (reclaimed) German culture and history, of art itself. But art, he reminds us, will survive its ruins. Despite his insistence on the restorative and resuscitative power of art, despite his belief that only art and poetry matter and are in fact more real than reality itself, despite his openly transcendental strains and his conviction that art can erase, or at least overcome, historical darkness, despite the dual valence of his images (ash, straw, lead, etc.)— despite this fairly positive and elevated credo, Kiefer is also the artist of blackness and of barrenness. The ruin lies at the heart of his vision, both as a site of rebirth and as what Nietzsche calls the abyss—that place that cannot be gazed at without producing after-images of horror. As Lyotard notes, the mission of art is to bear witness to the fact that there is such a thing as the unrepresentable.[57] Kiefer, with all of his layers of figuration and allusions, with all of his figural depictions, is paradoxically enough also the depicter of a certain unrepresentable; his art darkens into chasms by virtue of its very larger-than-lifeness, its scarred blackness, and its constant references to war and human suffering. Kiefer's representations, in other words, spiral into the ruination of representation.

Walter Benjamin wrote of a fascistic aestheticization of politics, the art of war being an example.[58] Rancière reminds us that art

57 See Jean-François Lyotard, *Lessons on the Analytic of the Sublime: Kant's Critique of Judgment* (Stanford: Stanford University Press, 1994).

58 See, for example, "The Work of Art in the Age of Mechanical Reproduction," in *Illuminations*, trans. Harry Zohn (New York: Schocken, 1969), 241-42.

and politics have always been in a symbiotic relation.[59] How might we characterize Kiefer's aesthetic vision? Does it mark the return of a certain romantic gaze, or the aestheticization of catastrophe? Or does it rather, by virtue of being haunted by the past and its ruins, produce "ruinscapes" that allude to present catastrophes and their contemporary ruins? Kiefer's work would then perform both a memory of the war and its devastation, and what Luc Boltanski calls a *politics of the present* (his emphasis). Is it not true, asks Boltanski, that there is often "a denunciation of those in power who exploit past victims in order to take possession of the future while ignoring present suffering?" As against the suffering of the past, writes Boltanski, or of the future, "the present has an overwhelming privilege: that of being real."[60] Whether or not Kiefer's work, in its production of vast landscapes and installations of destruction, is engaging in a politics of the present, or in the (sometimes ironic) disinterment of history and memory, is no doubt impossible fully to ascertain.

There is, however, an aspect of the artist as authoritarian all of this. As Buchloh puts it, the "rediscovery" of history serves the purpose of justifying the failure of modernism, and the "atavistic notion of the master artist is reintroduced." He continues, specifically commenting on the contemporary neo-expressionists in Germany, and (indirectly, but clearly) on Kiefer: "The language of the artists themselves . . . blatantly reveals the intricate connection between aesthetic mastery and authoritarian domination."[61] For Buchloh, the German neo-expressionist in particular holds an elitist notion of subjectivity, which "ultimately opts for the destruction of the very historical and cultural reality that it claims to possess." (67) The repudiation of the non-representable, for Buchloh, as represented by Kiefer and other European neo-expressionists, is an ideological backlash. Buchloh's point, clearly, is well taken, if intransigent.

59 Jacques Rancière, *The Future of the Image* (London: Verso, 2009).
60 Boltanski, *Distant Suffering*, 192.
61 Buchloh, "Figures of Authority," 46.

But I would submit an addendum to this view. The return to modes of traditional representation in painting, by Buchloh's own lights, begins around 1915—after one year of the First World War. The European neo-expressionists painting today are doing so in the long wake of the Second World War. The trauma of these two immensely destructive wars, and the ruins, deaths, and destruction they produced, may in themselves create the need to depict; an *insistence* on the figural in art. Siegfried may never be "just Siegfried" again, nor the *Braune Haus* "just another medium"—contra Kiefer's wishful (and reductive, if not overtly questionable) conviction. But the return to modes of representation (and I include Hofer here as well[62]) may be the result of the catastrophic wars that shaped and scarred the landscapes of twentieth-century Europe. Once again, we are reminded of the journalist Dagerman's refusal *not* to describe catastrophe—in his case, textually. These artists may feel—even if unconsciously—that given the destruction of war, abstract art or the painterly "indescribable" are inadequate and unacceptable— artistically as well as politically. I am not here disagreeing entirely with Buchloh, whose critique is persuasive at times. I am merely

62 In a 1955 article in the *Tagesspiel*, "Der Mut unmodern zu sein" (the courage to be unmodern), Hofer argued against the "apostles" of abstract art. Art will go where it wants, he argued, and in any case the problem of the visual arts is man himself and humanity. The intolerance of the art world, he continued, is not the answer. The "blind zeal" of the "scribes" and their rigid insistence on a return to the abstract is, writes Hofer, reminiscent of the Nazi state (a most provocative statement, needless to say). The article is a direct attack on the art critic Will Grohmann, who represented for Hofer precisely this intolerant view of art. Hofer's point was not, unlike popular opinion at the time, to attack abstract art, but to rail against an intransigent art culture that was easily satisfied with mediocrity. For a brief discussion of the fight between Hofer and Grohmann, see Hans Dieter Schäfer, "Culture and Simulation: The Third Reich and Postmodernity," in *Flight of Fancy: New Perspectives on Inner Emigration in German Literature, 1933-1945*, ed. Neil H. Donahue and Doris Kirchner (New York: Berghahn, 2005), 104-5. See also Muhle, *Karl Hofer*, 196-97. One might imagine that Buchloh was the sort of critic that Hofer would have railed against.

adding another possible motivation to the move to represent in neo-expressionist art: the will to make clearly visible. It is a repetition compulsion of Freudian proportions, and a classical symptom of trauma. It cannot, in my view, be summarily dismissed. And while the effort to depict catastrophe and its consequences is at best difficult, as we have seen in texts and paintings, such an effort may also be understood as a compulsive drive to nonetheless depict the appearance of things in the context of destruction.

Just as memory and amnesia are not necessarily contradictory, so too the figural and the abstract are not necessarily oppositional in painting. They can work in tandem, alternating like electrical currents. Photographs, too, can depict abstractly as well as show in sharp focus. The viewer's gaze, undeniably, is constructed by his or her circumstances, and by the span of time that separates the viewer from when the images were taken. "'Tis Sixty Years Hence," wrote Walter Scott to introduce the Waverley novels, and to invite his readers to look retrospectively. It is long since the photographs we are to consider were taken. In viewing them, I am inviting both a retrospective and a prospective gaze. To what extent is the photograph (before the digital era) able to describe war catastrophe? Can there be an indescribable in the photograph?

3 Through a Lens, Darkly

TEXTS AND IMAGES

We no longer believe in the objectivity of photography, but we do still regard photographs as, in some way or other, our reality.

BERND STIEGLER[1]

How does a photograph describe the results of catastrophe? Does it merely mutely record, as a witnessing? We tend to witness reluctantly, and not infrequently with prurient interest. And when photographs are "read," the undertaking I am about to engage in here, is there a redundancy in verbally describing what a photo already visually depicts? Is the silence of the photograph betrayed by verbal explication, like a silent movie on which a soundtrack is superimposed by a later era, or like a black-and-white film that is subsequently "colorized"?

The collection of images I present here was produced, of course, before the digital age with its Photoshopping and other technical capacities, and before the ubiquitous snapshots of the cell phone. These images are taken at the apogee of the camera—the 1940s. The fact that they were not meant to be propaganda, and that they are the

1 Bernd Stiegler, "Photography as the Medium of Reflection," in *The Meaning of Photography*, eds. Robin Kelsey and Blake Stimpson (Williamstown, MA: Sterling and Francis Clark Institute, 2008), 197.

work, not of a professional but of an amateur, suggests something like a possible moral ambiguity. Moreover, they cannot be easily understood as "art"—unlike, for example, the paintings of Hofer and Kiefer discussed in chapter 2, or some of the novels we considered in chapter 1. And yet there is a beauty of sorts in some of these images, such that one wonders on what grounds it can be said with certainty that they are *not* art.

There is much in these photographs that the viewer does not, and cannot, see: ruins and devastation from outside the frames, things that can't be zoomed in on to be viewed clearly, people who are cut out of the scenes, reconstructions that have already been undertaken but are cropped out, and so on. These images (like any image) leave a great deal unseen, unrecorded. On the other hand, the viewer may also see things the photographer never intended; the photograph's indexicality is not something we, as viewers, need obey. Yet the imprint of a photograph, its materiality, necessitates a response, a recognition: of the image as a container of (historical) memory, or as an aggression (on the part of the photographer, or of the image itself), or any number of other possibilities. It is also the case that any image, particularly of catastrophe, can lead to the anaesthetizing (or mummification, in Dan Morgan's term) of the image and/or the viewer's gaze. What, in other words, do these photographs want?[2] To what extent can we project ourselves backward, to the end of World War II, and try to get a sense of these images of a ruined Germany? Let us attempt a beginning.

2 I am here echoing W. J. T. Mitchell's question, "What do pictures want?" Like Mitchell, I do not believe that images "really" want things; but there is what Mitchell calls a "double consciousness" surrounding images: we talk about them as if we did believe that they have feelings or intents. Images, argues Mitchell, are like living organisms to us, even as we know intellectually that this is absurd. I also agree with Mitchell that there is such a thing as "image anxiety." W. J. T. Mitchell, *What Do Pictures Want? The Lives and Loves of Images* (Chicago: University of Chicago Press, 2005), 11.

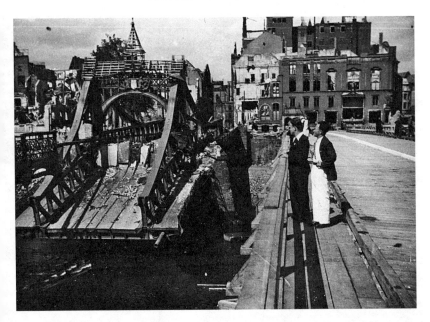

Fig. 1.

These first two photographs (figs. 1 and 2) were taken in the summer of 1945, somewhere in Germany. Two well-dressed young men stop to view a destroyed bridge. Behind them are more ruins—of buildings, roads, churches. The city has clearly been fairly recently bombed, although the rubble has already been removed from the streets to allow for circulation—principally for the vehicles of the victorious armies—and the church in the background is already under construction. In this scene, moreover, the bridge itself has been temporarily reconstructed with wooden planks, making it possible for traffic to move. No doubt a few months have passed since the bombing.

We know that the two men stand there for a while, because the military truck that appears when they decide to move on is not visible even in the background of fig. 1. In that first scene, the men stand

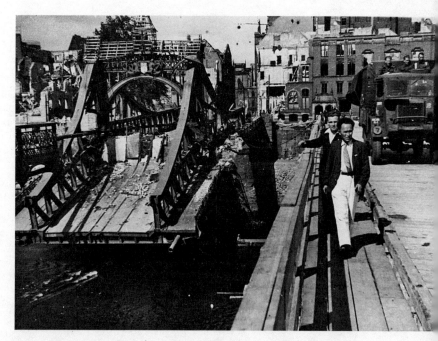

Fig. 2.

in what seems to be contemplation at the destruction. In the second, they hurriedly move on, as if they had seen enough (the first man's tie flapping in the wind, his head turned away from what he has just been looking at; the second man looking directly in front of him, though one wonders why his right arm is raised over the makeshift wooden balustrade). They are grimacing a bit, but it is hard to know if it is from the effects of seeing the ruins, or from the sun that seems to be hitting them almost directly in the eye (at a slant from their right), or if they are squinting with some curiosity directly at the photographer, who is meeting them head-on.

The military truck, complete with soldiers, rumbles behind them, although it is not clear to which of the Allied armies the truck be-

longs.[3] The same is true of the two well-dressed men: we do not know of what nationality they are. Do we assume, for example, that if they are German, it is the extent of the destruction that makes them grimace, or that if they are French (again, for example) their facial expression is merely caused by the sun, or their interest in the photographer? Their attire does not suggest that they are American. Are they French journalists? And what of the soldiers in the truck? We assume that the conquered Germans are no longer driving trucks, so that this one belongs to one of the Allies. The soldiers do not look American, either (the uniforms are wrong for US GIs). Are they Russians? Part of the Red Army that had just finished pillaging, plundering, and raping its way through the Reich? Perhaps the two men have moved on because of the truck's appearance. The war is over, but you never know.... In that case, the men are most likely German. Two of the three soldiers in the truck also seem to be grimacing. Is it just the sun, or is it, again, that they are noticing the photographer?

We have, in other words, very little information about these photographs except that we know, at this point, that they were taken in Germany at the end of the war by Jeanne Dumilieu, amateur French photographer. The photographer has captured a scene of two men coming to grips, one might say, with one result of the Allied destruction of German cities and towns. Her gaze is trained on that of the men. In the first scene, the men are staring at the ruined bridge; in the second scene, as they walk away, their eyes are looking directly at her, looking at them. And we, the beholders, are not exempt from all of this. In the second scene, everyone is also looking at us, even as we look at them. Moreover, the men are not put in the middle of the photographs; the photographer has contextualized the frames

3 It should be noted that a war historian could easily identify the truck and thus the soldiers. I am, however, staying with the gaze of an amateur in my reading of the photograph.

in order (one surmises) to be inclusive (the ruined bridge, the background of ruins, the two men, the military truck).

No doubt for the viewer of these photos there is *studium* here, as Roland Barthes so famously has it: "It is by *studium* that I am interested in so many photographs, whether I receive them as political testimony or enjoy them as good historical scenes."[4] On the other hand, there is little here that would produce Barthes's *punctum*— "that accident which pricks me (but also bruises me, is poignant to me)." (27) Barthes argues that to recognize the *studium* "is inevitably to encounter the photographer's intentions, to enter into harmony with them, to approve or disapprove of them, but always to understand them, to argue them within myself." Because, continues Barthes, culture is a contract "arrived at between creators and consumers." (28) For Barthes, representation is an obvious function of the photograph, which serves "to inform, to represent, to surprise, to cause to signify, to provoke desire."

But the photographer's *intention* in these two scenes here is at best ambiguous. Historical recording? Curiosity? Pleasure at the visible vengeance on Hitler's *Volk*? Recording for posterity? One might also say that my mother is recording the erasure of urban history. Her goal is clearly not aesthetic—that is, to capture beauty. She is, rather, recording loss and destruction. There is so much fullness here that we can't unpack. What was she facing in photographing these scenes? How much did she know? Did she understand her work as building a history; or an attempt to *hold* a history? We don't know—in that sense, the photographer is as opaque as her subjects.

Barthes further claims that the photographer has a "second sight," which "does not consist in 'seeing,' but in being there." (47) Michael Fried reads this "being there" as a continuation, since Diderot, of

4 Roland Barthes, *Camera Lucida: Reflections on Photography*, trans. Richard Howard (New York: Hill and Wang, 1983), 26.

anti-theatricality.[5] There can be no *punctum* for Barthes if the photograph is staged or if the photographer *intended* (there is that problematic term again) to shock, please, or otherwise manipulate the viewer. In other words, as Fried notes, the beholder must not be taken into account, because (for Diderot and for Barthes) that would be theater, not being there. In any case, we have a plurality of gazes here, as we do in all photographs: the photographer, the people photographed, and the spectator (Fried's "beholder"). And, we might add, the camera lens itself.

What is "the civil contract of photography" here, if any, to use Ariella Azoulay's indirect segue from Barthes's notion of culture as a contract between creators and consumers? For Azoulay, who is interested in photographs taken "on the verge of catastrophe," there is such a thing, even for the stateless person, as a civil space of photography, configured by the civil contract of photography.[6] The two photographs we have been considering, however, are taken somewhat after the catastrophe. Things are beginning to work again and are being rebuilt, even though for several months after the fall of the Third Reich, the German population is occupied but stateless; in the summer of 1945, the Allies have not yet portioned off Germany and there is as yet no stable bureaucratic authority, only military rule. What is the photographer attempting to capture in training her camera on these two men, and to what extent are they "allowing" themselves to be photographed (presumably without so much as a "by your leave")? There is but little of a civil contract here. Most of Azoulay's photographic subjects have to do with people; many staring

5 Michael Fried, *Why Photography Matters as Art as Never Before* (New Haven, CT: Yale University Press, 2008), 100. The entire chapter, "Barthes's *punctum*," is an extended reading of the two famous Barthesian terms in relation to the Beholder in art, as Fried proposes it.

6 Ariella Azoulay, *The Civil Contract of Photography*, trans. Rela Mazali and Ruvik Danieli (New York: Zone, 2008), 85.

directly at the camera, thus performing the civil contract that is pho-
tography for Azoulay. Many of her photos are staged, though not in
the sense that brings Barthes to refuse *punctum*; the faces that stare
into the camera in Azoulay's trove of images allow her to analyze
photography "within the framework of citizenship as a status, an in-
stitution, and a set of practices." (24) The primary goal in Dumilieu's
photographs here, however, is to record the war's structural (archi-
tectural) devastation. People are somewhat incidental in this collec-
tion, though the ruins return us, ineluctably, to the suffering of the
populace. The face is not the focus of these images, albeit in these
first two photographs, we have faces to consider.

They are the exception in my mother's photographs. Unlike Azou-
lay, whose book is filled with faces photographed from up close, Dumi-
lieu largely stays at a distance from her subjects. It is as if she didn't
want to get too close, to get to know her subjects, or to engage with
them. The French Resistance fighter does not seem to want proxim-
ity to the German populace she is filming. There is a discretion here,
as well as the suggestion, one might conclude, of a certain antipathy.

It is thus likely that the two men in the photographs are friends
of the photographer—given that they are nicely and cleanly dressed,
that they are training their gaze directly at the camera, and that the
photographs are taken from fairly close range. Very few if any of the
photographs in this collection show Germans looking straight into
the camera.

Are these two men in the photographs here to be understood as
specimens? Of what? Are they to be seen as merely curious onlook-
ers at destruction, taking it in much as one looks at exotic animals
in a zoo? Their gaze seems more like that of tourists. When, unlike
in Azoulay's study, the photographed individuals are not obvious
victims of political and/or physical violence, what are they convey-
ing, standing there with civilian death and injury as the backdrop? If
they were friends of the photographer's, perhaps she asked them to
stare at the destroyed bridge, and thus posed the men and set up the

picture. We are entering the problem of reading photographs, the murky aspect of speculating a narrative, and the gaze on ruins of war. It would, of course, help if we knew much more here. And yet, historical information, politically and factually essential though it is, can also lead to serious misreadings.

A gaze, believed to be informed, can create a seductive narrative for a photograph; motivated by a willed epistemology that assumes that seeing-is-interpreting, such a conviction can lead to retrieving knowledge that is otherwise undetectable. The viewer of the image becomes something like a perspicacious detective, sharing his/her privileged insights with a future viewer. But such insights are at best speculative, and often born of error. For example, Walter Benjamin "reads" a Dauthendey photograph from the nineteenth century, equipped with the knowledge that Dauthendey's wife will commit suicide several years later, "shortly after the birth of her sixth child." Her husband, says Benjamin, will find her "lying in the bedroom of his Moscow house with her veins slashed." In the photograph, the husband seems to be holding her, says Benjamin; but the gaze of this woman "passes him by, absorbed in an ominous distance." The beholder of such a photograph, continues Benjamin, in contemplating such an image, "feels an irresistible urge to search such a picture for the tiny spark of contingency, of the here and now, with which reality has (so to speak) seared the subject, to find the inconspicuous spot where in the immediacy of that long-forgotten moment the future nests so eloquently that we, looking back, may rediscover it. For it is another nature which speaks to the camera rather than to the eye." Moreover, says Benjamin, this other nature is "a space informed by human consciousness," but giving way "to a space informed by the unconscious."[7]

7 Walter Benjamin, "A Little History of Photography," *Selected Writings: Volume 2, 1927–1934*, ed. Michael W. Jennings et al., trans. Rodney Livingston et al. (Cambridge, MA: Belknap Press of Harvard University Press, 1999), 510.

All well and good, except that Benjamin is wrong here. Dauthend-ey's first wife did indeed commit suicide in 1855. But the photograph is from 1857 and is of his second wife, who died of pneumonia in 1873. What Benjamin imagines in the gaze of the young woman is inspired by a biographical detail that turns out to be misplaced. The observer's unconscious upstages, it would seem, the subject in the photograph. We, the observers, do indeed view a photo through the lens of the specters that haunt us, and our idea of the "here and now" is often overly nourished by the imagination.

Or take another example: on May 7, 1945 (the day of the German surrender), *Life* magazine produced a cover story on "The German People," with a photo-essay on "Atrocities." The essay was illustrated with black-and-white photographs, including one by George Rodger, of a young boy walking along a forest path. He is well dressed and looking to his right. The caption reads: "A small boy strolls down a road lined with dead bodies near camp at Belsen." Indeed, to his left (away from where he is looking), corpses are piled up, lining the road. As German scholar Werner Sollors points out, many such concentration camp photographs "were disseminated with General Dwight D. Eisenhower's encouragement."[8] The general had been told that the American soldier did not know what he was fighting for; "Now, at least," wrote Eisenhower, "he will know what he is fighting against."[9]

Sollors writes that a reviewer who examined the photograph determined that it was not a snapshot, and that the boy "has defi-nitely noticed the photographer." Rodger may even have asked the boy to walk along that path; in other words, Rodger may have set up the scene. The boy is squinting, and apparently looking at the pho-

[8] For a full (and riveting) history of this photograph, as well as the use and dis-semination of death camp photographs, see Werner Sollors, *The Temptation of Despair: Tales of the 1940s* (Cambridge, MA: Belknap Press of Harvard University Press, 2014), 56-82. My return to this photograph's story is indebted to Sollors's gripping rendition.

[9] Cited in Sollors, *Temptation of Despair*, 59.

tographer (just like our two young men in figs. 1 and 2). Despite the plausible theatricality of the photograph, however, some version of *punctum* seems to have been triggered, given the readers' responses to the scene. The photograph was part of the cover story on "The German People," and given a full page as the lead picture. As Sollors puts it,

It was part of the harrowing photojournalism that surrounded the liberation of concentration camps in Germany more broadly. That context suggested certain ways of seeing the image. Prominent in Allied photography of the time was the theme of perceived German indifference to the scenes of horror and suffering. *Life* magazine's caption cast the little boy's stance, his "stroll," and his casual expression as part of that story line. Such framing put the image in the company of much of the other photographic documentation of this moment. (62)

Much was made of the fact that the "German boy" in the photo is "turned away from death." People speculated as to why he was allowed to wander around the grounds in the first place, when there was so much death there. Why was he looking away from the corpses? Why was he so well dressed? The speculation was endless, but the strong implication remained that the Germans were indifferent to the horrors of the death camps, and that such indifference could be found even in a young boy. Indeed, as late as 2005, nine years before Sollors's book, Tony Judt published a voluminous book on Europe after 1945. Judt, too, reproduces the photograph of the young boy and adds, in a caption, "Shortly after Germany's defeat in 1945, a child walks past the corpses of hundreds of former inmates of Bergen-Belsen concentration camp, laid out along a country road. Like most adult Germans in the postwar years, he averts his gaze."[10] Here, too, the boy is seen as metonymic of the postwar German

10 Tony Judt, *Postwar: A History of Europe since 1945* (New York: Penguin, 2005), photograph opposite 234.

indifference to, or repression of, the Nazi horrors in which many of them collaborated.

But as it turns out, this is all wrong. The boy in the photograph is Dutch and Jewish and is himself a survivor of Belsen. His nice clothes are those he was able to choose from the clothing of dead children when he left the camp. As Sollors notes, the photograph now seems to change before our very eyes—even the boy's gait has changed (that he "strolls," for example, is no longer acceptable).[11] A new caption for the photograph, in a book about Rodger, reads: "A Dutch Jewish boy walks among the dead, Bergen-Belsen, 1945."[12]

As Sollors does in his book, I, too, am asking here what captions can do to photographs, and how biographical information about the photographer, and his or her subjects, can determine our reaction to a given image. We want images—particularly photographic images—to reveal meaning, to show what is otherwise hidden, to capture a particular moment in time, to be codes of sorts that can be deciphered by the astute interpreter.

And of course, images are indeed codes—or signs, as Roland Barthes reminds us[13]—a fact that in no way alters the possibility of misreading them; quite the contrary. We read images—particularly

11 See Sollors's discussion of the real person who had been the boy, identified in 1995, and the ensuing reprintings of the same photograph. (68)

12 Carole Naggar, *George Rodger : An Adventure in Photography, 1908-1995* (Syracuse, NY: Syracuse University Press, 2003), 137.

13 Well before Barthes, and from about 1895 until 1905, C. S. Peirce used the photograph as an example in his classification of signs. "Photographs," he writes, "especially instantaneous photographs, are very instructive, because we know that they are in certain respects exactly like the objects they represent." Emphasis, I would think, on "in certain respects." Cited in François Brunet, "'A better example is a photograph': On the Exemplary Value of Photographs in C. S. Peirce's Reflection on Signs," *The Meaning of Photography*, ed. Robin Earle Kelsey and Blake Stimson (Williamstown, MA: Sterling and Francine Clark Art Institute, 2008), 35.

war images—through a semiotics of ideology, in an endless herme-
neutics of a priori convictions, combined (particularly when the pic-
tures are of violence) with a voyeuristic curiosity. It is a process not
unlike what Eric Auerbach calls parataxis—a series of images or tex-
tual moments that are without conjunctions, such that the beholder
needs to fill in the gaps with a known cultural glue. Thus, for ex-
ample, you will be not a little bewildered as to why the eponymous
hero of the *Song of Roland* throws down his glove at the moment of
his death unless you know about feudal hierarchy—as he lies dying,
Roland is showing his vassalage to God, demonstrating that his alle-
giance to his lord is total.

 With photographs, the glue is not only cultural and contextual,
it is above all ideological. How we see is always shaped by ideology,
as Althusser has argued, which is what determines our status as
subject: "Individuals are always-already interpellated by ideology
as subjects."[14] To be a subject, moreover, is inherently contradic-
tory, since it is both to be free and responsible for one's actions, and
at the same time to be a "subjected being, who submits to a higher
authority, and is therefore stripped of all freedom except that of
freely accepting his submission." (182) For Althusser, what ideology
mystifies is not the reality of existence, but our relation to the other
subjects in a given social apparatus, thus ensuring the reproduction
(and continuation) of the same ideology. In other words, we cannot
really *see* photographs, for example, as objective products of mate-
rial reality, but rather view them through the filter of whatever reign-
ing state apparatus has educated and thus constructed our gaze. If
we follow this line of thought, then Benjamin's search for "the tiny
spark of contingency, of the here and now, with which reality has
(so to speak) seared the subject" would be, from Althusser's point of

14 Louis Althusser, "Ideology and Ideological State Apparatuses (Notes to-
wards an Investigation)," in *Lenin and Philosophy and Other Essays*, trans. Ben
Brewster (New York: Monthly Review Press, 1971), 176.

view, always-already partially predetermined. Althusser's ideology, then, is not unlike Benjamin's space informed by the unconscious.

Around the same time as Althusser's seminal essay on ideology, Stanley Cavell was to write something quite different about seeing and the subject: "So far as photography satisfied a wish, it satisfied a wish not confined to painters, but the human wish, intensifying since the Reformation, to escape subjectivity and metaphysical isolation.... Photography overcame subjectivity in a way undreamed of by painting, one which does not so much defeat the act of painting as escape it altogether: by *automatism*, by removing the human agent from the act of reproduction."[15] To which Joel Snyder and Neil Walsh Allen, after citing this Cavell quote, responded: "Photographs are not simply different from other kinds of pictorial representation in certain detailed respects; on the contrary, photographs are not really representations at all. They are the practical realization of the general artistic ideals of objectivity and detachment."[16] Further contra Cavell, argue Snyder and Allen, a photograph evinces no clear-cut break with older traditions of representation, and is as subjective as any artistic product, like a painting. Yet again conversely, André Bazin, in his famous essay of 1967, writes of the essentially objective character of photography: "All the arts are based on the presence of man, only photography derives an advantage from his absence."[17] These two points of view—on the one hand, that photography is mechanical and thus produces objective images, and on the other, that it is just as subjective as a painting—have been disputing each other for decades.

The advent of digital photography has further muddied the theory waters. Mary Ann Doane writes, in 2007, "The challenge of dig-

15 Stanley Cavell, *The World Viewed* (New York: Viking, 1979), 21, 23.
16 Joel Snyder and Neil Walsh Allen, "Photography, Vision, and Representation," *Critical Inquiry* 2, no.1 (Autumn 1975): 143–69, at 145.
17 André Bazin, "The Ontology of the Photographic Image," in *Classic Essays on Photography*, ed. Alan Trachtenberg (New Haven, CT: Leete's Island, 1980), 241.

ital media . . . is that of resisting not only a pervasive commodification of the virtual but also the digital's subsumption within the dream of dematerialization and the timelessness of information, returning history to representation and reviving the idea of a medium. Making it matter once more."[18] What exactly does this mean, quite apart from its rather recondite syntax? It is saying, I think, that despite the thrill of the virtual and the "timelessness" of information in the Internet age, photography needs to reclaim itself as a practice from within a medium, as an aspect of representation, thus returning to photography the status of representing history. It also seems to be an echo of Siegfried Kracauer's much earlier essay, "Photography." His study rests, writes Kracauer, "upon the assumption that each medium has a specific nature which invites certain kinds of communications while obstructing others."[19] Bridging that divide somewhat is John Berger's essay of 1974. "A photograph is effective," he claims, "when the chosen moment which it records contains a quantum of truth which is generally applicable, which is as revealing about what is absent from the photograph as about what is present in it."[20] On the other hand, and further complicating things, for Berger, a "photograph, whilst recording what has been seen, always and by its nature refers to what is not seen." And then, echoing Benjamin, Berger adds that the photograph "isolates, preserves and presents a moment taken from a continuum." (293)

Perhaps things can be somewhat simplified by saying that though photography does necessarily present a subjective view of things, we nonetheless scrutinize the photograph for fleeting glimpses into a past event, moment, or detail that go beyond a given photographer's perspective and beyond the materiality of a given photograph. "In

18 Mary Ann Doane, "The Indexical and the Concept of Medium Specificity," *differences* 18 no. 1 (2007): 148.

19 Siegfried Kracauer, "Photography," in *Classic Essays on Photography*, ed. Trachtenberg, 245.

20 John Berger, "Understanding a Photograph," *Classic Essays on Photography*, ed. Trachtenberg, 294.

the end," writes Bernd Stiegler, "photography plumbs the conditions and limits of our understanding of reality. Photography thus has both a conservative and an iconoclastic tendency: It can confirm concepts or call them into question; it can affirm the existing, autonomous rules or explore other forms of the visible."[21]

One such form of the visible is Benjamin's scrutiny of a photograph in the hopes, not only to find the tiny spark of contingency, but also, to repeat his words, "to find the inconspicuous spot where in the immediacy of that long-forgotten moment the future nests so eloquently that we, looking back, may rediscover it."[22] Such an effort at hindsight has been done before, it will be recalled, in the writings of Thucydides and Speer (a thoroughly unlikely pair!), and also in Baudelaire and Gandy. But photography, let us admit, engages (even if wrongly, subjectively, inconclusively) the question of time—much more than painting. "The most precise technology," writes Benjamin, "can give its products a magical value, such as a painted picture can never have again for us." (510) Perhaps this magical value is a belief (or the illusion) that time has been made to stand still, so that in scrutinizing the image, we can see the future already nesting there, and thus unveil the inevitability of ourselves in the present. This is for Barthes the metaphysical aspect of the photograph: "Why is it that I am alive *here and now?*"[23]

For it is the case that when we look at figs. 1 and 2, photographs from 1945, we are looking back at a long-lost moment from a future perspective that attempts, retrospectively, to find in those images the inevitability of now. And this is the case, even if, as in these two photographs, the people in them are unimportant or unknown. In any case, in these images, the subject matter is meant to be the ruins,

21 Stiegler, "Photography as the Medium," 194–97.
22 Benjamin, "Little History of Photography," 510.
23 Barthes, *Camera Lucida*, 84.

even if our gaze goes first to the two men. They are, moreover, added events here; useful to look at when the gaze seeks to be averted (and diverted) from the destruction that lies all around. If the photographs are asking *why* and *in what way* the two men are viewing the ruins, the triangulation of ruins, two men, and photographer seems to insist on an ironic commentary on the discrepancy between the well-dressed men and the devastation they are viewing. So that in scrutinizing these photos, we are both engaging time (how close is it to us, what it might teach us about the past—Germany after the surrender of 1945, the extent to which our future and thus we ourselves are already nested there, and so on), and various gazes that produce a willed irony that seems to be making some sort of political comment. There is time, too, in the lapse between the first and second photographs, almost like a movie clip with some frames missing. That lapse makes the imposition of a narrative almost inevitable. Time is further underscored by the fact that the photographs are in black and white, that the men's clothing is dated, and so on.

Despite all the sophistication of photograph theory, its denials and assertions, we are still left with the sense that all of this is to do with the gaze and with time, and thus with death. That's what Benjamin is contemplating when he looks at the second Mrs. Dauthendey and thinks she will commit suicide in her future; that's what Barthes is trying to grasp when he looks at a condemned prisoner ("He is dead and he is going to die . . ."[24]). And, of course, the photographs of the past always lead to the realization that the people in them are most likely all dead. For Barthes, the photograph's essence is to ratify what it represents—unlike writing, he adds, because language is not able to authenticate itself. But what of photographs that have no people in them, no gaze (apart from that of the photographer)? Do we then restructure our gaze?

24 Barthes, *Camera Lucida*, 95.

Seeing the Dead

Goebbels and his fellow party members are down in the safest bunkers of all, governing from beneath the ruins.

A FOREIGN REPORTER in Berlin

The living are not to be trusted.

JOEL AGEE, interpreting Hans Erich Nossack

On the back of a photograph (fig. 3) is written, in pencil, "Berlin, May 1945." It is, of course, impossible for us to view this image in the same way as the Berlin population must have done at the time. But we can consider what *we* see. Metaphors abound to describe the site: the gaping holes that were once windows stare out ominously, like so many skulls piled up together. The jutting and twisted steel beams, cluttered by heaps of rubble, rise like arms begging for help. We can assume that the cleaning up initiatives have not yet occurred. Or perhaps all of this rubble has in fact already been shoveled off the street to allow for the military vehicles to circulate, but we cannot see the street. Inside the ruins themselves, we can see traces of staircases that have been ripped off by the blast, and charred walls. Behind these shattered structures, other houses can be partially seen; they appear to be in somewhat better shape, though there seem to be no window panes. It is, apparently, a primarily residential area.

The reader will have noticed that a good deal of this description anthropomorphizes these ruins, as if the absence of people necessitated applying human characteristics to the fragmented edifices in an effort to understand them, to capture what is often referred to as their empty gaze, to take it all in with our own gaze(s). "Ruins," writes Sollors, "seem hauntingly anthropomorphic (ribs, wounds, eyes, vomiting)."[25] I have somewhat willfully engaged here in famil-

25 Sollors, *Temptation of Despair*, 103.

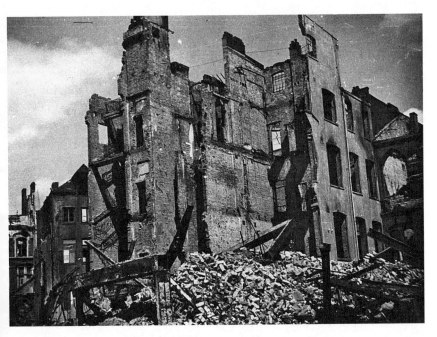

Fig. 3.

iar ruin descriptions—of ruins of modern war, and not of antiquity.[26]
For the ruins we have here are the result of war technology, and not
of time's erosion or of nature's return to dominate what had once
been a city. This, let us say, is a raw ruin—created in several min-
utes by airplanes, far above their targets, and continued by delayed
bombs and fires.

26 For one example among many, the writer Konrad Warner on the bombing
of Berlin: "We can see the remains of the walls in aerial photographs. Black and
dead, they stare up like the empty sockets of a mutilated corpse." Lubrich, ed.,
Travels in the Reich, 299. Or Stig Dagerman, describing ruined Hamburg as "a
vast dumping-ground for shattered gables, free-standing house walls whose
empty window-holes are like wide-open eyes staring down on the train ..." (*Ger-
man Autumn*, 20).

Moreover, it is not really the case that there are no people here—they are simply invisible, buried under the rubble. Most Berliners, during air raids, took shelter in the cellars, hoping to escape being crushed under collapsing buildings. Many died in those cellars, either trapped by fallen debris or asphyxiated by the fires that raged after the air raids.[27] Berlin was bombed by the Allies for four years, and by means of forty-five thousand tons of bombs. The casualties were less than in other cities, however, because the city was so spread out. Nonetheless, thousands of people perished, many buried alive or victims of the fires that quickly spread. Hundreds of thousands more were homeless, wounded, dazed. Though prisoners of war and the general populace tried to dig out survivors, many were left to die, if they hadn't already, under the buildings. "When there is a direct hit," writes the Norwegian reporter Theo Findahl, "you can imagine what a mountain of debris a five-story building creates. The people lie within the mountain; some were never found. Russian prisoners of war carefully cleared away one stone after another and they were getting nowhere. Down in the cellar the people were banging and not a single one of them could be rescued."[28] Thus fig. 3 is not without people; they are trapped under the mountain of debris. Among other things, this photograph provides the image of an invisible cemetery.

Does knowing that the rubble and the broken buildings are undergirded by dead bodies change our view of the photograph? I think, for many viewers, it does. The rubble, which otherwise looked like a straightforward pile of rocks and debris, begins to take on a kind of intensity or sinister aspect when we know that it is covering hun-

27 Jörg Friedrich writes that three-fourths of the Berlin population (about 4 million at the time) took to cellars during the bombings; many of the rest were allowed the highly prized bunkers. See *The Fire: The Bombing of Germany 1940–1945*, trans. Allison Brown, (New York: Columbia University Press, 2006), 354. My statistics are taken from Friedrich, with corrections when necessary (or possible).

28 Cited in Friedrich, *The Fire*, 320.

dreds of corpses. Dominick LaCapra has argued that when a historian goes about explaining a trauma, the explanation itself will be determined by the specific subject position of that historian. A photographer is such a historian only in part, because the images are frequently less overtly readable than is a historian's written text. Nonetheless, the particular subject position of the photographer, his or her relation to a given trauma, and thus what Eric Santner calls "the transferential dynamic," will help dictate the frame of the photograph. So, too, the transferential dynamic of the viewer to the event will construct a particular gaze on the photograph.

How you now see fig. 3 will depend, among other aspects, upon your perspective, your politics, your historical views, your age, gender, the time elapsed between now and the scene photographed, your knowledge of the events and, to repeat, the nature of your relation to them. A German viewer may respond, let us begin by agreeing, differently from a French one, say. The photographer is still the same—an amateur, French woman. Is she exultant in this example of what had contributed to the very recent Allied victory? Or, as a reporter would, is she showing the horrors of the war machines? Or perhaps both, which would align with the contradictory feelings of the photographer, discussed in the introduction? Fig. 3 takes on as well a certain tension that we had already sensed in figs. 1 and 2, the first two we considered, of the two men. The same holds true for the viewer assessing fig. 3; horror and mourning, for example, or a certain unspoken (or unacknowledged?) gratification or appeasement, and everything in between.

All of which brings us, inevitably, to the question of blame—or revenge. Susan Neiman writes that "Auschwitz stood for moral evil as other crimes did not because it seemed deliberate as others did not."[29] Neiman argues that how we judge evil is determined as a

29 Susan Neiman, *Evil in Modern Thought: An Alternative History of Philosophy* (Princeton, NJ: Princeton University Press, 2002), 270.

matter of intention: "Where evil intention is absent, we may hold agents liable for the wrongs they inflict, but we view them as matters of criminal negligence. Alternatively, anyone who denies that criminal intention is present in a particular action is thought to exonerate the criminal." (271) This was precisely the source of anger produced by Hannah Arendt's *Eichmann in Jerusalem*; the assumption that guilt "requires malice and forethought," and that by denying these in Eichmann, Arendt was absolving him of responsibility (she was not, as Neiman, among others—not to mention Arendt herself—made very clear). But if we return to Neiman's point that moral evil is at its height (Auschwitz) when the crime is deliberate, we are entering very problematic waters with respect to Allied bombing—for the bombing of German civilians during the Second World War was nothing if not deliberate.

The bombing of Germany between 1942 and 1945 was in great part the result of Churchill's desire for revenge—"We need," Churchill had declared in 1941, "to make the enemy burn and bleed in any way." This was contrary to what he had declared in 1917 during the First World War: "It is improbable," Churchill said then, "that any terrorization of the civil population which can be achieved by air attack could compel the government of a nation to surrender. Air offensives should consistently be directed at military and communication centres." But with the Second World War, Britain had lived through Dunkirk, the Blitzkrieg, and the Battle of Britain (1940). Revenge was certainly the order of the day, as was an initial belief in "morale bombing." Lord Cherwell, a physicist who was Churchill's key advisor and trusted friend, told the British government in 1942 that bombing civilians out of house and home "would break the spirit of the people."[30] Churchill was not, of course, alone in his de-

30 Cherwell was born Frederick A. Lindemann and (with the exception of one occasion) enjoyed Churchill's complete confidence and close friendship

sire for revenge. "After the ghastly suffering that Germany had inflicted upon the world," wrote Cherwell's biographer, "and the savage assaults on British cities, [Cherwell] shared the intense desire felt by millions of others for that country to feel the severity of war on her own soil." (245)

Thus the destruction of Dresden, for example, in February of 1945, was (as we know) for reasons of sheer retribution. That medieval town, famous for its beauty, had no reason to be annihilated from the point of view of military strategy; the war was in any case essentially won. Similarly, the unremarkable town of Halberstadt was bombed in April of 1945, only because the American bomber squadrons were told that their initial targets were under cloud cover and thus impossible to attack. Apparently, it was too late to turn back, so two hundred bombers were sent to Halberstadt. Even though the Allies had decided in the last year of the war to bomb strategic targets (railways, bridges, roads, munitions factories) rather than to do "morale bombing," Halberstadt was bombed anyway. Alexander Kluge's book, *The Air Raid*, is an eyewitness account of the devastation that ensued; his terse and minimalist account produces a matter-of-fact prose that brings his anger and despair all the more to the fore.

As W. G. Sebald notes, in his afterword to Kluge's book on the bombing of the town, in an equally restrained manner:

It is presumably indisputable today that the strategy pursued by the Allied air forces, of the area bombing of as many German towns and cities as possible, was unjustifiable in terms of military purpose. In that case—as Kluge's text shows—the destruction, the horrifying devasta-

throughout the war. See Cherwell's biography, by the Earl of Birkenhead, *The Prof in Two Worlds: The Official Life of Professor F.A. Lindemann, Viscount Cherwell* (London: Collins, 1961).

tion, of a middling town, quite insignificant strategically or as a centre of arms production, must make the dynamic of the factors determining technological warfare appear questionable in the highest degree. (127)

The bombing of these two strategically unimportant towns, and of others like them, was justified by the Allies as "morale bombing"—that is, (to repeat) following Churchill, Sir Arthur Harris, and Lord Cherwell, the notion that the German civilian population had to be targeted in order to demoralize the German people, and thus (still according to this theory) force the German government to surrender. Morale bombing was an idea generally attributed to "Bomber" Harris. Sir Arthur Harris was chosen by Churchill to be the Royal Air Force chief of the Bomber Command. Armed with his "morale bombing" theory, "Bomber" Harris "killed thousands of civilians using blanket bombing, with the resulting firestorms." Churchill himself had reservations about the effects of bombing. In an October letter to the Chief of the Air Staff, Churchill cautions, "Even if all the towns of Germany were rendered largely uninhabitable, it does not follow that the military control would be weakened or even that war industry could not be carried on."[31] He worried, he said, that even if German morale cracked because of the bombings, it was "quite possible that the Nazi war-making power in 1943 will be so widely spread throughout Europe as to be to a large extent independent of the actual buildings in the homeland." (508) As we will see, Churchill was prescient.

There were other misgivings: Sebald notes that Lord Salisbury and George Bell, Bishop of Chichester, "repeatedly and very forcefully express the opinion, both in the House of Lords and to the general public, that an attacking strategy directed primarily against the

31 Winston Churchill, *The Second World War*, vol. 3, *The Grand Alliance* (Boston: Houghton Mifflin, 1950), 508.

civilian population could not be defended morally or by the laws of war."[32] Harris himself, however, had no such scruples, even in hindsight. In his autobiography (1947), he argues that morale bombing was both "a counsel of despair, based on the previous failure of night bombing" and "an unbounded optimism, not, indeed, about the strategic effects of a bombing offensive, but about what could be achieved at this moment."[33] In a 1977 interview, Harris somewhat defiantly declared, "If I had to have the same time again, I would do the same again, but I hope I wouldn't have to."[34]

Kluge relates that a senior staff officer, Brigadier General William B. Roberts, was on the Halberstadt-bound plane as an observer on April 8, 1945. Also on the plane was a journalist from the Swiss newspaper the *Neue Zürcher Zeitung*. The journalist asks Roberts why he seems to be preparing to bomb the town of Halberstadt, rather than industrial plants or other such targets. "I'm sorry," Roberts responds, "It'll be morale bombing. I would have liked to show you a daytime attack on an industrial target." The journalist asks, with some bitter irony, "Do you bomb for moral reasons or do you bomb for morale?" "We bomb morale," answers Roberts. "The spirit of resistance must be removed from the given population by the destruction of the town." The journalist says that he thought that

32 Sebald, *On the Natural History of Destruction*, 14–15.
33 Sir Arthur Harris, Marshal of the R. A. F., *Bomber Offensive* (Toronto: Stoddart, 1990), 76.
34 http://www.dailymail.co.uk/news/article-2276944/I-destroyed-Dresden -Bomber-Harris-unrepentant-German-city-raids-30-years-end-World-War -Two.html. In 1992, a statue of "Bomber" Harris was erected in London. The statue caused a great deal of controversy and vandalism, and had to be kept under twenty-four-hour guard for several months. Though Harris is reputed to have helped end the war with his bombing policies (although there is no evidence for this), he is also held responsible for the deaths of thousands of civilians, and a very large number of his own men—over fifty thousand.

doctrine (of morale bombing) had been abandoned. Roberts's response is astonishing: "Sure. That's why I'm a bit surprised myself. You can't hit this morale with bombs. Morale is evidently not situated in the heads or here (*points to the solar plexus*), but is to be found somewhere between the persons or populations of the various towns. That's been researched and is well known at staff headquarters."[35]

Morale is left untouched after a bombing, says Roberts, but only because "those people who are smashed to pieces don't think or feel anything," not because they have reserves of strength or a firm belief in the Reich (especially in 1945). Rather, as Roberts makes clear, the population is beset by the kind of amnesia that sets in from the shock: "And those who, despite all the measures taken, escape the attack evidently don't bear the impressions of the disaster with them. They take all kinds of baggage with them, but it seems they leave the impressions of the moments of the attack behind." Roberts adds that at first morale seems to be sapped, but the next day "a couple of miles from the burnt-down town daily routine evidently continues." (58–59) Thus, explains Roberts, the people who survive the bombing leave the devastation with their "baggage," but with no memory ("impression") of the moment of the attack and return almost immediately to everyday life elsewhere. This is, needless to say, both true and false: true that the trauma tends to erase immediate memory; false that no "impression" is left of the attack, given the death tolls, loss of homes and belongings, lack of food and water, and certainly difficulty in achieving those "couple of miles" to a place where daily routine "evidently continues." Only a bomber, who views the destruction from above, could so easily confuse the effects of trauma with a rapid return to daily routine.

Hamburg, one might argue, was a different business, since the town was industrial and produced war machines. Hamburg had

35 Kluge, *Air Raid*, 58–59.

been targeted earlier by Harris, but again the weather was bad, and so Cologne was bombed instead (May 30, 1942).[36] By the time Hamburg was bombed in February of 1943, the Allies had ascertained that firebombing worked better than target bombing. The firestorms created by the bombing produced a kind of hurricane, sucking up oxygen and killing all the civilians in its proximity. Both Dresden and Hamburg experienced such firestorms, killing vast numbers of the population. A German secret document on the bombing of Hamburg reports that burning timbers and roof beams spread the fires farther and farther, "developing in a short time into a fire typhoon such as was never before witnessed, against which every human resistance was quite useless."[37] Firemen had difficulty putting out fires, since so many of the water mains had been burst.

The writer Konrad Warner was in Berlin during one of the bombings of that city. In his description of the firestorms that resulted from the bombs there, Warner uses an intense prose that attempts to convey such a disaster, although most survivors reported that it was impossible to understand the destruction unless one had actually witnessed it. With an abundance of powerful adjectives and a generally intense vocabulary, far from the minimalist style we considered earlier, Warner attempts to convey the horror to his readers.

36 After the bombing of Cologne, when the citizens crawled out of bunkers and cellars, they discovered the usual carnage and destruction—90 percent of the city had been flattened. The cathedral, however, remained almost untouched, towering among the ruins. *The New York Times* (June 2, 1992) noted that morale had been lifted, not lowered, by the sight of the cathedral: "This miraculous sight strengthened the people's morale and determination through the rest of the war, as the Allies continued to pound an already flattened city long after any real targets remained. . . . Within two weeks of the May 30 bombardment, life in Cologne was functioning almost normally." http://www.nytimes.com/1992/06/02/opinion/02iht-edma.html
37 Harris, *Bomber Offensive*, 174.

It is as if Warner believed that such a catalog of words could some-
how reproduce the event:

The fire storm gradually assumed unbelievable proportions.... The fire
roared, it boomed and howled, it crashed, crackled, exploded and im-
ploded, arching itself, in great billows, out of windows, doors and col-
lapsed walls. A black vault loomed over the sea of flames, as if embrac-
ing all the horrors in the world.[38]

Warner, like a modern Thucydides, writes that the bombing of
Berlin is a "catastrophe of historic proportions. It will be spoken
of for centuries to come. And who knows what this ruined city will
symbolize? We can see signs of collapse, but we cannot yet interpret
them." (299) But whereas Thucydides worried that future genera-
tions would fail to gauge the power of Athens if only the ruins were
considered, Warner wonders what symbolism the future will see in
a ruined Berlin. The present generation, he claims, cannot yet inter-
pret those ruins. For Warner, distance is necessary for comprehen-
sion of the event, and for its symbolic status in the history books to
come.

Harris and his bomber squads were the only military units that
were not given medals at the end of the war, as if a certain malaise
had crept in with the public's knowledge of the civilian death toll
from bombings.[39] Harris, however, remained convinced that he had
done the right thing. "In spite of all that happened at Hamburg," he
writes in his memoirs (1947), "bombing proved a comparatively hu-
mane method. For one thing, it saved the flower of the youth of this
country and of our allies from being mown down by the military in

38 Lubrich, ed., *Travels in the Reich*, 298.
39 Harris bitterly complained about this. "Every clerk, butcher or baker in the
rear of the armies overseas had a 'campaign' medal," he fumes, but not those in
Bomber Command. *Bomber Offensive*, 267–68.

the field, as it was in Flanders in the war of 1914–1918." He writes
that many people think bombing is "specially wicked" because it
targets civilians, and defends himself by noting that "all wars have
caused casualties among civilians." (176) Moreover, continues Har-
ris, he never forgets, "as so many do," that in "all normal warfare
of the past, and of the not distant past, it was the common practice
to besiege cities." If those cities refused to surrender, "every living
thing in them was in the end put to the sword." And "even in the
more civilised times of today," bombing a city "is still a normal prac-
tice." (177) This, then, is Harris's justification for killing somewhere
between 305,000 and 600,000 civilian Germans: it is a normal
practice of war and has saved the flower of English youth from dy-
ing in battle. There is, however, the unfortunate fact that over fifty-
five thousand young men in the bomber squads were killed in action
or in the assemblage of the bombs themselves (deaths for the latter
include women who worked in bomb assemblage).

Though Harris believed to the end that his bombing had short-
ened the duration of the war, this is far from an established fact, par-
ticularly since Hitler himself prolonged the war by refusing to surren-
der.[40] Moreover, during the years of "morale bombing," Germany
continued to produce a vast amount of armaments, war machinery,

40 For a full account of Hitler's insistence on continuing the war a good year af-
ter it was essentially over, and his refusal of an unconditional surrender, see Ian
Kershaw's magnificent *The End: The Defiance and Destruction of Hitler's Germany,
1944–1945* (New York: Penguin, 2011). Kershaw adds, it should be noted, that
while the Allies' demand for an unconditional surrender was a factor in prolong-
ing the war, "it cannot be regarded as the decisive or dominant issue compelling
the Germans to fight on." (387) For a full account of other factors—Kershaw gives
at least thirteen—that led Germany to continue fighting, see his final chapter,
"Conclusion: Anatomy of Self-Destruction" (386–400). Winston Churchill wrote
that though some thought the phrase "unconditional surrender" prolonged the
war, he himself did not agree with this. Winston Churchill, *The Second World War*,
vol. 4, *The Hinge of Fate* (Boston: Houghton Mifflin, 1950), 684.

and tanks—largely due to the incredible resourcefulness of Albert Speer, minister of armaments and war production (the mastermind of the theory of "ruin value," it will be recalled). It was not till the last year of the war that the Allies decided to bomb mainly strategic targets. Once the major thoroughfares were destroyed, German armaments and tanks were ready but unable to be moved. At the same time, however, Kershaw argues that for the German people as well as for those who were the victims of the Nazis, "the intensified terror alongside the terrible suffering could not end until the regime itself was destroyed by military might." (391) Whether this fact provides a need for bombing and killing more than half a million civilians is another question.

Kershaw writes, and produces his own statistics on the death toll:

For Germany itself—leaving aside the untold misery and suffering and vast numbers of war casualties suffered by the citizens of other countries—a colossal price was paid for continuing the war to the bitter end. In the ten months between July 1944 and May 1945 far more German civilians died than in the previous years of the war, mostly through air raids and in the calamitous conditions in the eastern regions after January 1945. In all, more than 400,000 were killed and 800,000 injured by Allied bombing, which had destroyed more than 1.8 million homes and forced the evacuation of almost 5 million people, the vast majority of the devastation being inflicted in the last months of the war. (379)

In a footnote, Kershaw writes that the 1976 *United States Strategic Bombing Survey* puts the death toll at 305,000, which "has been shown to be too low." He says that estimates go as high as 635,000, adding, "Establishing reliable figures for the number of deaths of refugees fleeing in the last months of the war is extraordinarily difficult." (505–6)

The Nazis, too, had difficulty counting the dead, hampered by the usual confusion, the buried corpses, and the generally forcefully optimistic (and dishonest, needless to say) propaganda. Nossack

complains that by constantly changing the death toll from the bomb-
ing of Hamburg, the Nazi regime was trying "to lie to the dead."
"Why don't they say," he asks, "We can't count them! That would
be a simple statement such as the dead, too, could understand."[41]
He adds that, in any case, the "convicts in striped suits" (prisoners
of war) who were supposed to recover the dead could not because
the corpses "were burned on the spot or destroyed in the cellars
with flamethrowers." Equally horrible were the huge quantities of
flies and maggots, making access to the cellars next to impossible.
Flames had to be used to reach "those who had perished in flames."
(44) Sebald remarks that the violent destruction contrived by man-
kind explains why the speaking and thinking machines in Stanislaw
Lems's *Imaginary Magnitude* "ask themselves whether humans can
really think at all or whether they merely simulate this activity from
which they derive their self-image."[42]

Dagerman had noted that the Germans of the war's end could not
be regarded as "one solid block, irradiating Nazi chill, but as a mul-
titude of starving and fleeing individuals."[43] Dagerman, as we have
noted, is known for his empathic description of the catastrophic
state of German towns after the bombings. Mark Kurlansky, in his
foreword to Dagerman's *German Autumn*, notes that the Swedish
journalist had a sharp eye for concrete details, "partly because he
could argue pungently, but mainly because he dared to see German
individuals as suffering human beings rather than simply as tokens

41 Nossack, *The End*, 43.
42 Cited by W. G. Sebald, in "Between History and Natural History: On the Lit-
erary Description of Total Destruction. Remarks on Kluge," a six-paged excerpt
from Sebald's *Campo Santo*, serving as an afterword to Kluge's *Air Raid* (131).
Stanislaw Lem, *Imaginary Magnitude*, trans. Marc E. Heine (San Diego: Har-
court Brace Jovanovich, 1984), 74.
43 Dagerman, *German Autumn*, 13.

of national disgrace or guilt." (2) Collective guilt, argues Dagerman, is too easy for the victors; and the suffering of the German civilian population in the bombed-out ruins, while it may satisfy or at least offer a modicum of justice to those who suffered under the Nazi regime, remains an ethical question. Dagerman, says Kurlansky, had contempt "for the naïve and cruel notion that the German people as a whole 'deserve' their suffering." Dagerman wonders if deserved suffering feels any different from undeserved suffering. He interviews death camp survivors, Nazis, and ordinary people sitting on the charred ruins of their homes. He gives us no answers but is staunch in his conviction that collective guilt is unacceptable. His ethical stance, then, is to show empathy for all suffering. For what is, ethically and precisely, *deserved* suffering?

But empathy, as Talal Asad notes, is not "simply a mode of generosity for the other." It can also be "a condition of insinuating oneself into and manipulating social and psychological structures to one's own advantage."[44] In other words, it is easy to feel empathy when one is in "a safe place," to recall Burke and Kant on the sublime, and when one wants to feel that civilian deaths are warranted by the greater evil of the Nazi regime (Harris's perspective, for example). Such "empathy" might be seen as a type of post hoc ergo propter hoc: a way of establishing your humanity, in the face of a lack thereof, in which you are implicated (if only indirectly, by literal or mental collaboration). Let us explore this fallacy by considering another photograph (fig. 4).

A couple walks down the street in Germany; it is the spring of 1945. The street has been completely cleared and cleaned, and a military convoy has driven by, unobstructed. The couple seems unaware of the photographer; the man is barely visible (we can see the profile of his face), blocked by the young woman walking with him. She is somewhat out of focus (the camera is focused on the ruins),

44 Talal Asad, "Reflections on Violence, Law, and Humanitarianism," in *Critical Inquiry* 41 (Winter 2015): 406.

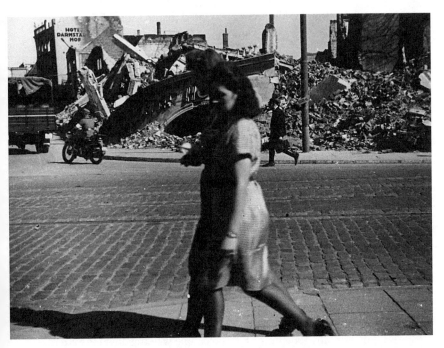

Fig. 4.

but seems to be averting her eyes from the pile of ruins to her right. The man is looking straight ahead, also apparently avoiding the rubble. In the background, on the opposite side of the road, another man is hurrying off somewhere, carrying a briefcase. Were it not for the ruins, one might consider this an ordinary scene. The woman's wristwatch, prominent on her left arm, could be read here as "time has started again."

The Hotel Darmstädter Hof, in the upper left, has been destroyed, and some of its large lettering obliterated. In the background is a mountain of debris that, as Findahl had put it, is no doubt covering over a good many corpses. Is this couple German? Then is it surprising that they are so well dressed (the woman, for example, seems to be wearing nylons—somewhat of a luxury at the time)? Why is the

woman healthy-looking, not emaciated like the rest of the population? Is she foreign? She does not look American. And why is the man carrying the briefcase wearing such a nice, dark suit? Is he perhaps a foreign journalist? What if he's a German businessman, hurrying along and unperturbed by the disaster to his immediate right? But we have learned from the photograph of the young boy at Bergen-Belsen not to make these assumptions.

There are, however, what we might call instinctive parameters of response. If I know that the woman in the foreground is German, and if I am a Nazi survivor, or from one of the Nazi occupied countries, or Jewish, or again part of the Allies, I will not see this woman as I will if I know she is not German, and not an ex-Nazi. If I know the photographer is French (which we know is the case), I will not respond to this photograph as I might if I were told the photographer is German. A Londoner who lived through the Blitz will not see this image as would, say, a Berliner trying to put his/her life back together at the end of the war. And so on. Moreover, I am likely to feel less empathy in viewing this photograph in 1945 than I might feel today.

But empathy for whom? For the couple walking down the street? For the businessman? Not likely. If I look carefully at the ruins, I see long shards of buildings rising up in the midst of the debris. Empathy for the corpses that lie underneath that pile of rubble? Or perhaps at least for the children who were buried alive (sixty thousand children were killed in the air raids)? The trouble with empathy is that it can be a self-serving way of feeling that one is a good person, covering over an unacknowledged satisfaction in knowing that a horrific revenge has been inflicted (by the victor). Or it can be a way of justifying the horrors visited upon innumerable victims by the Nazi regime, by demonstrating the extent of the German civilian disaster (on the vanquished). If I then think about the German bombings of Guernica, London, and Coventry (to mention the most obvious), am I then filled with righteous indignation? Asad has a point about the self-serving possibilities of empathy under these circumstances.

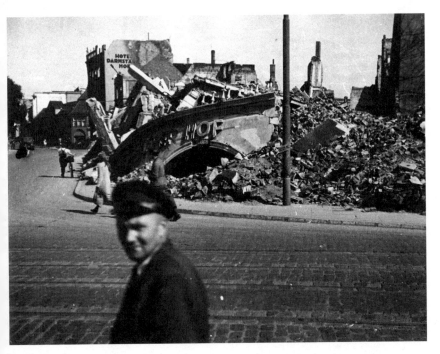

Fig. 5.

Fig. 4, it turns out, appears to allow for the construction of a narrative of sorts, since there are three more photos of the same scene. Fig. 5 gives a better sense of the destroyed hotel, because there is nothing blocking the view. The ruins are again in focus, with the (streetcar conductor, or postman?) fuzzily walking by and looking with bemused interest directly at the camera. He seems to think that he's the subject of the photograph. His smile and uniform are in direct contrast to the devastated hotel. There is no military convoy here, and only a few people can be seen on the street, which looks fairly deserted. Everything still standing looks off balance: the telephone pole, the towers tilting in the distance, the part of the hotel still upright.

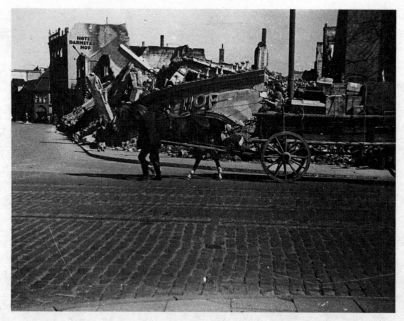

Fig. 6.

The next photograph (fig. 6) seems to have been taken at about the same time as fig. 5, since, again, there is no sign of the military convoy. Instead of the couple in fig. 4 or the smiling man in uniform in fig. 5, we have an older man with a horse and cart. He is hauling what seem to be his belongings past the same ruins and the same demolished Hotel Darmstädter Hof. A young woman is sitting on the cart, holding the reins in her hands. These are, it would appear, refugees. Are they fleeing the dreaded Red Army? Relocating after extracting what was left of their belongings from the ruins? Another woman can be discerned walking on the same side of the partially cleared sidewalk. She is holding her hands up near her waist, but it is impossible to see what she's doing. A huge fragment of the building teeters ominously behind her, but she is not perturbed. Notice that my description, too (like Barthes's and Benjamin's musings, and like my discussion of figs. 1 and 2), goes immediately to the people in the

photographs, to their gazes averted from the photographer (and the ruins), or, on the contrary, to looking straight on at the camera. It is tempting to imagine who they are and what they might be thinking. They surely all have different goals in their walk along the street; the ruins, on the other hand, do not change. Are we, like the pedestrians, already used to seeing them? And so do we turn our gaze to the people in the photographs, leaving—like these people—the ruins aside?

Fig. 7 puts the viewer in the same place, at the same curve in the road. It is shot from a slightly different angle—the photographer has changed positions. Another convoy is passing (a car, followed by a jeep, and then a motorcycle)—this time going in the opposite direction. We know that it is an American convoy, because of the markings on the car (a star), and the model of the jeep. The destruction of the Darmstädter Hotel is equally obvious. There are no visible pedestrians in this image, as if the American Army were invading a ghost town of its own creation. Is this photograph taken before or

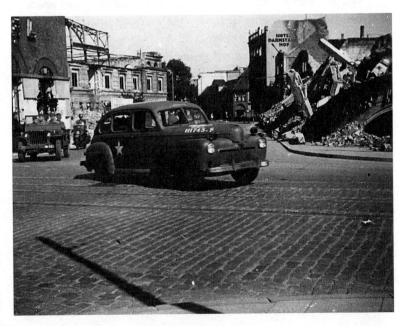

Fig. 7.

after the other three? We scrutinize the faces of the soldiers, quite blurred, perhaps not as much as we did the pedestrians, as if these military men were less interesting because their purpose is evident: they are the occupying force, driving through Darmstadt.

In all four photographs, the viewer is struck by how clean the streets have become. And one can recognize the lines in the cobblestoned pavement for what must have been a streetcar route. We note again that the rubble has been carefully stacked up, creating a simultaneous sense of neatness within the demolished remnants of the hotel. Rubble can be barely discerned (behind the motorcycle); it is too well "organized." A shadow juts out on the cobblestones, at the bottom of the image. Is it a streetlight or telephone pole, knocked down or at least bent by the blast(s)? Or is it a beam from another ruin across the street from the hotel; a ruin we cannot see? Lined by devastation, the street on which the convoy drives is shockingly well cleared. The American Army rolls by, unimpeded by any debris. Here, in contrast to fig. 6, the convoy is not slowed down by pedestrians. The soldiers are able to view the wreckage from the relative comfort of a car, jeep, and motorcycle. As viewers of the photograph, we spectate their spectatorial position. What are the Americans thinking, feeling, seeing? What about the photographer herself? She has almost foregrounded the Americans, with the ruins surrounding them slightly more in focus. The juxtaposition of these two aspects— the convoy and the ruins—could be read as a visual in-your-face, underlining the Allied triumph.

The four photographs were taken in Darmstadt, which was bombed in 1943 and 1944. The worst of the bombings was in September of 1944, when 226 Lancaster bombers and fourteen Mosquitoes destroyed almost all of the homes and caused a firestorm. At least 12,300 people died in what the Germans called "terror bombing." Darmstadt was also a town with few industrial targets; it was mainly a university center that had, once again, little strategic importance. In the photographs, then, it has been at least eight months

since the bombings, which explains the cleanliness of the street and no doubt the lack of interest in the ruins by the passersby: they have been looking at them for months. Life is beginning to return to some semblance of normalcy.

I noted earlier that these four photographs comprise a narrative of sorts. But such a narrative would be paltry at best, since we cannot establish a chronology and do not know anything about the figures captured by the camera. The people and soldiers, we might comment rather feebly, share the same sky. And they share the "ruinscapes" that envelope them. Like all of the other photographic images in this collection, the images here are taken outside. There is little of the inside of much of anything to photograph. Inside and outside seem somewhat reversed here, given that most of the living that the viewer sees is taking place on the street. There are, of course, the insides of buildings that are left standing, but we do not see those in this collection. We see ruins, and know the "inside" they conceal, covering hundreds of bodies. We look away, scrutinizing the faces of strangers who themselves avert their gaze.

In these four photographs, how are we looking at the populace that is not looking at either the ruins or (with one exception) the photographer? We would be well served here by considering a photographic installation like that of Shimon Attie, whose "The Writing on the Wall" (1991–1993) projected photographs in Berlin of old Jewish quarters onto precisely the same locations of "rehabilitated" buildings in the Scheunenviertel section of the city. In Attie's illuminated projections, passersby and drivers could see what looked like ghostly figures superimposed onto the renovated structures. A double vision was created, or a fused narrative, since the viewer could see the obliterated Jewish figures and their storefronts, libraries, schools, and homes, on the one hand; and, on the other, the colorful facades of present-day renovated stores and other constructions. Attie thus created a museum in a public space, the projections on the walls acting as ghostly hauntings of what that space had once contained. This

is akin to what Andreas Huyssen has called the palimpsestic aspect of the city. For him, the city is a text that can be read as a semiology of signs.[45] Like Freud's metaphor of Rome for memory, with its many layers pointing to lost eras and buried social orders, in these images the city in ruins looks back (one "reads" the destruction by imagining how it must have looked before; one imagines the population remembering their city when it was intact) and forward (the twenty-first century viewer knows that Germany was rebuilt with incredible speed, palimpsestically covering over the communities of the past and the ruins of the war). In a sense, we are in a situation similar to that of Baudelaire at the Carousel, staring at the ruins of the old Paris and the fragments of the new one—both at his feet. Except that in these Attie photographs, death is never far—nor are the ghosts.

Attie's installations, apart from providing visual superimpositions from the past, raise as well the question of representation. Representation, after all, necessitates absence. The ghosts in his project are Jews who have disappeared from the neighborhood that was once theirs; they are the presence that is not, in fact, present. In Dumilieu's photographs of Germany in ruins, there are also ghosts—though unseen—both those that lie lost under the rubble, and those more unseen still, and yet sensed, that hover over the entire "atmosphere" of the photograph: dead in the camps, in deportation, in forced labor, from cold and hunger, and from Germany's own bombings elsewhere in Europe at the start of the war. These photographs certainly perform what Huyssen calls present pasts, but they also suggest—by the very fact of the devastation they display—the "economic miracle" that was to characterize the German recovery and swift rebuilding at the end of the war. Indeed, when the European Common Market was founded (1957)—just a short twelve years after

45 Andreas Huyssen, *Present Pasts: Urban Palimpsests and the Politics of Memory* (Stanford, CA: Stanford University Press, 2003).

the war—Germany was economically thriving, whereas the United Kingdom was still wrestling with a weak economy. And today, the Hotel Darmstädter Hof is completely redone, its website advertising lovely rooms and a beautiful, pristine exterior. Nowhere is it mentioned that it was once a ruin.

Such cheery displays of amnesia at the service of profit, along with the avoidance of what is today "unpleasant," are no doubt understandable in such context long after the fact. But such displays can also stir, even today for some viewers, a muffled annoyance. We have reached the unwieldy question of justice, which engages the polar opposites of revenge and forgiveness. These are, as Martha Minow notes, two poles of contemporary response to human atrocities.[46] But Hannah Arendt had written, after the war, that neither revenge nor forgiveness is able properly to judge; they can only punish. For her, the only viable act of political judgment is reconciliation, which allows for political rebuilding and stabilizing a war-torn world.[47] Reconciliation for Arendt "posits a new concept of solidarity" after a political and social trauma (6). But solidarity has its own fraught issues.

A hag in Sir Walter Scott's *Heart of Midlothian* (1818) calls revenge "the sweetest morsel to the mouth that ever was cooked in hell!" Conversely, Gandhi famously said that the biblical passage on an eye for an eye "only ends up making the whole world blind." Certainly, Gandhi's point is accurate, but the hag, unfortunately, also expresses a not uncommon sentiment. The extent to which viewers will see these photographs as horrible or properly retributive will

46 Martha Minow, *Between Vengeance and Forgiveness: Facing History after Genocide and Mass Violence* (Boston: Beacon, 1998).

47 Hannah Arendt, *Denktagebuch*, (Munich: Piper Verlag, 2002), 7. Arendt's complex view on Eichmann, it should be added, will motivate her to respond in his case with *non-reconciliation*.

depend upon which "we," or collective, they align themselves with, politically, ethnically, socially, aesthetically, nationally, historically, and so on. Such alignments will construct the gaze on these images. They can also suggest that there is such a thing as deserved, and un-deserved, suffering. But what, exactly, is undeserved suffering? Is humanitarianism determined by victimization? Should it be? It is to these questions that we now turn.

4 Suffering and Victimization

Civilians do not show mercy to civilians; pain comes from the destruction of *my* body, *my* loved ones, *my* city. Total war consumes the people totally, and their sense of humanity is the first thing to go. JÖRG FRIEDRICH[1]

No "we" should be taken for granted when the subject is looking at other people's pain. SUSAN SONTAG[2]

In Burke's study of the sublime, it will be recalled that he is convinced that we have a degree of delight, and no small one, "in the real misfortunes and pains of others."[3] Schadenfreude is always lurking, it seems, in the response to other people's catastrophes. Viewing catastrophe is in itself fascinating, "when it does not press too close," as Burke puts it. In Kant's reading of the sublime, distance rather than proximity can provide a safe place. The distance of the photograph, combined with the distance of time, in this instance, presumably

1 Friedrich, *The Fire*.
2 Sontag, *Regarding the Pain of Others*.
3 Burke, *Philosophical Enquiry into the Origin of Our Ideas*, 43.

allow us such a safe place. No amount of historical knowledge can
conjure up the catastrophe imaged, unless you were a witness, un-
less you were there. Even then, as Pascal noted, humans seem inca-
pable of sustaining any strong feeling—good or bad—for any length
of time. The point of these photographs here is not, then, somehow
to elicit passion or reignite the experience of the trauma (whether
for homeopathic purposes, in the case of a survivor, or for reasons
of historical accuracy, motivating empathy, and so on, for any other
viewer). Forcing photographs of war onto people in order to prevent
future wars or violence doesn't work anyway, as the antiwar writer
Ernst Friedrich discovered. Friedrich was convinced, as noted in
chapter 1, that such photographs would work to make any future war
unthinkable. Needless to say, he was wrong.

On the opposite side of the spectrum was Filippo Tommaso Mari-
netti, the founder of futurism, who declared (as Benjamin reminds
us) war to be beautiful because it allows, in Marinetti's view, for an
aesthetic that in turn inspires "a new poetry and a new plasticity."
War is beautiful because it inaugurates "the dreamt-of metallization
of the human body . . . new architecture, like that of the big tanks,
the geometrical formation flights, spirals of smoke from burning
villages."[4] In this almost cybernetic vision, there is an aesthetici-
zation of horror and a mélange of the human and the technologi-
cal that supports the logic of war and its death machines. But there
is also here—despite the emphasis on gleaming metal bodies and
nature seen as the handmaiden of politics—a certain neoromanti-
cism, though it veers off from that in its ultimate interpretation of
images. That is, Marinetti is gazing on war devastation and images

4 Cited in Walter Benjamin, "The Work of Art in the Age of Mechanical Repro-
duction," in *Illuminations*, ed. Hannah Arendt, trans. Harry Zohn (New York:
Schocken, 1969), 241.

of destruction from a distance,[5] and allowing himself much medi-
tation on ruins, beauty, and on (in his case) the "interesting" blend
of humans and machines. I don't mean to go further in this and sug-
gest that war imagery is sublime for Marinetti (although such an ar-
gument could be made), but war and its destruction hold his gaze
as exciting *aesthetic* images. The weight of a futuristic attraction to
violent, mechano-sleek imagery thus neutralizes a recognition of
the horror that is imaged. The image, in other words, is reinscribed
with a political aesthetic, combined with a reverie on automata and
what would come to be labeled cyborgs. Further, such aestheticiza-
tion provides distance from the trauma by introducing a protective
veil, as it were, which transliterates horror into the gratifying tropes
of futurism. How then do we guard against this perspective that, as
Benjamin points out, belongs to a fascist economy?

If aesthetics means, as Rancière has argued, a mode of articulat-
ing between doing and making, and their corresponding forms of
visibility, Benjamin is more forceful—or at least, more forebodingly
political, in good part because of the terrifying times that surround
him. Mankind has reached such a level of self-alienation, Benjamin
writes, in *Illuminations*, that "it can experience its own destruction
as an aesthetic pleasure of the first order. This is the situation of pol-
itics which Fascism is rendering aesthetic." (242)[6] Moreover, adds

5 Although it was not always at a distance: Marinetti volunteered for service in
the Italian army during World War I, and was seriously wounded as an officer
in May of 1917.
6 See also Susan Sontag's "Fascinating Fascism," a review of Leni Riefenstahl's
The Last of the Nuba (New York: Harper and Row, 1975). Sontag gives an account
of Riefenstahl's film productions, and points out that the book jacket for *The Last
of the Nuba* describes Riefenstahl's film as a "tensely romantic production." For
Sontag, the Nuba book is "the third in Riefenstahl's triptych of fascist visuals"
(Riefenstahl's early "fictional mountain films" being the first, and the commis-

Benjamin, "all efforts to render politics aesthetic culminate in one thing: war." (241) If Marinetti is claiming that war is aesthetic, Benjamin underlines the dangers of aestheticizing politics.

Perhaps there is no danger of that here, since these photographs do not, one assumes, imagine themselves to be "art." But the need to aestheticize seems fairly persistent; there is a way in which fig. 8, the first photograph under discussion in this chapter, for example, can be read as oddly alluring: the differing shades of black and gray—almost sepia in their tones—harmonizing into a muted canvas: the empty doorways that stand eerily in front of vanished houses; the disturbing rubble hiding dead bodies and pulverized buildings; the yawning holes left on the facades by the bombs and shelling; the buildings cut open and partially standing like sentry houses, as if protecting the buried lying in the empty space between. Even the scratches all over the image, attesting to age and poor developing, but providing the surface of the image with the patina of time, add to the lure of this image. Were we to concentrate on these aspects only, and allow ourselves such aesthetic ruminations, we, too, would not be far from a romantic gaze.

And yet two aspects would be missing from this possible reverie, aspects that would obstruct any romantic ruin meditation: the political reality that produced the images (and the devastation they display), on the one hand, and the modern insertion of technology into war, on the other. The ruins here attest to that technology as much as they do to the German defeat in 1945—the technology of bombs, of airplanes, of targeting and other navigational devices, of incendiary materials in bombs, of the political and cultural superstructure, and of photographic technology—itself a machine technology. The

sioned Nazi films the second). With Nazism, argues Sontag, politics appropriated art "in its late romantic phase." Sontag, "Fascinating Fascism," *New York Review of Books* (February 6, 1975).

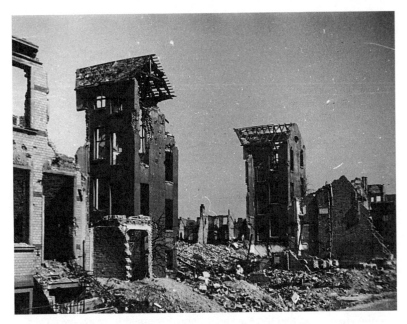

Fig. 8.

political, of course, is what launches it all. Were we to see, along with the landscape in fig. 8, the machines that created the disaster, and were we to contemplate the "beauty" of their metals, the architecture they destroyed (subsequently and rapidly rebuilt, differently), we would be looking at the "beauty" of war with Marinetti. We might add that what also differentiates Marinetti's perspective on ruins from a romantic one is his insistence, not only on bloodshed, but on the aesthetics of technology as well: "War is beautiful," he writes, "because it combines the gunfire, the cannonades, the cease-fires, the scents, and the stench of putrefaction into a symphony." (241) To which Benjamin drily comments, "This manifesto has the virtue of clarity." (242)

What Is a Victim?

In contrast to the Holocaust survivor Jean Améry, who is caught in the dyadic relation between victim and perpetrator,[7] Hannah Arendt introduces a third term: "civic." For Arendt, the word engages individual responsibility, and thus rejects collective guilt. Most discussion of crimes against humanity, including the specific category of genocide, raises the question of victimization as the basis for humanitarianism. Arendt is no exception (though she has much to say about passive victims). But in refusing to categorize the Germans under Hitler as collectively guilty, she tends to essentialize various "types" of victims. We are on very difficult ground here.

As many critics and scholars have noted, recent bestsellers in Germany "now seek to render the victims of carpet-bombing implicitly equivalent to murdered Jews—all victims of human indifference to life rather than of particular historical moments and political decisions."[8] The danger evinced here is that the historical specificity of the Holocaust, and the Nazi teleology of genocide, are erased.[9] Certainly, books we have been considering—such as Friedrich's *The Fire*, Nossack's *The End*, Kluge's *Air Raid*—all arguably suggest, if only by their graphic descriptions and photographs of the horrors of fire-bombing, that German victims of the war suffered as much as any other victims. Other authors writing on the subject have argued that

7 On Améry, see Dennis B. Klein, "Resentment and Recognition: Toward a New Conception of Humanity in Améry's 'At the Mind's Limits,'" in *On Jean Améry: Philosophy of Catastrophe*, ed. Magdalena Zolkos (Lanham, MD: Lexington, 2011), 87–108. Klein suggests that Améry writes for the neighbor-perpetrator.
8 Dean, *Aversion and Erasure*, 18.
9 Thomas Trezise among many makes this point: "Comparisons of the Holocaust with other traumas tend to raise objections, especially where important differences between them are elided, along with the very difference between comparing and equating." Competition in suffering is distasteful, he adds. I fully agree on both counts. Thomas Trezise, *Witnessing Witnessing: On the Reception of Holocaust Survivor Testimony* (New York: Fordham University Press, 2013), x.

the fact of German deaths and trauma as a result of the bombings makes those victims no different from Jews who died in the camps. As Arendt had noted, in her "Report from Germany," "educated and intelligent Germans will proceed to draw up a balance between German suffering and the suffering of others, the implication being that one side cancels out the other."

While suffering is suffering, and a fatality a fatality, such equalizing of victimhood can relativize the Holocaust, by making the villain a general indifference to life, or the need of humans to wage wars, rather than the political context, genocidal practices, or the sadistic and murderous agenda of the Nazis. Such relativizing can also be used to shift responsibility from the German people during the war onto those (whoever they may be, wherever they may be from) who do not value life, particularly the lives of civilians. The Holocaust thus loses its distinctiveness as a particular act of genocide against Jews and against other groups chosen for death, and gets blended into the overarching evil and sadism of war.[10] As Ian Leveson and Sandra Lustig note, the national memorial on Unter den Linden in Berlin (erected in 1993) was dedicated "to the military and civilian victims of the Second World War, the *Shoah*, and Stalinist persecution in East Germany all at once, without differentiation."[11] All of the various victims are monumentalized, all together, for all time. Clearly such essentializing of victimhood is both ahistorical and ethically problematic. What, exactly, is the Berlin monument of 1993 commemorating? And on whose terms, and with memory from what perspective?

So the real question becomes what, in fact, is a victim? It is a question that has been much studied of late, and raises the corollary issue of rehabilitation—not only of the destroyed cities and towns,

10 Such logic was particularly the trend among many German scholars during the 1980s, as I will discuss later in this chapter.

11 "A Response to Diana Pinto," in *Turning the Kaleidoscope: Perspectives on European Jewry*, ed. Sandra H. Lustig and Ian Leveson (New York: Berghahn, 2006), 192.

not only of those most obviously guilty (the supporters of Hitler and of his genocidal agenda), and not only of the German population at large—but also of the German lexicon itself. Certain words were tainted by the Final Solution, the Nazi regime, and Nazi propaganda. In the 1980s, there were some attempts to reinvest such words with their prewar connotations. For example, Eric Santner points out that the "hugely successful" film series *Heimat*, broadcast on German television in 1984, had the effect of making the word *Heimat* (homeland) itself "newly available for libidinal investment in Germany, if only as the elegiac token of something lost." Santner adds that the word *Heimat*, which was prominent in the social marginalization and eventual destruction of European Jewry, is, by way of the film series, "occupied within a new ideological and narrative ensemble in which Germans can see and cathect themselves as bereft victims, as the dispossessed."[12] Another such term that has been reappropriated in certain contexts is, precisely, the word *victim* (*Opfer*). Jörg Friedrich's *The Fire*, for example, presents an unambiguous picture of the bombed civilian population in Germany as victims—of the Allied planes, and also of National Socialism itself. The problem is

12 Eric L. Santner, "History beyond the Pleasure Principle: Some Thoughts on the Representation of Trauma," in *Probing the Limits of Representation: Nazism and the "Final Solution,"* ed. Saul Friedlander (Cambridge, MA: Harvard University Press, 1992), 149. Edgar Reitz, who produced the series *Heimat*, felt that Germans, after the Second World War, had been stripped of their sense of identity. In particular, Reitz believed that the American production *Holocaust* had "terrorized" Germans and expunged their local memories. His series was meant to help restore German identity with portrayals of everyday German village life, beginning in 1919 and extending to 1982. On this, see Santner, "History beyond the Pleasure Principle," 149–50. But, as the *New York Times* review of the series on September 5, 1986, points out, while *Heimat* is no "Holocaust," and not about guilt, "neither does it excuse anybody." The increasing persecution of Jews is made clear, as is the Nazi depravity. http://www.nytimes.com/1986/09/05/movies/the-screen-heimat-an-epic-on-german-life.html?mcubz=0.

that while such a retrieval of the term "victim" relativizes the Holocaust, and is thus unacceptable, it is also and at the same time the case that the German civilian population under Allied bombing, as well as under Hitler's particularly horrific rule at the end of the war, created hundreds of thousands of victims. How is this difference among the victims to be articulated?

Adding to the difficulty are the photographs themselves that we have been discussing here, for they are images located between two positions and two kinds of historical and other documentation. On the one hand, there are the narratives, autobiographies, literary texts, museums, films, and photographs of the death camps and the destruction of European Jewry during the Third Reich. With respect to the Shoah, the term "victim" is clear; it means anyone who was killed in the Holocaust, or anyone who is a victim-survivor with all of the suffering and horror that come with that status. On the other hand, we have a German civilian population, particularly at the end of the war, that is traumatized by everything from bombing, constant air raids, firestorms, flight, homelessness, starvation, statelessness, and the pillaging and raping of women that characterized the advance of the Red Army toward Berlin in 1945. Here the word "victim" is more complicated, I repeat: first because not all of the population, to say the least, was innocent of the Nazi agenda. This recognition—that much of the suffering civilian population is far from innocent—goes far, I think, to explain the highly ambivalent responses to the works, including these photographs, that chronicle the catastrophic results of carpet- and fire-bombing by the Allies. (It is worth noting that there is a general consensus that the bombing of Dresden was a crime, and an unnecessary one at that. But this reaction does not, generally speaking, arise out of empathy for the victims of the bombing and the firestorms that ensued; rather, most of the outrage is to do with the beauty of the city of Dresden itself, with its old churches, art treasures, and medieval architecture that the bombs indifferently destroyed.)

Let us take an example among many of an ambivalent response to German victim narratives—a reaction to Andreas Hillgruber's *Zweierlei Untergang* (Dual Destruction), a work that narrates the German population's vain attempts to save Germany's eastern border from the invading Red Army. Saul Friedlander comments, "In the new representation, the Wehrmacht becomes the heroic defender of the victims threatened by the Soviet onslaught. The crimes of the Wehrmacht are not denied by Hillgruber, although he prefers to speak of the 'revenge orgy' of the Red Army."[13] Representing the Wehrmacht as "heroic" in trying to save the German "victims" of the Red Army changes the lexical valence of both heroic and victim, in two disparate contexts. Because while it is indeed accurate that the Wehrmacht was, from the point of view of the German civilian population, heroic in this particular instance, it is also the case, as Santner reminds us, that during this "heroic" effort to save the Eastern front, the machinery of the death camps was allowed "to continue unabated."[14] The dilemma here is that the change of context reverses lexical stability; in the Hillgruber book, "Wehrmacht" becomes equivalent to "heroes," and "victims" refers only to German civilians. At the same time, in the context of the death camps, the Wehrmacht is the perpetrator along with the collaborating population, and the inmates are the victims. The denotation of "victim" is thus loosened by alternating contexts, and comes to have too many meanings. If the word *Heimat* was "liberated" from its Nazi connotations in order to reconstruct the concept of German-ness, the word "victim" was appropriated, in the context of the German bomb fatalities, in order to broaden its applicability, with the result that German responsibility is shifted. Perhaps, then, there should be a disappropriation of the word "victim." As we will consider shortly, victimization is an increasingly fraught term.

13 The citation is from Saul Friedlander, "Historical Writing and the Memory of the Holocaust," *Writing and the Holocaust*, ed. Berel Lang (New York: Holmes and Meier, 1988), 35.

14 Santner, "History beyond the Pleasure Principle," 148.

The justification of the pain of one's fellow man is certainly the source of all immorality. EMMANUEL LÉVINAS[15]

In viewing these photographs, taken once the war is over and the death camps have been liberated, we are paradoxically confronting two groups of victims visually absent from the photographs, but present by virtue of historical and visual references. The first group, as noted earlier, consists of the thousands of dead civilians, covered over by rubble and ruins, who are the unseen victims of the bombings. The second group is as it were intuited in these images, and is comprised of the millions of dead in the camps. This second group, I would argue, is equally inextricable from these pictures, silently and invisibly hovering over the scene. These images then perform a visual prosopopoeia, of sorts: the unseen dead make their presence felt in these images by virtue of their very absence from the photographs. No living people are to be seen here, either.

The first photograph (fig. 9) shows a doorway into nowhere—but a nowhere of devastation. The bricks, presumably once part of this structure, are neatly stacked up, leaving the street cleared. The Trümmerfrauen have been busy.[16] There is an odd sense of silence

15 Emmanuel Lévinas, _Entre Nous: On Thinking-of-the-Other_, trans. Michael B. Smith and Barbara Harshav (New York: Columbia University Press, 1998), 99. I have slightly altered the translation.
16 At the end of the war, German women between the ages of fifteen and fifty were ordered by the Allies to join in the cleanup operation. As there were far more German women than men to do the job, for obvious reasons, restrictions on female labor were lifted. Working in all weather conditions, these women made chains to pass the rubble from hand to hand. They used mainly picks and manual pulleys to tear down the ruins, shovels to clean the streets of rubble, and carts and wheelbarrows to haul away the debris. In both West and East Germany, the efforts of _Trümmerfrauen_ were later recognized.

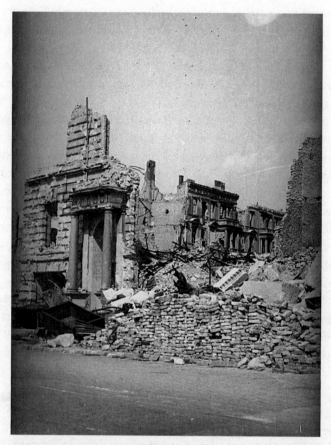

Fig. 9.

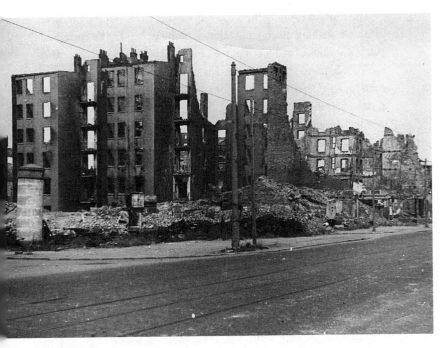

Fig. 10.

in this photograph—no doubt because there are no people—and the
ruins are left nakedly, as if unapologetically, on display, themselves
laid bare, but covering their dead. The same may be said of the sec-
ond photograph (fig. 10)—empty street, desolate ruins. Even a kiosk
on the left is stripped of its posters. Telephone or electricity wires
can be seen, stretching across the sky; they presumably lead to noth-
ing, and allow for neither light nor phoning. Like the kiosk, they are
vestiges of life before the bombs. Oddly enough, the two invisible
groups of the dead seem even more present in photographs that
include the living. The war's surviving population is busy trying to
clean, rebuild, and return to some sort of normalcy.

The tentative emergence of everyday life in fig. 11, for example, affords a striking discrepancy between the debris of the ruins and the beginnings of order out of the chaos. A path has been cleared in the rubble to allow for pedestrians and bicycles. A military policeman (of sorts; his uniform is indistinct, but his armband is very emphatic) stands at attention, watching the people file by. Apparently, one must walk one's bike on this path rather than ride it. (Is this an order from the MP? Or is the path too bumpy to allow for riding?) On the right, the teetering remains of a house can be seen. As we move our gaze to the foreground, there are twisted scraps of metal and chunks of buildings, strewn everywhere and becoming increasingly smaller—almost powdery in some places—as we go to the bottom right of the photograph. In the background is the city in ruins, with what seems to be a railroad bridge and heavily damaged buildings behind it (they look like they could collapse with a strong gust of wind). Some of the windows are black, having been blown out by the bombs; others seem to have remained relatively intact. The MP looks like he's almost smiling. Is he encouraging the pedestrians in this semi-return to daily life? Or is he, perhaps, aware of being photographed? He may be German, in which case maybe he's happy the victors have given him a steady job; or maybe he's glad to see things returning to some sort of normalcy. In any case, he may not be German at all, but rather a member of the International Patrol that functioned after the war. He's a symbol of order, like the cleared path, in direct opposition to the mayhem of the ruins. On the upper left, there's a strange panel of light. Is it an overexposure in the photograph? On the upper right, extending to the middle, the photograph is damaged, the scratches attesting to the years that separate the viewer now from the scene captured by the camera. The photographer must be standing on higher ground, or upwards of the rising road that may bend and thus allows for this perspective.

This resembles a phantom city, except that it has people in it. The city gives off a sense of the haunted—by the unseen dead lying under

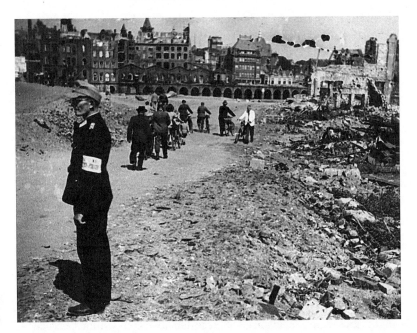

Fig. 11.

the rubble and by the Holocaust that makes itself everywhere felt,
and equally unseen. In other words, the few people walking their
bikes are in stark contrast to those millions who will not be there to
rebuild, to put their lives back together. One man is walking in the
opposite direction of the others, and he is wearing a white coat. Is he
a doctor? Shoe salesman? The pedestrians could almost be a group
of refugees, fleeing in orderly fashion under the gaze of the appar-
ently satisfied policeman/MP. One woman is holding a child on her
bicycle as she steers it. A boy is walking beside the bicycle; the child
on the bicycle (who seems to be a girl) is holding his shoulder with
her right hand. Most of the men are in suits, and look like they're
hurrying off to some sort of business engagement.

 We do not know who these people are, or where, exactly, this
scene is taking place. We know only that it is Germany in the spring

of 1945, that the war is over, and that there has been a series of trau-
mas: first and above all, the Holocaust and the knowledge of its mag-
nitude; second, the bombing of German civilians and the resulting
destruction of many cities, with the hundreds of thousands of fatal-
ities; third, the destruction caused by the Red Army, including pil-
laging and destruction of property, and the rape of over 1.5 million
women.[17] Added to this are the wounded, the homeless, the starv-
ing, and the bereft. We cannot know if the people in fig. 11 belong to
any of these last categories; we only know that they have survived.[18]

The special issue of *New German Critique* in the winter of 1980
was devoted to German responses to the 1979 television broadcast
of "Holocaust" in West Germany. In their introduction to the is-
sue, the editors write, "Certainly recognition of historic suffering is
crucial for any radical vision of the future which desires its elimi-
nation. But suffering does not automatically give license to moral
absolutism or to grandiose equanimity in the face of the suffering
of others." (5) While such is the case, at least from an ethical point
of view, we are seeing in all of these debates a competition between
victims. In the 1980s, as we have noted, German historians began
demanding recognition of carpet-bombing victims during the war.

17 On the rape of German women in 1945, and the silence that ensued on the
subject until after German reunification, see Anita Grossman, "A Question of Si-
lence: The Rape of German Women by Occupation Soldiers," *October* 72 (Spring
1995): 42–63; and Stuart Liebman, ed. "Berlin 1945: War and Rape. 'Liberators
Take Liberties,'" *October* 72 (Spring 1995): 1–114.

18 Another trauma is the 1944 repatriation of between two and three million
Russian prisoners of war who had been in German hands, most of whom, upon
returning to the USSR, would face immediate death or the Gulag. British policy
was largely responsible for this disastrous undertaking (although the Americans
also played an important role), the justification being that Russian cooperation
was essential to winning the war. The Allies were convinced that the Russians
had to be mollified; a secret agreement was made in 1944, and legalized at
the Yalta Conference in 1945. For an account of this horrific event, see Nikolai
Tolstoy, *The Secret Betrayal* (New York: Scribner's, 1977).

Jörg Friedrich's *The Fire* is in many senses the culmination of such a view. Conversely, in 1997, the French historian Jean-Michel Chaumont produced a book claiming that the suffering of the Jews was not immediately acknowledged at the war's end.[19] This lack of recognition, according to Chaumont, explains the Jewish insistence on the priority of their own suffering in the Holocaust. Recognition (*reconnaissance*), argues Chaumont, is the basis for identity.

During the 1970s, German historians began a microhistory, the *Alltagsgeschichte* (history of daily life), which concentrated on such things as food, utensils, clothing, habitat, and work in everyday German life. By the 1980s, these historians began to examine the connection between the working class and the Nazi regime. *Alltagsgeschichte* historians also considered and interviewed the survivors of catastrophic events, such as war. They were accused (by the equally controversial *Alltagsgeschichte* historian Martin Broszat among others) of trivializing the Nazi era. Between 1986 and 1988, the *Historikerstreit* (historians' quarrel) flared, steeped in the fraught matter of comparing Nazi crimes with the crimes of the Red Army. Historians from West Germany, France, Israel, and the United States (among others) were in conflict about whether the Holocaust was being relativized when historians turned to such comparisons, or to German daily life *tout court* during the Nazi era. Indeed, critics of the microhistorical approach argued that the Shoah was displaced from its central position with studies of other groups that suffered during the war. As Robert Paxton succinctly remarks, in his review of a book on the Vichy government, students of *Alltagsgeschichte* in the 1980s began to realize that, from their perspective, "the Nazi, anti-Jewish pogrom faded into the background, while a different set of victims— housewives confronted by rationing and scarcities, families who

19 Jean-Michel Chaumont, *La concurrence des victimes: Génocide, identité, reconnaissance* (Paris: Édition de la Découverte, 1997). On the comparison of suffering under Stalinism and Nazism, see Henry Russo, ed., *Stalinisme et nazisme: Histoire et mémoire comparées* (Paris: Éditions Complexes, 1999).

lost their homes to Allied bombing—came to center stage."[20] Such "comparisons" and struggles to achieve some sort of foregrounding, critics of the microhistorical approach argued, cannot be deployed (nor will they achieve anything).

This unacknowledged competition (for lack of a better word) between victims—those of the Holocaust, German soldiers on the Eastern front, civilians carpet bombed and burned alive, targets of the Red Army—has, finally, to do with the definition of morality and the stance one takes with respect to human suffering. This is a different question, I want to emphasize, than whether or not the Holocaust is central; it is so—incontrovertibly. Robert Antelme has written that with the Shoah, men saw "those things that men ought not to have seen, things that could not be put into words."[21] Let us begin by agreeing with this statement, and by refusing all comparison, all contestations for "center stage"—political, material, or moral—between the Shoah and, in this context, the bombings of German civilians during the war. Given the conditions of Berlin 1945, we turn to face a different kind of ontological crisis. The economy of vengeance will not help us here; indeed, on the contrary, it is the cause and motivation that leads to the destruction.

Susan Sontag, in her book *Regarding the Pain of Others*, writes (echoing Foucault) that "to designate a hell is not, of course, to tell us anything about how to extract people from that hell, how to moderate hell's flames." (14) Charles Taylor remarks that the distinctive trait of modern morality is "the importance we give to avoiding suffering" and adds that although "we are much more sensitive to suffering, [this] of course can be translated as the simple refusal

20 Robert Paxton, "Vichy Lives!—In a Way." *New York Review of Books*, April 25, 2013. See also https://www.nybooks.com/articles/2013/04/25/vichy-lives-in-a-way/.

21 Robert Antelme, "Revenge," in *On Robert Antelme's "The Human Race": Essays and Commentary*, ed. Daniel Dobbels, trans. Jeffrey Haight (Evanston, IL: Northwestern University Press, 2003), 14.

to hear about it rather than an action to remedy it."[22] Didier Fassin
adds a paradox: If suffering is continually avoided today, it is at the
same time omnipresent because in order to work (*s'exercer*), "com-
passion needs suffering to be designated and represented."[23]

So on the one hand, as this logic goes, we—the onlookers—do not
look at suffering enough; we avert our gaze, we barely speak of it. At
the same time, we often search for suffering, out of voyeuristic curi-
osity, or in order to motivate compassion, a feeling that allows us to
imagine the recognition of the Other; a sort of identification from a
distance. But even with the compassion that the knowledge of suf-
fering allows for (given that we need to feel compassion in order to
overcome our guilt, or indifference, or impotence), too often we can
do nothing, or choose to do nothing, for the sufferers. We have ar-
rived, then, at the problem of the rights of man—a perspective, or
index, that Arendt, for example, takes for granted as determined
by victimization. She assumes a definition of humanitarianism as
it is largely conceived today. In 1951, during the postwar period, she
writes, "The destruction of a man's rights, the killing of the juridi-
cal person in him, is a prerequisite for dominating him entirely."[24]
As the philosopher Alain Badiou notes, this attitude produces a hu-
manism founded entirely on victimization. In many ways, Badiou is
the opposite pole of Arendt on this issue, and so it is worth taking a
closer, if brief, look at his thinking on victims.

Badiou, for his part, detests victimization: "First of all, because
the state of the victim, of the suffering animal, of the emaciated dy-
ing, subsumes man into his animal sub-stance, into his pure and sim-
ple identity of living."[25] What is more, says Badiou, "if man's human-
ity is understood in terms of his subjective capacity, there is, strictly

22 Taylor, *Sources of the Self*, 12–13.

23 Didier Fassin, "Un éthos compassionnel," in *La Souffrance sociale: Nouveau
malaise dans la civilisation*, ed. Marc-Henry Soulet (Fribourg, Switzerland: Aca-
demic Press Fribourg, 2009), 56.

24 Hannah Arendt, *The Origins of Totalitarianism* (New York: Meridian, 1962), 451.

25 Alain Badiou, *L'éthique: Essai sur la conscience du mal* (Paris: Nous, 2003), 31.

speaking, absolutely nothing such as the 'rights of man.'" On the
one hand, humanity is "an animal species"—whether executioner
or victim, man is not worth much. On the other hand—and this is
fundamental in Badiou—there are certain people who, "by means
of an incredible effort" and with a "nearly incomprehensible" re-
sistance, do not take on the identity of victim. Here, Badiou tells us,
is Man; and it is from here "that we must start." (32) Two aspects of
his thought are to be noted here. The first is that there is in Badiou
no question of a juridical figure (a figure that is essential for Arendt).
For Badiou, all universality is born of singularity that, in turn, has its
origins in an event. Philosophy itself is a "bet with universal impact."
It is a Pascalian bet, one might say, but without God.

Secondly, for Badiou, man is immortal (despite his death-to-
come), precisely when he is in "the worst situations that can possi-
bly be inflicted upon him." The rights of man thus have nothing to do
with "the rights of life against death, or the rights of survival against
poverty." (33) They have rather to do with one's response to suffering
and cruelty. Badiou maintains that every man or woman is "*capable*
of becoming this immortal being, in great or small circumstances,
for an important or trivial truth; it doesn't matter." (33)

These two aspects of Badiou's thought are both dangerous and, in
the context of this book, quite unhelpful except insofar as they de-
lineate a negative conception of victim, and an insistence on a kind
of heroism that is at best extraordinary. For if man can become "im-
mortal" in any given circumstances, he is really finally Human for
Badiou only in the exceptional cases of atrocity, where man, treated
as an animal, manages to transcend his situation and become "Man"
(*l'Homme*). To situate the immortal aspect of Man (here understood
in scare quotes) in circumstances that aim to kill him, to make him
suffer, is a philosophy in extremis that demands suffering in order to
prove man's capacity to overcome evil and oppression. Victimiza-
tion, then, must above all not serve to define human rights; indeed,
rights based on the victim are "a scandal" because they have con-
tinually been based on suffering, which, for Badiou, is not the issue.

And yet suffering is essential to Badiou's system, for it is the only means (and that on rare occasion alone) of demonstrating what Man is. If a resister refuses to be defined by his animal state, and thus becomes "immortal," there is at the same time no language in Badiou for preventing circumstances that would force such extreme circumstances; no juridical recourse when they occur.

And where is history in this thought? It is no longer a continuum manifested through events, nor is it an attempt to blast such a continuum (Benjamin) out of its complacency. For Badiou, history is recognized after the event as he conceives of it: "pure conviction"—a revelation of which the event is the rupture; the "miracle" that yields a truth that is perceived retrospectively in its particular situation. All of this may be interesting in the abstract, but makes for what I would call a certain luxury that philosophy can offer itself: an ahistorical perspective, which allows for the contemplation of catastrophes not unlike Romantic meditations on ruins and on the great empires that have been crumbled. This means that viewing from a distance and suffused with abstractions, philosophy, per Badiou, thinks on the results of a catastrophic tear in the being of being. It means reinscribing tragedy in a near-optimism, one that attempts to combat passivity and cynicism by arguing that it is in the worst of suffering that the "Eternal Man" becomes manifest. What truth event would emerge from, for example, the bombing of Berlin? Mass murder does not count as an event for Badiou (which doesn't prevent him from thinking of Hiroshima). What do we do, not with an ethical stance, but with ethical stances determined by varying situations? Badiou learns from Lévinas that there is no greater hypocrisy than well-ordered charity; but he takes this notion in a completely different and (to repeat this adjective) dangerous direction. It is this dangerous view—concentrating on extreme human suffering in order to discover "Man"—that gives Badiou's philosophy its import. It is a view that not only relativizes victimization; it trivializes it as well by considering those who succumb to suffering as less than Man.

Lévinas offers another, more palatable and admirable extreme. For him, Occidental philosophy shows "a refusal to engage with the Other; waiting preferred to action; indifference to others."[26] I cannot know the Other; I cannot identify with the Other; his or her radical alterity prohibits this. The incorporation of the Other into myself is impossible. As for suffering, Lévinas writes, "the suffering of suffering ... opens the ethical perspective of the inter-human."[27] The inter-human for Lévinas is by definition non-indifference. Further, "the justification of the neighbor's pain is certainly the source of all immorality." (99) In its ethical stance, the I is distinct both from the citizen of the polis and from the individual in his/her natural egotism. Lévinas here understands himself as correcting Western philosophy: ontology examines being-in-itself, but not being in relation to the Other. Thus the negative and frequently evoked notion of *indifference* in Lévinas is of the first importance for him, for the word marks the erasure of the Other. The description of the incontestable proximity of the state and the Christian religion thus grows in amplitude. Lévinas describes both as being *indifferent* with respect to the Other. To ignore the difference between the polis and religion, to attempt to obliterate that difference in a totalitarian economy, is for Lévinas the denial of the Other, of alterity; for indifferentism rests on the analogy of the same to the same.

This philosophical/ethical approach, however, remains somewhat impractical in concrete terms for rescuing the subject inside the totalitarian state—a state that, in its pursuit of hegemonic omnipresence, seeps into every aspect of existence. This ubiquity gradually and irrevocably marks the subjugation of all aspects of daily

26 Emmanuel Lévinas, *Humanisme de l'autre homme* (Saint Clément de Rivière, France: Fata Morgana, 1972), 43.

27 Emmanuel Lévinas, "Useless Suffering," in *Entre Nous: Thinking of the Other*, trans. Michael B. Smith and Barbara Harshav (New York: Columbia University Press, 1998), 94.

life and thought by the omnipotent state; it fosters an ideology that differentiates only between the people and the enemy (which, from the purely doctrinal perspective of the state comes to the same thing, since both people and enemy serve to define state power). This is another aspect of indifferentism, one might say. Politically speaking, such a system throws the subject, even when inscribed as one of the "people," into his or her solitude—one can trust no one, one is haunted by the possibility of violence, war, catastrophe, betrayal, horrific loss, and death. At the same time, however, the individual of the "people" is metonymic of the whole that is the state; he or she is without agency, however, and recognized as such: metonymic.

A potent example of what I am calling the metonymic position—the people as one, each representing the whole and thus forming the full-blown "glory" of the Third Reich—is no doubt Leni Riefenstahl's film *Triumph of the Will* (1935), in which soldiers are asked, at the huge Nuremburg rally, to shout out from what part of Germany they hail. Once all the regions of Germany have been represented by young men serving as (Aryan) specimens of each, the soldiers infamously chant, together and in deafening, thunderous voices, "Ein Volk, ein Führer, ein Reich, ein Deutschland" (one people, one Führer, one Reich, one Germany). The metonymic economy at the service of Third Reich ideology is too obvious to comment upon further.

More significant for our purposes is the famous opening of the film, which shows the clouds as they are viewed, the footage suggests, by Hitler, who is flying to Nuremberg in his private plane. As the town of Nuremberg gradually comes into view and the plane lands, the camera shows hundreds of thousands of people ecstatically lining the streets, shrieking with joy at the sight of Hitler in his motorcade, crowding to get a good look at him. Unanimously (and with near hysteria), they all perform the Nazi salute, screaming "Heil Hitler" over and over again. Women, men, the old, the young, children—all are delirious with joy and heady elation, scrambling to get a glimpse of the Führer, and triumphant with nationalist frenzy.

These are many of the same people who will, some ten years later, be killed or made homeless by Allied bombs. German soldiers will be massacred on the Eastern front; the Red Army will wreak havoc on German territory and on women; the death camps will have been liberated, showing the extent of the Nazi horror; there will be millions of refugees and millions of prisoners of war. And yet it is difficult, upon seeing Riefenstahl's film, to feel compassion for the German civilian population. One has difficulty resisting the conviction that they brought their suffering on themselves; that they deserved it, such that compassion is debarred from any reaction. This is, of course, a common view, including in Germany itself.

But that view also raises serious questions, many of which we have already been considering. On what grounds is it ethically acceptable to target a civilian population, even if much of it is politically suspect or downright guilty? What kind of an Other is such a population, to use Lévinas's term? To what extent does the desire for revenge justify murdering the enemy population and leveling its cities?

If Carl Schmitt saw the category of enemy as the essence of the political, the earlier Lévinas sees violence as the hidden essence of the state.[28] It is worth stressing here that Lévinas argues for neither compassion nor sympathy for the Other, particularly given that an identification with the Other is fundamentally impossible. Lévinas asks rather for nonreciprocal substitution (responsibility, one might say, for the Other).[29] The face for Lévinas is a summons and a command; it meets the gaze with "Do not kill me." Responsibility, espe-

28 The later Lévinas looks upon the state—assuming it is a liberal one—less severely. See, e.g., "Peace and Proximity" (1984), in *Alterity and Transcendence*, trans. Michael B. Smith (New York: Columbia University Press, 1999).

29 See Lévinas's fourth chapter, "Substitution," in *Otherwise than Being, or Beyond Essence*, trans. Alphonso Lingis (Pittsburgh: Duquesne University Press, 1998).

cially in the late Lévinas, is the a priori basis for the structure of the self. As Derrida reminds us, Lévinas does not want to propose laws or moral rules: "It is a question [in Lévinas] of writing the ethics of ethics," says Derrida, and not to institute *an* ethics or a system.[30] Thus Lévinas's concept of the Other, and of the face of the Other, is a metaethics that is conceptually, but not materially, helpful in viewing suffering of civilians targeted in war.

Let us take up Lévinas here in a different register—the specifically historical one of the civilian victims in the last years of the war. If we have recourse to Lévinas in this particular historical context, we can say that compassion is not the goal, and we can bear this in mind as we contemplate the landscape of ruins that followed on civilian targeting. We can also maintain that the word "victim" here is to mean those civilians who suffered in the war, nothing else. How they suffered, how many in one group suffered as against others, will only result in what Jean-Michel Chaumont, mentioned earlier, calls "the competition of victims." "Victim" then will here be a label that will not aspire (or otherwise attempt) to dislodge the Holocaust from its position as paramount; nor will it be used in a comparative manner to demonstrate the numbers of one scene of death from another. The question is simply, to return to Lévinas, *What is our human responsibility in the light of this destruction?*

We might begin by asking how our gaze is structured by these photographs. We have noted more than once that one's nationality, politics, gender, ethnic identity, and so on will play a role. The distance of time, and the filtering aspect of the photograph itself, will also contribute to the way the gaze functions. More importantly perhaps, the viewer's knowledge of the events of the end of the war will structure his or her gaze in important ways.

30 Jacques Derrida, "Violence and Metaphysics," in *Writing and Difference* trans. Alan Bass (Chicago: University of Chicago Press, 1978), 111.

Can We Understand a Photograph?

A photograph, whilst recording what has been seen, always and by its nature refers to what is not seen. It isolates, preserves and presents a moment taken from a continuum.... One learns to read photographs as one learns to read footprints or cardiograms. The language in which photography deals is the language of events. All its references are external to itself. Hence the continuum. JOHN BERGER[31]

In the first of two photographs (fig. 12), we note, once again, that the street has been carefully cleaned. Thus, the American military vehicle (the star on the side identifies it as such) has been able to drive up to the ruins and park. To the side of the car, on our left, we see a chain of ruins; two with their entrance doors still visible. The houses further down from these two doorways are barely recognizable as the townhouses they once were. The rubble is massive, with huge chunks of the buildings lying among smaller, unidentifiable pieces of destruction. The contrast between the neat, rather new car, and the debris is notable. The former residents cannot have retrieved much of anything from this rubble. There is no one here (not even the driver of the car, who cannot be the photographer; but maybe the photographer herself hitched a ride with an American officer to view the ruins?). No gaze meets ours, unless it is the metaphorical one of those same, black openings where the windows once were. It is hard, upon seeing this photograph, to resist a mental reconstruction of sorts—to imagine what the scene was like before the bombs and thus before the ruins. Such a mental effort is somewhat reminiscent of the books sold for tourists—in Rome, for example—in which photographs of the present-day ruins of the Roman Empire can be covered with transparent pages that superimpose drawings of what the buildings presumably looked like when they were intact.

31 John Berger, *Understanding a Photograph*, ed. Geoff Dyer (New York: Penguin, 2013).

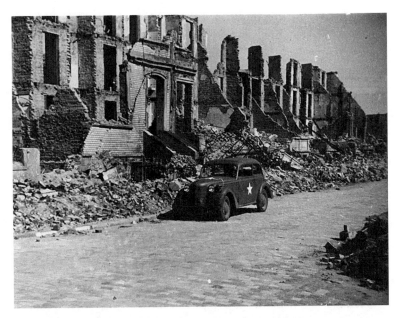

Fig. 12.

It is, clearly, a residential street, so that there can have been no attempt at strategic bombing here. This must have been the result of "morale bombing." What else can be seen here? Mainly what is not, in fact, seen. It will be recalled that John Berger, in his essay *Understanding a Photograph*, notes that the unique power of the photograph is precisely that *"What it shows invokes what is not shown. . . . The immediate relation between what is present and what is absent is particular to each photograph."*[32] His examples of this power of the absent in relation to the present are "that of the ice to sun, of grief to a tragedy, of a smile to a pleasure, of a body to love, of a winning race-horse to the race it has run." Absent from the photograph in question here are the people who lived on that street; they have either fled (and are most likely refugees), or they are buried under the debris.

32 Trachtenberg, ed., *Classic Essays on Photography* (Berger's emphasis), 293.

This photograph, then, is a representation of the missing. Missing as well are the movements and noises of everyday life, of traffic, voices, streetcars. Or the clutter (orderly or not) of belongings. Paradoxically enough, only the car is alive *in potentia*, since the driver will (one imagines) soon get in his car, start the engine, and drive away from this frightful scene. The sound of the engine is the only sound we can imagine. Thus, to extend Berger's point, it is also what is not mentally *heard*—the lack of visual allusions to any sources of urban noise—that haunts this photograph. It is a scene of desolation that engages the economy of representation at its most literal level: what is shown here is (to return to Berger) what is not shown. The complete absence of people going about their daily lives here underscores their disappearance. The absence of any referent to city noise forcefully reinforces that disappearance, and makes the silence palpable.

The ruins attest, then, not only to catastrophic destruction, but simultaneously to the image of the domestic spaces as they had been, intact and full of life, before the bombs. If the Romantics meditated on ruins while dreaming of fallen empires and the long-disappeared populations who lived within them, this photograph brings us, head-on, into another reality. The population here has also disappeared, but it was specifically targeted, and the loss of their homes and lives was a technologically driven goal. We cannot contemplate this scene as we would the "charming" ruins of Romantic paintings or literature. Nor could this photograph be confused with some accident of nature, such as an earthquake or cyclone. The extent of the damage to solid brick houses (*massif gebaut*) is evidence of human intelligence, with "collateral damage" the outcome. In a sense, however, one cannot even call this collateral damage, since the noncombatants in this instance were neither unintentionally nor accidentally killed: they were the targets. The question that this photograph seems loudly to raise is one of ethics: can there be grounds on which the use of bombs and fire, specifically aimed at a civilian pop-

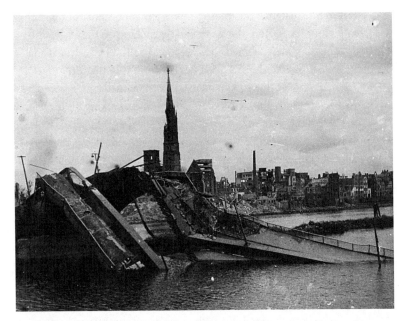

Fig. 13.

ulation, are acceptable? This question, needless to say, is far from limited to Germany at the war's end.

 In the second photograph (fig. 13), we see what we can presume to be an instance of strategic bombing, wherein bridges were targeted along with railroads, industrial plants, armaments factories, and all other superstructures. Here, too, there seems to be an absence of people. In the background, a ruined town is visible. Even the church has a missing part on one side of its steeple. There is rubble everywhere in the background, with partially collapsed buildings, heaps of debris, shattered roofs, and so on. The bridges lie collapsed into the river, like corpses. Once again, what is not shown are the people who lived here, who crossed this bridge. Once again, we are met with what seems like an eerie stillness, the photograph attesting to a landscape of silence.

But in this instance the photographer took another shot (fig. 14) from further back. Here there are people walking on the makeshift bridge that has been cobbled back together to allow pedestrians and bicycles to cross the river. A good deal of trash is in the foreground, and we can still see the ruined town with its damaged church steeple in the background. A man is crossing the bridge, walking his bicycle, in one direction; in the other direction are several pedestrians walking what looks like a bit gingerly to the opposite side. Does the presence of these survivors change our perspective on the ruins? (Are they in fact survivors?) We are viewing post-trauma; what Žižek calls the "Real Real"—the twentieth-century proclivity for bodily violence, atrocities, man-made death. The ruins stand, tattered as they are, like witnesses to the machines of war; no longer quiet sources for contemplation, they show the murderous machines that are the result of human ingenuity. What is not shown, in other words, are the "real" protagonists of these photographs: the triumph of technology, produced by the Masters of War, as Bob Dylan put it, with the focus on civilian vulnerability. When we direct our attention, then, at the people who are *not* shown, we can be witnesses to the horrors visited on civilians by modern war machines. Such a vision of the absent, even given the individual connotations they necessarily engage in every viewer, transcends (at least this is the hope) nationality, gender, race, ethnic identity, or any other kind of individual position.

There is a third photograph of this scene (fig. 15), taken at yet another angle. The man furthest from the viewer, walking his bicycle on the temporary walkway, is carrying a bundle of clothing on the bike. Behind him, another man is walking his bike as well, but he is not the same man we saw in the previous image (what he has on the back of the bike is different in form). He is looking back; is he waiting for the woman behind him to catch up with him, or is he just curious as to who is walking behind him? The "scenery" for this shot, like the others, is full of twisted metal (just the sort of ruin that Speer was dedicated to avoiding). On the right, in the river, three large beams stand vertically, like a modern sculpture.

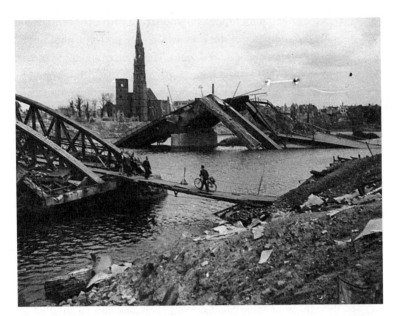

Fig. 14.

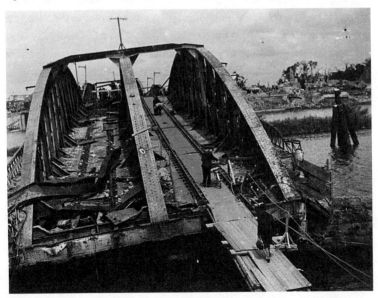

Fig. 15.

Where is the photographer standing to be above the bridge? Presumably, on the bank of the river, which the previous photograph (fig. 14) shows is a high embankment. The photographer has moved around to take these three images; perhaps she was fascinated by the contrast between the ruins (stark and looming all around), and the patchwork bridge (which allows people to cross to the other side, in an attempt at some semblance of daily life). The viewer's gaze on these images alternates between the raw display of destruction and the people calmly crossing the half-submerged bridge. The black and white of the photographs seem to echo the disparity. The sky appears to be gray, as if offering a neutral backdrop for the sharply contrasting sights. The scratch that can be seen on all three of these images (upper right) serves as a reminder of their age, and adds to the catalog of aspects of deterioration.

In the next shot (fig. 16), a man and a woman are walking along, she, carrying a large bag (food from the black market?). We cannot see their faces, as their backs are largely facing away from the photographer. Destruction looms all around them, but they are almost strolling (we know their gait is relatively slow, because their legs are in focus). The contrast between the couple's gait of everyday-ness, and the line of towering ruins that pave the path alongside them, makes for an arresting image. As usual, the street has been thoroughly cleared. The ruins of a department store, windows shattered, is on the couple's immediate left. The store has posters on a wall that is still standing—or were these added after the bombings? The sidewalk on which the couple walks is clear, but if we follow it, we can see that it will soon be debris-filled, and that the two pedestrians will have to walk in the street.

On the extreme left of the photograph is an electricity pole (or telephone pole?). It stands, a testimony to a past of normalcy. Upon looking more closely, the viewer realizes that there is a large hole, with charred edges, near the bottom of the pole. This hole, this small witness to the bombing event—small in relation to the large ruins around it—produces in this viewer what Barthes calls *punctum*.

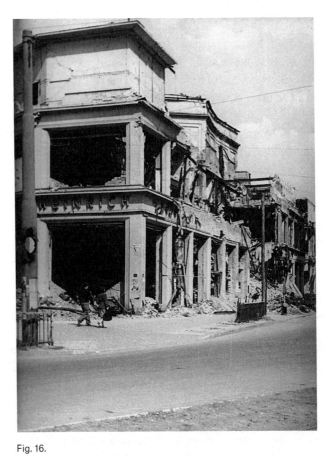

Fig. 16.

In other words, it is not a detail one seeks out (indeed, how could one expect it?). It is rather, in Barthes's words, the "element which rises from the scene, shoots out of it like an arrow, and pierces me."[33] The hole is a literal *punctum*: that is, not only does it pierce me; it is also itself what has been pierced. A photographer's *punctum*, Barthes famously writes, "is that accident which pricks me (but also bruises me, is poignant to me)." (27) This hole is somehow poignant.

Far from wishing again to deploy the overused Barthesian *studium/punctum* dyad, I have rather, in this study, been mostly trying to avoid them. And yet fig. 16 elicits *punctum*: first, as that which disturbs the *studium*. We have been considering the ruins in this image, and the couple walking among them. I have noted that the juxtaposition between the couple's "normal" walk and the surrounding "ruinscape" makes for a fascinating tension. I have commented on the fact that we cannot see their faces. This is all clearly a variation of *studium*, which allows the viewer to receive the photographs "as a political testimony or enjoy them as good historical scenes." It is with the cultural aspect essential to *studium* that, per Barthes, "I participate in the figures, the faces, the gestures, the settings, the actions." (27) *Studium* is "a kind of education"; though we cannot follow Barthes, with respect to the photographs displayed here, by holding that *studium* engages "liking," or that it is "inevitably to encounter the photographer's intentions." (27) As with literature, the author (or photographer, in this case) has intentions that cannot be fully known. Moreover, once produced, texts or images lead a life of their own, as it were, and exert their own intentions within the structure of the work.

Perhaps the source of the *punctum* in this image is that a small detail speaks as much about the devastating bombings as do the crumbled edifices that line the street here. Perhaps it is that the very smallness of the detail allows for the viewer to take in the totality of the disaster, in a way that the endless ruins do not. Albert Camus

33 Barthes, *Camera Lucida*, 26.

once noted that in order to understand the fact that thousands of people had died of the plague, you would have to rent a huge gymnasium and fill it with corpses. Representation can demand literalness. As many of the writers we have considered have noted, you cannot understand catastrophe unless you have experienced it. Perhaps *punctum*, or at least some version of it, is all that we have to convey the full scale of ruination and the human suffering it creates.

But images can themselves fashion perception, including of ourselves. "Human beings," writes the philosopher Vilém Flusser, "forget they created the images in order to orientate themselves in the world. Since they are no longer able to decode them, their lives become a function of their own images: Imagination has turned into hallucination."[34] Flusser's theory is that in the post-industrial era we have been so bombarded by images and the ease of photographing that we are no longer able to "decode" images at all; we use images to "recode" ourselves, according to the signs images produce. "Cameras," writes Flusser, "are purchased by people who were programmed into this purchase by the apparatus of advertising.... Apparatuses improve by means of social feedback." (57) Images, particularly now computer images, are for Flusser digital codes that are replacing the alphanumerical one; linearity replaced by what he calls "dot-interval thinking."[35] This rupture of the linear by the numerical mode of thought was not yet fully evident in photographs from 1945, though the technological advances in warfare show the beginnings of digital coding.

Flusser further argues that photography forces the viewer to think about historical time, and in this he is particularly useful here. We have remarked how most of the Romantics engaged time in their

34 Vilém Flusser, *Towards a Philosophy of Photography* (London: Reaktion, 2000), 10.
35 Vilém Flusser, "Krise der Linearität," in *Absolut Vilém Flusser*, ed. Nils Röller and Silvia Wagnermaier (Freiburg: Orange Press, 2003), found at http://boots contemporaryartspace.org/blog/bootprint/ In English: "Crisis of Linearity," trans. Adelheid Mers, found at http://fbauldcnm.pt/joelfilip/docs/flusser.pdf.

contemplation of ruins. For the Romantics, time is a continuum, a sequentially linear flow from then till now—Heraclitean, as Flusser would have it. You may never step into the same river twice, you may change like the river, but it keeps flowing. Paintings or photographs from this point of view can be easily entered into the current of time, and perhaps far too neatly settled and fixed into a given era. Indeed, it is just such a view, such a facility, that Benjamin argues against, using Klee's *Angel of History* as his metaphor for history as a chaotic pile of accumulating catastrophes.

The photographs of the ruins in Germany are like an exemplum of Benjamin's perspective on history; what they represent is a blasting out of the continuum (a term to which John Berger, in the epigraph to this section, has recourse as well). These photographs are also evocative of what Flusser dubs the Democritean: the randomness of drops of rain, rather than a river; the aleatoric movements of atoms in the void, rather than a flow of events. Both analogies (the rain, the atoms in the void) are from Democritus. As against the Heraclitean flowing stream, then, the Democritean is grounded in the moment, in shards and fragments, in incomprehensibility, in the random. These two binaries—the *durée*, as Bergson called it, and the absurd, or the Heraclitean versus the Democritean notions of time— are Flusser's working metaphors. They have recently been taken up in another book on photography and trauma by Ulrich Baer. Heavily influenced by Flusser, Baer writes, "In the photograph, time itself seems to have been carved up and ferried, unscathed, into the viewer's present; critics don conceptual and explanatory frames like tinted lenses to master this uncanny impression, maintaining a proper emotional and cognitive distance from the subject in order to map the picture onto an epistemological grid that structures the field between viewer and photograph."[36] Critics create grids, it would seem, for taxonomic and organizational purposes in order to

36 Ulrich Baer, *Spectral Evidence: The Photography of Trauma* (Cambridge, MA: MIT Press, 2005), 2.

control images. But critics do not, for Baer, *see* photographs; they classify them for viewing, even as they distance themselves from the photographs themselves. Critical works on photographs, then, for Baer, who follows Flusser's argument, do not really engage with photographs at all; rather, the photographs engage with them. If we acknowledge this impasse, how do we avoid it?

We might say that the photograph can be made to work on both ends of this Heraclitus/Democritus binary—indeed, Flusser suggests as much, arguing that a photograph consists both in process (particularly photographs that need to be developed) and dot codes (particularly in the digital realm). A given photograph can indeed be positioned into an "epistemological grid" of history when history is understood as a sequential, continuous narrative. At the same time, a photograph can also be viewed as a moment frozen in time; a fragment or irruption that both shatters and questions the *durée*. As Flusser puts it, with respect to the binary, "it is possible to reduce both sides to each other: to see a thin river in the rain, or a river in a dense rain."[37] It will be noted that both of these moves, disparate though they are, assume the economy of representation—that is, they both demonstrate the attempt to situate an event into time, and to iconologize it. If Flusser is right, and dot interval thinking is taking over linear thought, it might explain as well why the Democritean is today so frequently aligned with trauma: that which ruptures the continuum.

In any case, the photograph, then, at first appears to present a contradiction for the viewer: is it a random moment in time or metonymic of an endless sequence? And if we combine these, with what are we left? On the one hand, to repeat, the photograph is easily inserted into the stream that is traditionally understood as history; the photograph's claims to reality are undisturbed by such an insertion, perhaps even augmented. We can look at the ruins of 1945 and place them in the context of the Second World War, and thus thicken the

37 Flusser, "Crisis of Linearity," 11.

understanding of that particular historical era. At the same time, the photograph that is understood as a frozen moment of time, and thus outside any narrative, can be reinscribed a posteriori into history-as-narrative—a kind of cognitive backformation, demonstrating a moment of rupture in the fabric of time (linear or not). In this sense, then, viewing photographs seems only at first glance to provide an either/or choice. What we have come up against here, I think, is the ineluctability of narrative; as humans, we don't seem able to think without it.

Indeed, photographs insist on creating narratives, even the narrative that there is no continuous narrative at all, or the narrative that trauma has interrupted time. Metahistory itself, as Hayden White has famously put it with respect to historiography, can embrace or attempt to expel narrative from its writing; but narrative, it seems, will always out. Such seems to be the case for the spectral evidence of a photographic image as well. We can ask the viewer to bear witness rather than simply look; we can ask for a certain ethical responsibility and historical comprehension in the viewing of a given photograph. But narrative will somehow always reassert itself.

Consider the final photograph in this chapter (fig. 17). Is the wheeled object being pushed by the woman (walking with the man, in the center of the photograph) a grocery cart? Or is it a baby buggy? Probably the former, though it is hard to ascertain. Is the woman crossing the street in front of the couple with a bag a medical doctor, or just someone going home with black-market or other items? Again: clean streets, ruins, rubble, and debris everywhere that is not the street—the ruins go as far back as the eye can see. The image has a lot of foregrounding (attesting, in some opinions, to the photographer's amateur status), which allows the viewer to "admire" the cleanliness of the street, and the photographer, one may surmise, to keep her distance. Questions, like those we've directed at the other images, cannot be answered here, either. The intent in asking them, however, is primarily for the purpose of constructing (or at least imagining) a narrative for the viewer. We want to know what these

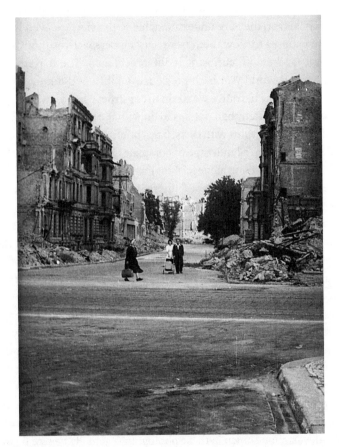

Fig. 17.

people are thinking, feeling, going through, so we can understand the "implications" of the image. On the one hand, the protagonists of these photographs are the endless, mind-boggling ruins that scar, not only the cityscapes, but also (metaphorically) the photographs themselves. But because the narrative that encloses these ruins is historical fact, they are understandable to the viewer—even if she or he chooses to view them from varying perspectives (horror, revenge, fascination, curiosity, indifference, etc.). The narrative of the Second World War is chronicled, even if from differing points of view. But the narrative we strain to construct when viewing these images more often than not has to do with the survivors, who here walk among the ruins with carts, bags, briefcases, and bicycles, as if all was normal in a landscape of complete desolation. It seems that we look at destruction alone fairly quickly, and that we want to "read" the people in the "ruinscapes" more urgently. When there are no people in the images, we often turn more quickly away.

Perhaps constructing a narrative is a type of psychological defense for the viewer, providing a backstory that serves to veil the wreckage that dominates. Mythology, after all, is the invention of explanations for events; a manner of putting order into what is otherwise incomprehensible. Creating narratives for images of disaster is another form of aestheticizing, thus muffling the image. Revenge itself implies a narrative: the idea that the lex talionis will right what has been overturned. Thus, from the perspective of revenge, images of catastrophic destruction on enemy territory merely put the scales of justice back into balance. So, too, a voyeuristic impetus in viewing these photographs is another narrative: imagining a participation in the events viewed. We then return to my initial question: can the devastation shown in these photographs actually be *seen* by the viewer, or are we fundamentally unable to avoid mentally editing, evading, aestheticizing, reinterpreting, or narrativizing them away? I think the answer is something like this: we cannot avoid reimaging the devastation presented to the eye.

Foregone and Other Conclusions

We have been considering texts, paintings, and photographs, the landscapes of which display not only (Allied) military force, but also revenge. Is there a question, now, of forgiveness? Certainly, there can be no forgiveness for the Holocaust, as Vladimir Jankélévitch (to cite perhaps the most profound philosophical argument) has demonstrated. But what if we are limiting ourselves to discussing the bombing of civilians? Both revenge and forgiveness are in any case problematic: forgiveness raises the possibility of forgetting, and revenge can prolong an endless cycle of violence. The Nazi and philosopher Carl Schmitt sublates these two by proposing amnesty: as willful forgetting, amnesty in principle also breaks the cycle of violence. Schmitt's binary of friend/enemy is of import here; in *The Concept of the Political*, he argues that the enemy is a necessary concept because state unification is formed by resistance to the Other. The enemy is not "just any partner of a conflict in general," writes Schmitt, nor is she or he a private adversary: "An enemy exists only when, at least potentially, one fighting collectivity of people confronts a similar collectivity. The enemy is solely the public enemy, because everything that has a relationship to such a collectivity of men, particularly to a whole nation, becomes public by virtue of such a relationship."[1] The enemy for Schmitt, in other words, allows the collective "we" to understand itself as such.

1 Carl Schmitt, *The Concept of the Political*, trans. Matthias Konzen and John P. McCormick (Chicago: University of Chicago Press, 2007), 28.

This is not an uncommon view. Jacques Lacan, for example, argues that subjects can be united only by a shared hatred of other subjects.[2] But his is, of course, a psychoanalytic approach. Hitler also thought shared hatred was a human trait, but he believed that a good leader should manipulate his people into loathing a common enemy, "for psychological reasons alone, it is not expedient to place two or more sets of adversaries before the masses." The people need to concentrate "the full and undivided force of their attack against a single adversary." The mistake the Pan-German Movement made, he writes, was failing to understand the need for a common enemy. Hitler adds, "The leader of genius must have the ability to make different opponents appear as if they belonged to the one category."[3] Hatred unites; this is essentially Schmitt's point when he argues that state unification is made possible by an impersonal enemy, an Other. The political enemy, writes Schmitt, need not be evil or "aesthetically ugly," but "he is, nevertheless, the other, the stranger … so that in the extreme case conflicts with him are possible." (27)[4]

The economy of shared hatred necessitates aggression and leads, inescapably, to revenge in the collectivity formed by the hatred itself. The inevitability of revenge also leads to a certain resignation on the part of the civilian population. As Sven Lindqvist puts it, after the 1940 bombing of Coventry,

2 Richard Macksey and Eugenio Donato, ed., *The Structuralist Controversy: The Languages of Criticism and the Sciences of Man* (Baltimore, MD: Johns Hopkins University Press, 1971), 186–201.

3 http://www.greatwar.nl/books/meinkampf/meinkampf.pdf. It is emphatically the case, however, that the choice of Jews as objects of hatred in the Third Reich was far from fortuitous. On this point see, e.g., Moishe Postone, "Anti-Semitism and National Socialism: Notes on the German Reaction to 'Holocaust,'" in *New German Critique* 19, no.1 (Winter 1980): 97–115, esp. 112–13.

4 It has been noted by several scholars that this is a Hegelian move by Schmitt (and Kojèvian at that), which may explain why *Concept of the Political* text was initially censored.

most of Coventry's citizens realized that a raid to avenge a raid that was in its turn revenge for an earlier raid would not prevent new raids, but just make the war even more bitter.[5]

Lindqvist also notes that, even today, "there is no hint in any British museum of the systematic attacks on German civilians in their homes, no hint that these attacks constituted crimes against international humanitarian law for the protection of civilians." (92) Is there a hint of such attacks in the museums of the United States, or France, or Russia? Many World War II museums in the US, for example, show bombers flying off to Germany, but what they don't show is the resulting civilian casualties.

In 2014, a new museum, the St. Nikolai, opened in Hamburg. The museum displays photographs of the Allied bombing of Hamburg in 1943, and its horrific results on the civilian population. It is the first such museum in Germany and has become popular with tourists. Billing itself as showing the "forgotten victims of the War," the St. Nikolai is a memorial honoring the civilian dead. What happened in Hamburg, Dresden, and other flattened cities is taken to constitute a war crime, and is presented as such. And yet today, there is insufficient discussion of war crimes in the contemporary targeting of civilians.[6] Drone attacks, the leveling of Palestinian, Syrian, and

5 Lindqvist, *History of Bombing*, 84.

6 See, however, the recent book by Philippe Sands, *East West Street: On the Origins of "Genocide" and "Crimes against Humanity"* (New York: Knopf, 2016). Sands writes that it was the Ukrainian Jewish lawyer Hersch Lauterpacht who formulated the concept of "crimes against humanity" in 1946. Lauterpacht argued that those three words needed to be included in the Nuremberg statute in order, in the words of Sands, "to describe the murder of four million Jews and Poles on the territory of Poland." (3) Sands argues that whereas Lauterpacht was interested in the protection of individuals, another lawyer, Rafael Remkin—also from Ukraine as well as Jewish—was more concerned with the protection of groups. Remkin coined the term "genocide."

Lebanese cities (to mention just three of many such destroyed areas), terrorist attacks in crowded urban centers, the catastrophic results of September 11—all of these aim at civilian populations and are largely reported by the media without mention of "war crimes." Televised reporting of these and other incidents of intentionally organized civilian deaths (including "lone wolves") can turn the viewer, from her or his "safe place," into a voyeur of sorts—titillated and fascinated, even as she or he is aghast.

Walter Benjamin's is a valiant attempt to overcome Romanticism. But his is an uphill battle, to say the least. It is hard to insist on a catastrophic view of history, and more difficult still to argue that history can only be understood as an "accumulation of failings." The Romantic view of bridging the gap between the material world and some sort of transcendent one is much more appealing. Perhaps that is why Romanticism has only very partially left us. Moreover, and equally vestigial to our way of thinking, is the fact that European Romanticism is in many ways tied to the idea of the nation. Marcel Detienne, in his study of French national identity, writes, "In Europe in any case, it is in the eighteenth century that the Nation, that of indigenous birth and of the great nationality of customs, begins to be formulated in a juridical figure, founded on a collection of individuals. The radical turn occurred on the 23rd of July, when the *Nation* is embodied in the Third Estate, with the grand revolutionary idea of a People."[7]

The idea of the nation can suggest the privileging of totality in a political and philosophical sense. Consequently, a line can be too easily drawn—and, arguably, simplistically—from the works of the early German Romantics, to the later writings of Fichte (e.g., *Reden an die Deutsche Nation*), to the totalitarian ideology of the Third Reich. Such a line was for many strongly insinuated when, in the spring of 2013,

7 Marcel Detienne, *L'Identité nationale, une énigme* (Paris: Gallimard, 2010), 46.

the Louvre, in putative conjunction with the German government, put together an exhibit entitled "De l'Allemagne—1800–1939: German Thought and Painting from Friedrich to Beckmann." The title of the exhibit alone seems to draw such a line with its dates, starting directly from the *Frühromantik* and ending on the eve of the Second World War. Further suggesting such a teleology from Romanticism to Nazism was the exhibit's rather sudden move from the writings of Goethe on plants (complete with stunning drawings by the writer) to, in the next room, a video excerpt from Leni Riefenstahl's *Olympia* (1936).

The exhibit was a Franco-German collaborative effort celebrating the fiftieth anniversary of the Elysée Treaty, meant to cement a friendship between the two countries. But friendship is not what ensued, at least with respect to the German press, and nationalism became the fraught subject surrounding the show. The exhibit included two hundred paintings, most of which had never been seen in France, and was divided into three parts: Apollonian and Dionysian (Nietzsche's terms, used to center on the search for a German identity beginning in 1800); The Hypothesis of Nature (with breathtaking paintings by Caspar Friedrich, and the Goethe plant studies and drawings mentioned); and Ecce Homo, works produced between the two world wars (neoromanticism or neo-expressionism). Apart from the Riefenstahl clip, the third part included works by Max Beckmann, Otto Dix, and a clip from Fritz Lang's *Metropolis* (1927). The section closed (most controversially) with the painting *Birds' Hell*, a satire of Nazism by Max Beckmann, who had been labeled "degenerate" by the Nazis and was living in exile.

For the German press, this installation clearly marked a teleological narrative from the dark ("Dionysian") paintings of the early nineteenth century straight to the inexorability of National Socialism. One journalist wrote, "German newspapers ... feel the Louvre is showing paintings of an abysmal country rocked by stark som-

ber powers that, via the Romantic period, was more or less headed straight for National Socialism."[8] Both the *Frankfurter Allgemeine* and *Die Zeit* responded with immediate anger, saying that "De l'Allemagne" "presents Germany as programmed for war and catastrophe, making the culture of National Socialism appear inevitable."[9] An art critic at *Die Zeit* wrote that "this French exhibition, in the country's largest museum, suggests that Nazism was the logical conclusion of German history and culture and that these could not do otherwise but to succumb to it."[10] Rebecca Lamarche-Vadel, the curator of Paris's Palais de Tokyo, makes the same argument in an article published in the German daily *Frankfurter Allgemeine* on April 6, 2013. "It is the suggestion of an inevitable German catastrophe," she writes, "of which all this darkness and Romanticism seems to be the harbinger, that makes the political subtext of this exhibition so irritating." Clearly, many saw the exhibit as an affront to Germany and German culture.

Henri Loyrette, director of the Louvre, sent a detailed response to *Die Zeit* on April 13th. "This long period was chosen [...]," he writes, "with no intention of causing a controversy, to allow three keys to understanding to be proposed to the French public: relations with the past; relations with nature; and relations with human endeavor. This choice has, among other things, the aim of avoiding any teleological reading which would indicate that there could be continuity from Romanticism to Nazism."[11] Whether or not the last sentence is

8 http://www.dw.com/en/creative-or-shocking-german-art-in-paris/a-1676 3370.
9 http://www.spectator.co.uk/arts/exhibitions/8909141/interrogating-the -german-soul/.
10 Adam Soboczynski: http://www.zeit.de/2013/15/ausstellung-louvre-deut sche-kunst.
11 http://www.lefigaro.fr/arts-expositions/2013/04/13/03015-20130413ART FIG00245-henri-loyrette-repondaux-attaques-du-zeit.php.

to be taken *à la lettre* remains to be conjectured, but Loyrette is emphatic that a teleological Bismark-Wilhelm-Hitler progression never crossed the curators' minds—quite the contrary, if Loyrette is to be believed.

All of which points to the fraught notion of the German *Sonderweg* (unique path). H. A. Winkler opens his study of modern German history by remarking,

Was there or was there not a German *Sonderweg*? Did Germany develop along its own "unique path" through history? This is one of the most controversial questions in German historical scholarship. For a long time, educated Germans answered it in the positive, initially by laying claim to a special German mission, then, after the collapse of 1945, by criticizing Germany's deviation from the West. Today, the negative view is predominant. Germany did not, according to the now prevailing opinion, differ from the great European nations to an extent that would justify speaking of a "unique German path." And in any case, no country on earth ever took what can be described as the "normal" path.[12]

One wonders if the Louvre exhibit incited so much German resentment because the exhibit itself seemed tacitly to suggest a *Sonderweg*—a path tracing a "line," as I called it earlier, starting from Romantic paintings and texts, through Goethe and his plant drawings, leading squarely to the initial triumph of the Third Reich. Romanticism seemed to pave the way to the Reich in that exhibit. On the one hand, Romanticism as a motivating force in nineteenth-

12 Heinrich August Winkler, *Germany: The Long Road West, Volume 1: 1789–1933*, trans. Alexander J. Sager (Oxford: Oxford University Press, 2006), 1. First published in Germany in 2000. For a rapid but very useful overview of this term and the controversies surrounding it, see also Jürgen Kocka, "German History before Hitler: The Debate about the German *Sonderweg*," *Journal of Contemporary History* 23, no.1 (January 1988): 3–16.

century German aesthetics is hardly disputable. As Winkler notes, "In France and Britain, too, Romanticism was a powerful force challenging the Enlightenment, but it was far more successful in Germany." (70) On the other hand, tracing the Romantic legacy straight to Nazism is at best dubious.

All of this engages questions of representation, as frequently noted in this book. To what extent does art (one thinks of Picasso's *Guernica* again, or paintings by Hofer and Kiefer) or a museum exhibit provide—wittingly or not—an occlusion for viewing horror, allowing the gaze instead to concentrate on details, or on the aesthetic? Is such an aestheticization an unacknowledged return to the Romantic gaze on ancient ruins? A museum exhibit can function like captions on photographs; it can manipulate and control the viewer's gaze.

Do photographs represent differently, or better, or at all? Is it in fact possible to represent mass civilian death from a distance—any distance—that the photograph provides, and thus manage to *see* the horror and its ethical implications (i.e., war crimes)? Is the sublime, in Burke's sense and in Kant's, such that viewing at a distance, or from a safe place, in fact the only way to gaze on representations of such disasters? These are the questions that have traversed this study, and the answers have been at best minimal, and certainly inconclusive.

Can we bear witness to the suffering of others? Can suffering be represented in such a way that the viewer recognizes the targeting of civilians as a war crime, and can respond, not only with a rejection of such tactics, on moral grounds, but also with the will to engage in resistance, or activism, to reduce human suffering? On rare occasion, one would think. But perhaps, in confronting representations—whether iconic or textual—of civilians suffering from war technologies, the viewer can be motivated to think beyond systems of collective hatred and the vicious cycle of revenge. Perhaps the viewer will be able to think beyond the category of "enemy" and see

that the real enemy, truism though this may be, is war itself, along with its political and technological machinery. Admittedly, this "perhaps" is a tenuous and very fragile one. Moreover, it has been tried before and has clearly failed—by Ernst Friedrich with his *War on War* and by many others. Here, then, I am proposing not a conclusion, but rather something like a paltry hope of sorts.

The texts, art images, and photographs we have considered lie in one kind of present; the beholder sees now, in the immediacy of her or his gaze, with a distance of a long stretch of time. The other present is the suffering occurring now in the world, to which these images of the past serve as an echo, even as they often work, paradoxically, to help the beholder put the horror aside by aestheticizing the image or the textual description of horror. Memory and amnesia are not necessarily contradictory, as noted earlier. They work in tandem, alternating like electrical currents. So, too, seeing and refusing to see. These are incongruities that will not be tamed, that no amount of theorizing or moralizing will domesticate.

———————————

In lieu of a conclusion, the appendix to this book contains more of my mother's photographs of German towns in 1945, after the War. I have another tenuous hope in exhibiting these photographs: that having read this study, the viewer will be able (will want, even) to see them somewhat differently.

Appendix

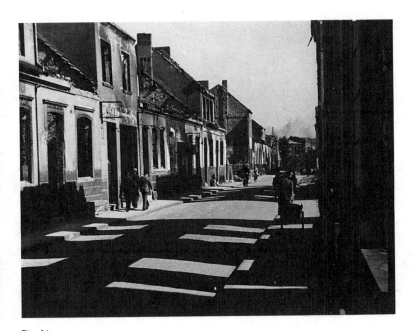

Fig. A1.

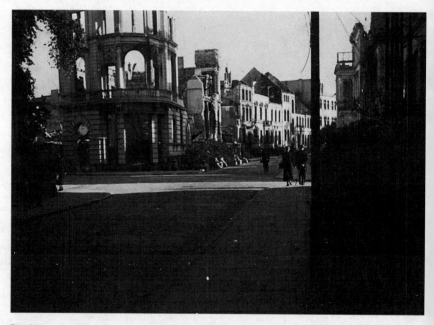

Fig. A2.

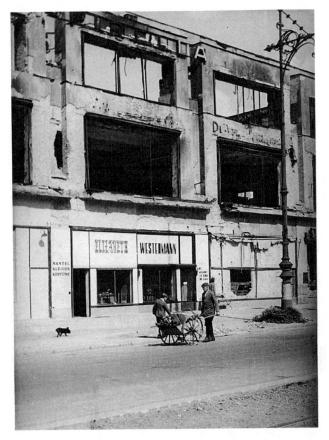

Fig. A3.

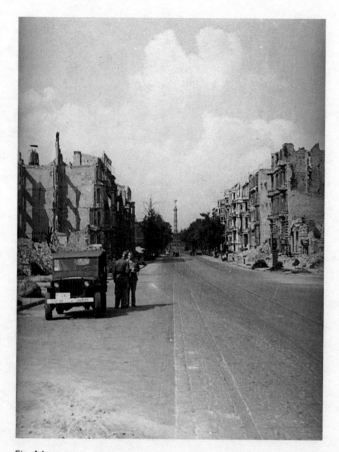

Fig. A4.

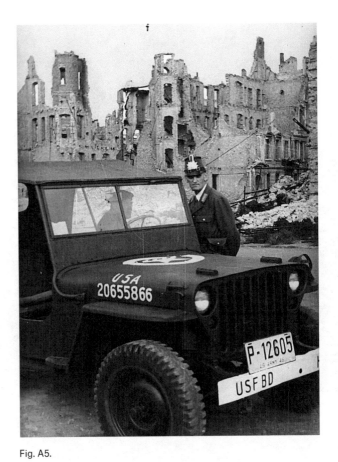

Fig. A5.

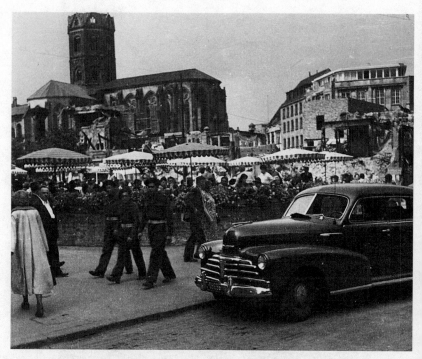

Fig. A6.

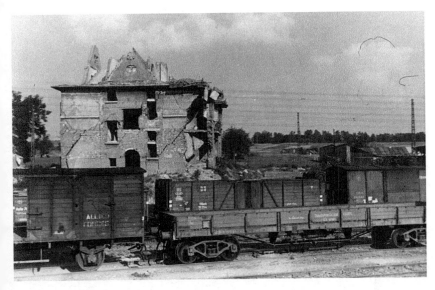

Fig. A7.

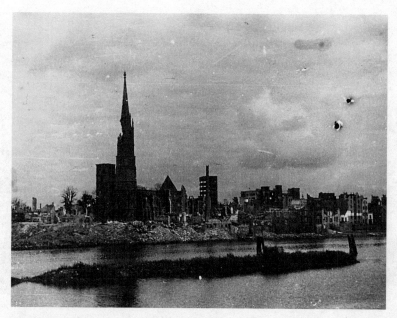

Fig. A8.

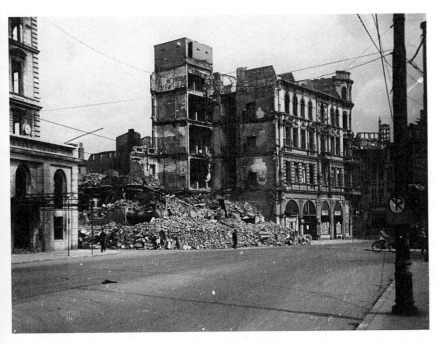

Fig. A9.

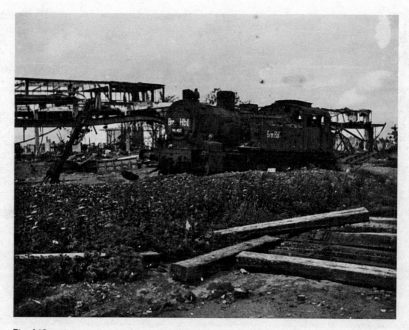

Fig. A10.

Fig. A11.

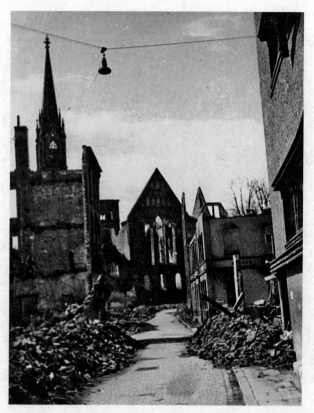

Fig. A12.

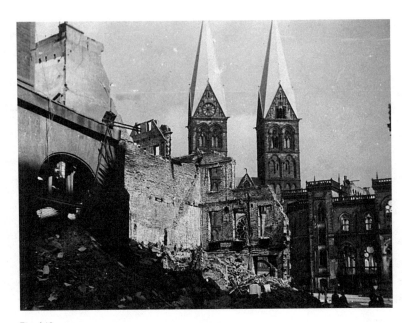

Fig. A13.

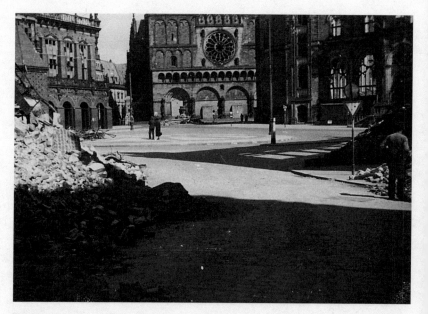

Fig. A14.

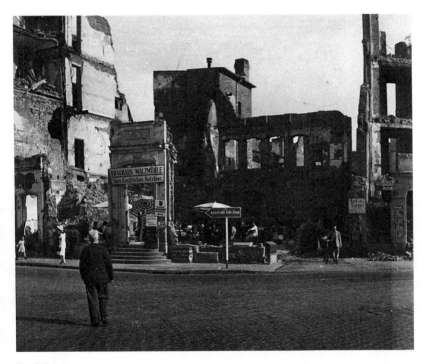

Fig. A15.

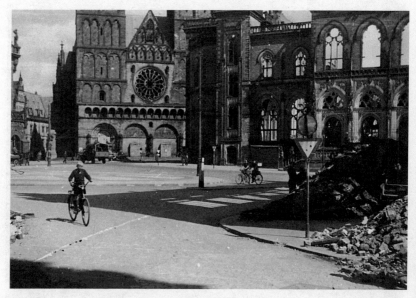

Fig. A16.

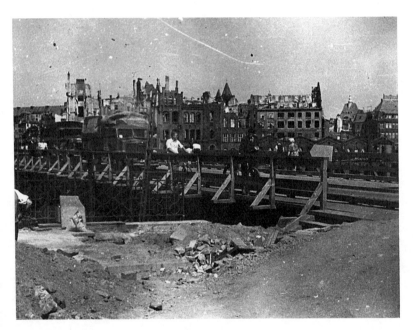

Fig. A17.

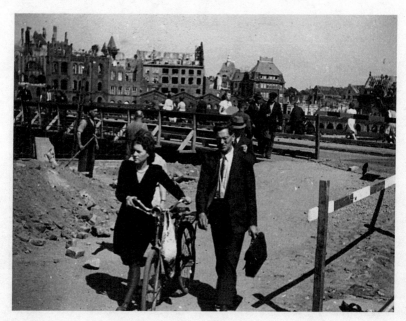

Fig. A18.

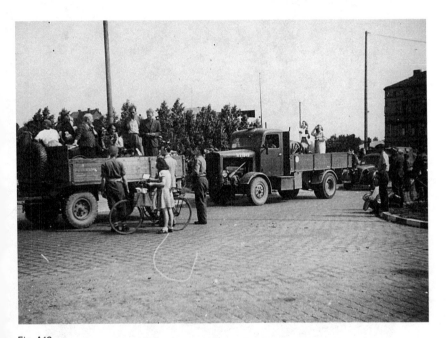

Fig. A19.

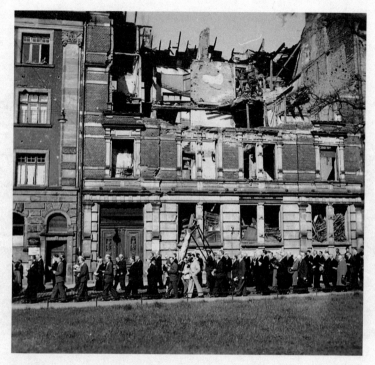

Fig. A20.

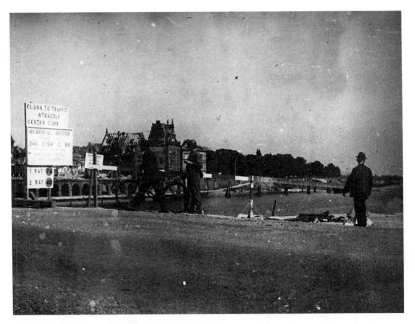

Fig. A21.

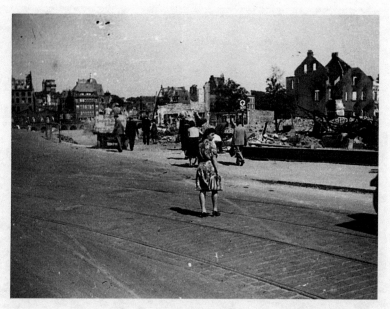

Fig. A22.

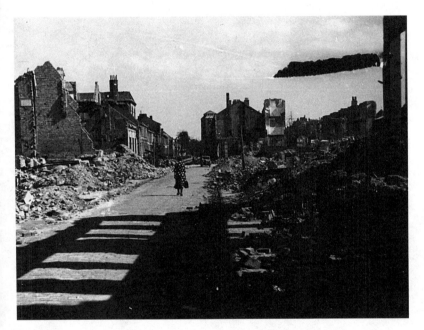

Fig. A23.

Fig. A24. Jeanne Dumilieu, ca. 1945.

Acknowledgments

Many thanks to the University of Chicago Humanities Council, whose generous research funds did much to make the research for this book possible. I am most grateful. Martha Roth, the dean of humanities at the University of Chicago during the majority of this study, was very supportive and singularly helpful. The subsequent dean, Anne Robertson, has also been of great assistance and encouragement.

As always, my friends have been unwavering in their support of this project, and in putting up with my constant questions. Dianne Levitin was involved from the beginning, helping me try to make sense of the photographs early on, and arguing with me about pretty much all of it, once she had the text to read. Raquel Scherr also read the manuscript and did her usual brilliant and insightful editing, painstakingly correcting and questioning. This book is dedicated to Dianne and Raquel—wonderful readers and thinkers, incredible friends. They know the rest.

Ziva Ben-Porat also read, commented on, and discussed the manuscript with me at length. I continue, as always, to profit immensely from her deep insights, her perspective (with the ensuing constant— and stimulating—disputes), and unfaltering friendship.

Many friends who are also colleagues gave me their support and help (intellectual as well as tactical). Jás Elsner, with his usual depth and incisive astuteness, read and commented on the historical passages about ruins, and gave me much bibliographical homework,

insights, and interpretations. The course Jás and I taught together at the University of Chicago on ruins, and the present book that emerged, greatly helped to shape my argument and to educate my interpretations. Sepp Gumbrecht read much of the text and vigorously supported me during various publication problems. W. J. T. Mitchell also read the manuscript, cheered me on, and provided me with his deep understanding of images. Christine Mehring generously responded to some of my concerns about Karl Hofer and modern German art more generally. I also thank Werner Sollors, and my friend and colleague Thomas Pavel, for their generosity and encouragement.

The important photographer and my friend Alan Cohen helped enormously with commenting on the photographs, guiding and educating me on how to view them, and arranging to have them digitally reproduced. I am most grateful for his patience and for his expertise. To my editor, Alan Thomas, an excellent photographer in his own right, I give grateful acknowledgment as well. Many thanks are also due to Randolph Petilos at the press, for his help in getting the rights for the Hofer and Kiefer images, and for checking and correcting the manuscript. And to Susan Karani, my excellent copyeditor, whose calm forbearance and perceptive reading of the text could not have been more helpful.

I have been blessed with two terrific research assistants: Mikki Kressbach, who was in on the beginning of this project, and David Burnham, who followed. Both helped to keep me bibliographically honest and did what they could to bring clarity and reasoning to the manuscript.

My thanks as always to David Tracy, dearest friend and remarkable philosopher, who read the manuscript with his usual care and assured me of his belief in it. And to my husband, Bernard Rubin, always my first reader and cherished interlocutor. Finally, to our daughter Marie-Claude, who (in spite of her youth) fully understood

the necessarily fragmented and somewhat aleatoric nature of this study, and conveyed that understanding to me.

Parts of this book were read at varying venues, and I profited greatly from the ensuing discussions: the Sorbonne in Paris, the Lévinas Seminar also in Paris (twice), the University of Chicago's Center in Paris (which was also good enough to mount an exhibit of some of the photographs), Duke University, Stanford University, Western University in Canada, and the Franke Humanities Institute at the University of Chicago. I am also grateful to the press's readers of this manuscript, whose suggestions were helpful.

Bibliography

Adorno, Theodor. *Minima Moralia: Reflections from Damaged Life.* Translated by E.F.N. Jephcott. New York: Verso, 2005.

Adorno, Theodor, and Max Horkheimer. *Dialectic of Enlightenment: Philosophical Fragments.* Translated by Edmund Jephcott. Stanford, CA: Stanford University Press, 2002.

Agamben, Giorgio. *Homo Sacer: Le pouvoir souverain et la vie nue.* Translated by Marilène Raiola. Paris: Éditions du Seuil, 1997.

———. *The Time That Remains.* Translated by Patricia Daley. Stanford, CA: Stanford University Press, 2005.

Agee, Joel. *Twelve Years: An American Boyhood in East Germany.* Chicago: University of Chicago Press, 2000.

Althusser, Louis. *Lenin and Philosophy and Other Essays.* Translated by Ben Brewster. New York: Monthly Review Press, 1971.

Anderson, Benedict. *Imagined Communities.* New York: Verso, 1983.

Anonymous. *A Woman in Berlin: Eight Weeks in the Conquered City.* Translated by Philip Boehm. New York: Picador, 2005.

Antelme, Robert. "Revenge." In *On Robert Antelme's The Human Race: Essays and Commentary,* edited by Daniel Dobbels. Translated by Jeffrey Haight. Evanston, IL: Northwestern University Press, 2003.

Arendt, Hannah. "The Aftermath of Nazi Rule: Report from Germany," in *Commentary* X/10, 1950.

———. *Denktagebuch.* Munich: Piper Verlag, 2002.

———. *The Origins of Totalitarianism.* New York: Meridian, 1962.

———. *Le système totalitaire.* Paris: Gallimard, 2002.

Asad, Talal. "Reflections on Violence, Law, and Humanitarianism." *Critical Inquiry* 41, no. 2 (Winter 2015): 390–427.

Assman, Jan. *Moses the Egyptian: The Memory of Egypt in Western Monotheism*. Cambridge, MA: Harvard University Press, 1998.

Assmann, Aleida. *Cultural Memory and Western Civilization: Functions, Media, Archives*. New York: Cambridge University Press, 2013.

Azoulay, Ariella. *The Civil Contract of Photography*. Translated by Rela Mazali and Ruvik Danieli. New York: Zone, 2008.

———. *Civil Imagination: A Political Ontology of Photography*. Translated by Louise Bethlehem. New York: Verso, 2012.

———. *From Palestine to Israel: A Photographic Record of Destruction and State Formation, 1947–1950*. Translated by Charles Kamen. London: Pluto Press, 2011.

Bachelard, Gaston. *The Poetics of Space*. Translated by Maria Jolas. Boston: Beacon Press, 1994.

Badiou, Alain. *L'éthique: Essai sur la conscience du mal*. Paris: Nous, 2003.

Baer, Ulrich. *Spectral Evidence: The Photography of Trauma*. Cambridge, MA: MIT Press, 2005.

Balzac, Honoré de. *Le père Goriot*. Paris: Garnier-Flammarion, 1966.

Barthes, Roland. *Camera Lucida: Reflections on Photography*. Translated by Richard Howard. New York: Hill and Wang, 1981.

———. *La chambre claire: Note sur la photographie*. Paris: Gallimard, 1989.

———. "L'effet du réel." *Communications* 11 (1968): 84–89.

Bedford, Sylvia. *A Legacy*. Washington, DC: Counterpoint, 2001.

Beer, Edith Hahn, and Dworkin, Susan. *The Nazi Officer's Wife: How One Jewish Woman Survived the Holocaust*. New York: Harper Collins, 2000.

Beevor, Anthony. *The Fall of Berlin 1945*. New York: Penguin, 2003.

Benjamin, Walter. *Illuminationen*. Frankfurt: Suhrkamp Verlag, 1955.

———. *Illuminations*. Translated by Harry Zohn. New York: Schocken, 1969.

———. *L'Œuvre d'art à l'époque de sa reproductibilité technique*. Translated by Lionel Duvoy. Paris: Éditions Allia, 2013.

———. *Petite histoire de la photographie*. Translated by Lionel Duvoy. Paris: Éditions Allia, 2012.

———. *Reflections*. Translated by Edmund Jephcott. New York: Schocken, 1978.

———. *Selected Writings*. Volume 2, *1927–1934*. Edited by Michael W. Jennings, Howard Eiland, and Gary Smith. Translated by Rodney Livingston et al. Cambridge, MA: Belknap Press of Harvard University Press, 1999.

———. *Understanding Brecht*. Translated by Anna Bostock. New York: Verso, 1988.

——. *The Writer of Modern Life*. Edited by Michael Jennings. Translated by Howard Eiland et al. Cambridge, MA: Harvard University Press, 2006.

Berger, John. *Understanding a Photograph*. Edited by Geoff Dyer. New York: Penguin, 2013.

Bergson, Henri. *Matière et mémoire*. In *Henri Bergson, Oeuvres*, edited by André Robinet. Paris: Presses universitaires de France, 1959.

Bernstein, Michael André. *Forgone Conclusions: Against Apocalyptic History*. Berkeley: University of California Press, 1994.

Birkenhead, Frederick Winston Furneaux Smith, Earl of. *The Prof in Two Worlds: The Official Life of Professor F.A. Lindemann, Viscount Cherwell*. London: Collins, 1961.

Blanchot, Maurice. *Political Writings, 1953–1993*. Translated by Zakir Paul. New York: Fordham University Press, 2010.

——. *The Writing of the Disaster*. Translated by Ann Smock. Lincoln: University of Nebraska Press, 1986.

Boltanski, Luc. *Distant Suffering: Morality, Media, and Politics*. Translated by Graham Burchell. New York: Cambridge University Press, 1999.

Bouhours, Jean-Michel. *Anselm Kiefer*. Paris: Éditions du Centre Pompidou, 2015.

Bourke-White, Margaret. *"Dear Fatherland, Rest Quietly": A Report on the Collapse of Hitler's Thousand Years*. New York: Simon and Schuster, 1946.

Boym, Svetlana. *The Future of Nostalgia*. New York: Basic Books, 2001.

——. "Ruinophilia: Appreciation of Ruins." In *Atlas of Transformation*, edited by Zbynek Baladrán and Vit Havránek. Zurich: JRP Ringier, 2011.

Bradley, David. *No Place to Hide*. Boston: Little, Brown and Company, 1948.

Buch, Robert. *The Pathos of the Real: On the Aesthetics of Violence in the Twentieth Century*. Baltimore, MD: Johns Hopkins University Press, 2010.

Buchloh, Benjamin H. D. "Figures of Authority, Ciphers of Regression: Notes on the Return of Representation in European Painting." *October*. 16 (Spring 1981): 39–68.

Buck-Morss, Susan. *The Dialectics of Seeing: Walter Benjamin and the Arcades Project*. Cambridge, MA: MIT Press, 1991.

Burke, Edmund. *A Philosophical Inquiry into the Origin of Our Ideas of the Sublime and Beautiful*. Oxford: Oxford University Press, 2015.

Butler, Judith. *Precarious Life: The Powers of Mourning and Violence*. New York: Verso, 2006.

Carrara, Alfonso. *Happenchance: World War II Photographs, Italian Campaign*. Chicago: Italian Cultural Institute, 2015.

218 BIBLIOGRAPHY

Caruth, Cathy. *Unclaimed Experience: Trauma, Narrative, and History*. Baltimore, MD: Johns Hopkins University Press, 1996.

Cavell, Stanley. *The World Viewed*. New York: Viking, 1979.

Celan, Paul. "Todesfuge." In *Poems of Paul Celan: Revised and Expanded*. Translated by Michael Hamburger. New York: Persea, 2002.

Chaumont, Jean-Michel. *La concurrence des victimes: Génocide, identité, reconnaissance*. Paris: Éditions La Découverte, 1997.

Churchill, Winston. *The Second World War*. Volume 3, *The Grand Alliance*. Boston: Houghton Mifflin, 1950.

———. *The Second World War*. Volume 4, *The Hinge of Fate*. Boston: Houghton Mifflin, 1950.

Cohen, Alan. *Earth with Meaning*. Edited by Mary Jane Jacob. Chicago: Distributed Art Publishers, Inc., 2015.

Dagen, Philippe, ed. *Anselm Kiefer: Sternenfall, Chute d'étoiles; Monumenta 2007*. Paris: Éditions du Regard, 2007.

Dagerman, Stig. *German Autumn*. Translated by Robin Fulton Macpherson. Minneapolis: University of Minnesota Press, 2011.

Dean, Carolyn. *Aversion and Erasure: The Fate of the Victim after the Holocaust*. Ithaca, NY: Cornell University Press, 2010.

de Certeau, Michel. *The Practice of Everday Life*. Translated by Steven Rendall. Berkeley: University of California Press, 1984.

Derrida, Jacques. *Athens, Still Remains: The Photographs of Jean-François Bonhomme*. Translated by Pascale-Anne Brault and Michael Nass. New York: Fordham University Press, 2010.

———. *Memoirs of the Blind: The Self-Portrait and other Ruins*. Translated by Pascale-Anne Brault and Michael Nass. Chicago: University of Chicago Press, 1993.

———. "Violence and Metaphysics." *Writing and Difference*. Translated by Alan Bass. London: Routledge, 2005.

———. *Writing Difference*. Translated by Alan Bass. Chicago: University of Chicago Press, 2017.

Detienne, Marcel. *L'identité nationale, une énigme*. Paris: Gallimard, 2010.

Didi-Huberman, Georges. *Ce que nous voyons, ce qui nous regarde*. Paris: Éditions de Minuit, 1992.

———. *Quand les images prennent position: l'œil de l'histoire, 1*. Paris: Éditions de Minuit, 2009.

Dillon, Brian, ed. *Ruins*. New York: MIT Press, 2011.

Dillon, Brian. *Ruin Lust: Artists' Fascination with Ruins, from Turner to the Present Day*. London: Tate, 2014.

Doane, Mary Ann. "The Indexical and the Concept of Medium Specificity." In *differences* 18, no. 1 (2007): 128–52.

Dobie, J. Frank. "What I Saw Across the Rhine." *National Geographic* 91, no. 1 (January 1947): 57–86.

Douhet, Giulio. *The Command of the Air*. Translated by Dino Ferrari. Washington, DC: Office of Air Force History, 1983.

Elsner, Jás. "From the Pyramids to Pausanias and Piglet: Monuments, Travel and Writing." In *Art and Text in Ancient Greek Culture*, ed. Simon Goldhill and R. Osborne, 244–52ff. (Cambridge: Cambridge University Press, 1994).

———. "Picturesque and Sublime: Impacts of Pausanias in Late Eighteenth- and Early Nineteenth-Century Britain." *Classical Receptions Journal* 2, no. 2 (2010): 219–53.

Fassin, Didier. "Un éthos compassionnel." In *La souffrance sociale: Nouveau malaise dans la civilisation*, edited by Marc-Henry Soulet. Fribourg, Switzerland: Academic Press Fribourg, 2009.

Feldman, Shoshana. *The Juridical Unconscious: Trials and Traumas in the Twentieth Century*. Cambridge, MA: Harvard University Press, 2002.

Flaubert, Gustave. *Correspondence*. Edited by Giovanni Bonaccorso. Saint-Genouph, France: Nizet, 2001.

Flusser, Vilém. "Krise der Linearität." In *Absolut Vilém Flusser*, edited by Nils Röller and Silvia Wagnermaier. Freiburg: Orange-Press, 2003.

———. *Towards a Philosophy of Photography*. London: Reaktion, 2000.

Foer, Jonathan Safran. *Extremely Loud and Incredibly Close*. New York: Mariner, 2006.

Fried, Michael. *Absorption and Theatricality: Painting and Beholder in the Age of Diderot*. Chicago: University of Chicago Press, 1980.

———. *Why Photography Matters as Art as Never Before*. New Haven, CT: Yale University Press, 2008.

Friedlander, Eli. *Walter Benjamin: A Philosophical Portrait*. Cambridge, MA: Harvard University Press, 2012.

Friedlander, Saul. "Historical Writing and the Memory of the Holocaust." In *Writing and the Holocaust*, edited by Berel Lang. New York: Holmes and Meier, 1988.

Friedrich, Jörg. *The Fire: The Bombing of Germany 1940–1945*. Translated by Allison Brown. New York: Columbia University Press, 2006.

Freud, Sigmund. *Civilization and Its Discontents.* Edited and Translated by James Strachey. New York: Norton, 1962.

Genette, Gérard. "Frontières du récit." In *L'analyse structurelle du récit,* 158–69. Paris: Éditions du Seuil, 1981.

Gere, Kathy. *Knossos and the Prophets of Modernism.* Chicago: University of Chicago Press, 2009.

Goodman, John, ed. *Diderot on Art.* Volume 2, *The Salon of 1767.* New Haven, CT: Yale University Press, 1995.

Gordillo, Gastón. *Rubble: The Afterlife of Destruction.* Durham, NC: Duke University Press, 2014.

Grass, Günter. *Crabwalk.* New York: Harcourt Inc., 2003.

Grosshans, Henry. *Hitler and the Artists.* New York: Holmes & Meier, 1983.

Grossmann, Atina. *Jews, Germans, and Allies: Close Encounters in Occupied Germany.* Princeton, NJ: Princeton University Press, 2007.

———. "A Question of Silence: The Rape of German Women by Occupation Soldiers." *October* 72 (Spring 1995): 42–63.

Gumbrecht, Hans Ulrich. *After 1945: Latency as Origin of the Present.* Stanford, CA: Stanford University Press, 2013.

Hamon, Philippe. "Qu'est-ce qu'une description?" *Poétique* 12 (1972): 465–85.

Harbison, Robert. *Ruins and Fragments: Tales of Loss and Rediscovery.* London: Reaktion, 2015.

Harris, Sir Arthur. *Bomber Offensive.* Toronto: Stoddart, 1990.

Hegel, G. W. F. *The Philosophy of History.* Translated by J. Sibree. New York: Dover, 1956.

———. "The Life of Jesus." In *Three Essays, 1793-1795,* edited and translated by Peter Fuss and John Dobbins. Notre Dame, IN: University of Notre Dame Press, 1984.

Heidegger, Martin. *Nietzsche: The Will to Power as Art.* Vol. 1. Translated by David Farrell Krell. New York: Harper and Row, 1979.

Hell, Julia, and Andreas Schönle, eds. *Ruins of Modernity.* Durham: Duke University Press, 2010.

Herzog, Dagmar. *Sex after Fascism: Memory and Morality in Twentieth-Century Germany.* Princeton, NJ: Princeton University Press, 2005.

Hinz, Berthold. *Art in the Third Reich.* New York: Pantheon, 1979.

Hirsch, Marianne. *Family Frames: Photography, Narrative, and Postmemory.* Cambridge, MA: Harvard University Press. 2012.

———. *The Generation of Postmemory: Writing and Visual Culture after the Holocaust.* New York: Columbia University Press, 2012.

Hofer, Karl. "Der Kampf um die Kunst." *Karl Hofer: Schriften*. Berlin: Gebr. Mann Verlag, 1995.

———. *Karl Hofer aus Leben und Kunst*. Berlin: Rembrandt Verlag, 1952.

———. "What Is German Art?" in *German Expressionist Art: The Robert Gore Rifkind Collection*, edited by Orrel P. Reed. Los Angeles: Frederick S. Wight Art Gallery and University of California Los Angeles, 1977.

Hoffmann, Stefan-Ludwig. "Gazing at Ruins: German Defeat as Visual Experience." *Journal of Modern European History* 9, no. 30 (November 2011): 328–50.

Homans, Peter, ed. *Symbolic Loss: The Ambiguity of Mourning and Memory at Century's End*. Charlottesville: University Press of Virginia, 2000.

Hull, Isabel V. *Absolute Destruction: Military Culture and the Practices of War in Imperial Germany*. Ithaca, NY: Cornell University Press, 2005.

Hung, Wu. *A Story of Ruins: Presence and Absence in Chinese Art and Visual Culture*. Princeton, NJ: Princeton University Press, 2012.

Hunt, Irmgard. *On Hitler's Mountain: Overcoming the Legacy of a Nazi Childhood*. New York: Harper Collins, 2006.

Huyssen, Andreas. *Miniature Metropolis: Literature in an Age of Photography and Film*. Cambridge, MA: Harvard University Press, 2015.

———. *Present Pasts: Urban Palimpsests and the Politics of Memory*. Stanford, CA: Stanford University Press, 2003.

Iversen, Margaret. *Photography, Trace, and Trauma*. Chicago: University of Chicago Press, 2017.

Jankélévitch, Vladimir. *Forgiveness*. Translated by Andrew Kelley. Chicago: University of Chicago Press, 2005.

Jennings, Michael. *Dialectical Images: Walter Benjamin's Theory of Literary Criticism*. Ithaca, NY: Cornell University Press, 1987.

Judt, Tony. *Postwar: A History of Europe since 1945*. New York: Penguin, 2006.

Kant, Immanuel. *Critique of Judgment*. Translated by Werner S. Pluhar. Indianapolis: Indiana University Press, 1987.

———. *Observations on the Feeling of the Beautiful and Sublime*. Translated by John T. Goldthwait. Berkeley: University of California Press, 1960.

Kaplan, Alice Yaeger. *Reproductions of Banality: Fascism, Literature, and French Intellectual Life*. Minneapolis: University of Minnesota Press, 1986.

Karp, George A. *The Maquis Connection*. Glencoe, IL: Amber Mountain Press, 2016.

Kelsey, Robin, and Blake Stimson, eds. *The Meaning of Photography*. Williamstown, MA: Sterling and Francis Clark Institute, 2008.

Kernan, Thomas. *France on Berlin Time*. Philadelphia: J. B. Lippincott Company, 1941.

Kertész, Imre. *Fatelessness*. New York: Random House, 2004.

Kershaw, Anthony. *The End: Germany 1944–45*. New York: Penguin, 2011.

Kiefer, Anselm. *L'art survivra à ses ruines; Art Will Survive Its Ruins: Anselm Kiefer au Collège de France*. Paris: Éditions du Regard, 2011.

Kirsch, Adam. "Beware of Pity: Hannah Arendt and the Power of the Impersonal." *New Yorker*, January 12, 2009.

Klein, Dennis B. "Resentment and Recognition: Toward a New Conception of Humanity in Amery's 'At the Mind's Limits.'" In *On Jean Améry: Philosophy of Catastrophe*, edited by Magdalena Zolkos. Lanham, MD: Lexington, 2011.

Kluge, Alexander. *Air Raid*. Translated by Martin Chalmers. New York: Seagull, 2014.

Knell, Hermann: *To Destroy a City: Strategic Bombing and Its Human Consequences in World War II*. Cambridge, MA: De Capo, 2003.

Kocka, Jürgen. "German History before Hitler: The Debate about the German *Sonderweg*." *Journal of Contemporary History* 23, no. 1 (January 1988): 3–16.

Krammer, Mario. *Berlin und das Reich: Die Geschichte der Reichshauptstadt*. Berlin: Ullstein A. G., 1935.

Kuspit, Donald. "Diagnostic Malpractice: The Nazis on Modern Art." *Artforum International* 25 (1986): 90–98.

LaCapra, Dominick. *Writing History, Writing Trauma*. Baltimore, MD: Johns Hopkins University Press, 2001.

Ladd, Brian. *The Ghosts of Berlin: Confronting German History in the Urban Landscape*. Chicago: University of Chicago Press, 1997.

Lavocat, Françoise. *Pestes, incendies, naufrages: Écritures du désastre au dix-septième siècle*. Turnhout, Belgium: Brepols, 2011.

LeFebvre, Henri. *The Production of Space*. Translated by Donald Nicholson-Smith. Cambridge, MA: Blackwell, 1991.

Lejeune, Philippe. *The Autobiographical Pact*. In *On Autobiography*, translated by Katherine Leary. Minneapolis: University of Minnesota Press, 1989.

Lem, Stanislaw. *Imaginary Magnitude*. Translated by Marc E. Heine. San Diego: Harcourt Brace Jovanovich, 1984.

Lévinas, Emmanuel. *Alterity and Transcendence*. Translated by Michael B. Smith. New York: Columbia University Press, 1999.

———. *Humanisme de l'autre homme*. Saint Clément de Rivière, France: Fata Morgana, 1972.

———. "Substitution." *Otherwise than Being, or, Beyond Essence.* Translated by
 Alphonso Lingis. Pittsburgh: Duquesne University Press, 1998.
———. "Useless Suffering." In *Entre Nous: Thinking of the Other.* Translated by
 Michael B. Smith and Barbara Harshav. New York: Columbia University
 Press, 1998.
Liebman, Stuart, ed. "Berlin 1945: War and Rape; 'Liberators Take Liberties.'"
 October 72 (Spring 1995): 1–114.
Lindqvist, Sven. *A History of Bombing.* Translated by Linda Haverty Rugg. New
 York: New Press, 2001.
Lubrich, Oliver, ed. *Travels in the Reich, 1933–1945: Foreign Authors Report from
 Germany.* Translated by Kenneth Norcott, Sonia Wichmann, and Dean
 Krouk. Chicago: University of Chicago Press, 2010.
Lustig, Sandra H., and Ian Leveson, eds. "A Response to Diana Pinto."
 In *Turning the Kaleidoscope: Perspectives on European Jewry.* New York:
 Berghahn, 2006.
Macksey, Richard, and Eugenio Donato, eds. *The Structuralist Controversy:
 The Languages of Criticism and the Sciences of Man.* Baltimore, MD: Johns
 Hopkins University Press, 1971.
Martin, Pauline, and Parise, Maddalena. *L'œil photographique de Daniel Arasse:
 Théories et pratiques d'un regard.* Lyon: Fage Editions, 2012.
Marx, Ursula, et al., eds. *Walter Benjamin's Archive: Images, Texts, Signs.* Trans-
 lated by Esther Leslie. New York: Verso, 2007.
Mazower, Mark. *Dark Continent: Europe's Twentieth Century.* New York:
 Vintage, 2000.
Mehlman, Jeffrey. *Walter Benjamin for Children: An Essay on His Radio Years.*
 Chicago: University of Chicago Press, 1993.
Meyer, Beate et al, ed. *Jews in Berlin: From Kristallnacht to Liberation.* Chicago:
 University of Chicago Press, 2009.
Minow, Martha. *Between Vengeance and Forgiveness: Facing History after Geno-
 cide and Mass Violence.* Boston: Beacon, 1998.
Mitchell, W. J. T. *What Do Pictures Want? The Lives and Loves of Images.* Chicago:
 University of Chicago Press, 2005.
Moeller, Robert G. "Germans as Victims? Thoughts on a Post–Cold War
 History of World War II's Legacies." *History and Memory* 17, nos. 1–2 (2005):
 147–94.
Morris, Errol. *Believing Is Seeing: Observations on the Mysteries of Photography.*
 New York: Penguin, 2014.

Mortier, Roland. *La poétique des ruines en France: Ses origines, ses variations de la Renaissance à Victor Hugo.* Geneva: Librarie Droz, 1974.

Muhle, Kirsten. *Karl Hofer (1878–1955): Untersuchungen zur Werkstruktur.* Lohmar, Germany: Josef Eul Verlag, 2000.

Nägele, Rainer, ed. *Benjamin's Ground: New Readings of Walter Benjamin.* Detroit: Wayne State University Press, 1988.

Neiman, Susan. *Evil in Modern Thought: An Alternative History of Philosophy.* Princeton, NJ: Princeton University Press, 2002.

Nietzsche, Friedrich. *The Case of Wagner: Nietzsche contra Wagner, and Selected Aphorisms.* Translated by Anthony M. Ludovici. New York: Gordon, 1974.

———. *Twilight of the Idols and the Anti-Christ.* Translated by R. J. Hollingdale. New York: Penguin, 1968.

Nossack, Hans Erich. *The End: Hamburg 1943.* Translated by Joel Agee. Chicago: University of Chicago Press, 2004.

Novick, Peter. *The Holocaust in American Life.* New York: Mariner, 2000.

O'Brian, Patrick. *Picasso: A Biography.* New York: Norton, 1994.

O'Donnell, James P. *The Bunker: The History of the Reich Chancellery Group.* Boston: Houghton Mifflin, 1978.

Oehler, Dolf. *Le spleen contre l'oubli Juin 1848: Baudelaire, Flaubert, Heine, Herzen.* Paris: Éditions Payot & Rivages, 1996.

Olick, Jeffrey K. *In The House of the Hangman: The Agonies of German Defeat 1943-1949.* Chicago: University of Chicago Press, 2005.

Orlando, Francesco. *Obsolete Objects in the Literary Imagination: Ruins, Relics, Rarities, Rubbish, Uninhabited Places, and Hidden Treasures.* Translated by Gabriel Pihas, Daniel Seidel et al. New Haven, CG: Yale University Press, 2006.

Palumbo-Liu, David. *The Deliverance of Others: Reading Literature in a Global Age.* Durham, NC: Duke University Press, 2012.

Picasso, Pablo. "In Conversation with Christian Zervos." *Cahiers d'Art* 10, no. 1 (1935): 173-78.

Plato. "Phaedrus." In *Plato: The Collected Dialogues*, edited by Edith Hamilton and Huntington Cairns, translated by Lane Cooper. Princeton, NJ: Princeton University Press, 1973.

Portelli, Alessandro. "So Much Depends on a Red Bus, or, Innocent Victims of the Liberating Gun." *Oral History* 34, no. 2: War Memory (Autumn 2006): 29–43.

Porter, James I. "Ideals and Ruins: Pausanias, Longinus, and the Second

Sophistic." In *Pausanias: Travel and Memory in Roman Greece*, edited by S. E. Alcock and Jás Elsner. Oxford: Oxford University Press, 2003.

Postone, Moishe. "Anti-Semitism and National Socialism: Notes on the German Reaction to 'Holocaust.'" *New German Critique* 19, no. 1 (Winter 1980): 97–115.

Rancière, Jacques. *The Future of the Image*. London: Verso, 2009.

———. *Malaise dans l'esthétique*. Paris: Éditions Galilée, 2004.

———. *The Politics of Aesthetics*. Translated by Gabriel Rockhill. New York: Continuum, 2004.

Rankin, Nicholas. *Telegram from Guernica: The Extraordinary Life of George Steer, War Correspondent*. London: Faber and Faber, 2003.

Reck, Friedrich. *Diary of a Man in Despair*. Translated by Paul Rubens. New York: New York Review of Books, 2013.

Rémy. *Comment meurt: Un réseau*. Paris: Raoul Solar, 1947.

———. *Le livre du courage et de la peur*. Paris: Éditions Trois Couleurs, 1947.

Riffaterre, Michael. "Descriptive Imagery." *Yale French Studies* 61 (1981): 107–25.

Ritchin, Fred. *After Photography*. New York: Norton, 2009.

Rosenthal, Mark. *Anselm Kiefer*. Chicago: Art Institute of Chicago, 1987.

Roth, Michael, with Claire Lyons and Charles Merewether. *Irresistible Decay: Ruins Reclaimed*. Los Angeles: Getty Research Institute Publications and Exhibitions Program, 1997.

Rouillé, André. *La photographie: Entre document et art contemporain*. Paris: Éditions Gallimard, 2005.

Russo, Henry, ed. *Stalinisme et nazisme: Histoire et mémoire comparées*. Paris: Éditions Complexes, 1999.

Ryback, Timothy W. *Hitler's Private Library: The Books that Shaped His Life*. New York: Vintage, 2008.

Sands, Philippe. *East West Street: On the Origins of "Genocide" and "Crimes against Humanity."* New York: Knopf, 2016.

Santer, Eric L. "History beyond the Pleasure Principle: Some Thoughts on the Representation of Trauma." In *Probing the Limits of Representation: Nazism and the "Final Solution,"* edited by Saul Friedlander. Cambridge, MA: Harvard University Press, 1992.

Sax, Benjamin, and Dieter Kuntz, eds. *Inside Hitler's Germany: A Documentary History of Life in the Third Reich*. Lexington, MA: D. C. Heath and Company, 1992.

Schäfer, Hans Dieter. "Culture and Simulation: The Third Reich and Postmodernity." In *Flight of Fancy: New Perspectives on Inner Emigration in German Literature, 1933-1945*, edited by Neil H. Donahue and Doris Kirchner. New York: Berghahn, 2005.

Schmitt, Carl. *The Concept of the Political*. Translated by Matthias Konzen and John P. McCormick. Chicago: University of Chicago Press, 2007.

———. *Théologie Politique*. Translated by Jean-Louis Schlegel. Paris: Gallimard, 1988.

Sebald, W. G. *On the Natural History of Destruction*. Translated by Anthea Bell. New York: Modern Library, 2004.

Shirer, William. *À Berlin: Journal d'un correspondant Américain 1934-1941*. Translated by Par C. de Palaminy. Paris: Librarie Hachette, 1946.

Simmel, Georg. "Two Essays." Translated by David Kettler. *Hudson Review* 11, no. 3 (Autumn 1958): 379-85.

Simon, Marie Jalowicz. *Untergetaucht: Eine Junge Frau überlept in Berlin 1940-1945*. Frankfurt: S. Fischer, 2014.

Smith, Gary, and Puttnies, Hans. *Benjaminiana: Eine Biographische Recherche*. Giessen: Anabas-Verlag, 1991.

Smith, Gary, ed. *On Walter Benjamin: Critical Essays and Recollections*. Cambridge, MA: MIT Press, 1988

Smith, Shawn Michelle. *At the Edge of Sight: Photography and the Unseen*. Durham, NC: Duke University Press, 2013.

Snyder, Joel, and Neil Walsh Allen. "Photography, Vision and Representation. *Critical Inquiry* 2, no. 1 (Autumn 1975): 143-69.

Sollors, Werner. *The Temptation of Despair: Tales of the 1940s*. Cambridge, MA: Belknap Press of Harvard University Press, 2014.

Sontag, Susan. "Fascinating Fascism." Review of Leni Riefenstahl's *The Last of the Nuba*. *New York Review of Books*, February 6, 1975.

———. *On Photography*. New York: Picador, 1973.

———. *Regarding the Pain of Others*. New York: Picador, 2003.

———. *Under the Sign of Saturn*. New York: Picador, 1972.

Speer, Albert. *Inside the Third Reich*. Translated by Richard Winston and Clara Winston. New York: Macmillan, 1970.

Steer, George. *The Tree of Gernika: A Field Study of Modern War*. London: Faber and Faber, 2009.

Steimatsky, Noa, *Italian Locations: Reinhabiting the Past in Postwar Cinema*. Minneapolis: University of Minnesota Press, 2008.

Steinberg, Michael P., ed. *Walter Benjamin and the Demands of History*. Ithaca, NY: Cornell University Press, 1996.

Taylor, Charles. *Sources of the Self: The Making of Modern Identity*. Cambridge, MA: Harvard University Press, 1989.

Tisseron, Serge. *Le mystère de la chambre claire: Photographie et inconscient*. Paris: Belles Lettres, 1996.

Tolstoy, Nikolai. *The Secret Betrayal*. New York: Scribner's, 1977.

Trachtenberg, Alan, ed. *Classic Essays on Photography*. New Haven, CT: Leete's Island, 1980.

Trevor-Roper, Hugh. *The Last Days of Hitler*. Chicago: University of Chicago Press, 1992.

Trezise, Thomas. *Witnessing Witnessing: On the Reception of Holocaust Survivor Testimony*. New York: Fordham University Press, 2013.

Vassiltchikov, Marie. *Berlin Diaries, 1940–1943*. New York: Vintage, 1988.

Virilio, Paul, and Lotringer, Sylvère. *Pure War: Twenty-Five Years Later*. Los Angeles: Semiotext(e), 2008.

Virilio, Paul. *The University of Disaster*. Translated by Julie Rose. Malden, MA: Polity, 2010.

———. *War and Cinema: The Logistics of Perception*. Translated by Patrick Camiller. New York: Verso, 1989.

Vonnegut, Kurt. *Slaughterhouse Five*. New York: Random House, 1991.

Weigel, Sigrid. "The Flash of Knowledge and the Temporality of Images: Walter Benjamin's Image-Based Epistemology and its Preconditions in Visual Arts and Media History." *Critical Inquiry* 41, no. 2 (Winter 2015): 344–66.

Winkler, Heinrich August. *Germany: The Long Road West, 1789–1933*. Translated by Alexander J. Sager. Oxford: Oxford University Press, 2006.

Woodward, Christopher. *In Ruins: A Journey Through History, Art, and Literature*. New York: Random House, 2003.

Zola, Émile. "De la description." From *Le roman expérimental*, in *Œuvres complètes*, vol. 10, 1299–1302. Paris: Cercle du Libre Précieux, 1968.

Index

working toward, 81; as regressive, charges of, 75; representation, 89–90; as romantic, 85–86; ruin, as motif of, 80, 88–89; *Ruins Woman, The*, 88; *Siegfried's Difficult Way to Brunhilde*, 83–84; *Silk Road, The*, 88; spiritual bent of, 85; *Sternenfall* series, 77–78; straw, and metabolism, 82; sublime, as transcendental, 85–86, 89; transition, notion of, 82; Trümmerfrauen, 88; war, cruelty of, 79

Klee, Paul, *Angel of History*, 170
Kleist, Heinrich von, 84
Kluge, Alexander, 50n28, 116–17; *Air Raid*, 50, 115, 140
Kracauer, Siegfried, "Photography," 107
Kronica, Jacob, 29
Kuntz, Dieter, 70–71n27
Kurlansky, Mark, 123–24
Kuspit, Donald, 57n4

Lacan, Jacques, 11, 176
LaCapra, Dominick, 113
Lamarche-Vadel, Rebecca, 180
Lang, Fritz, 179
Last of the Nuba, The (film), 137–38n6
Lauterpacht, Hersch, 177n43
Lebanon, 8, 17, 177–78
Lejeune, Philippe, 34
Lems, Stanislaw, *Imaginary Magnitude*, 123
Le père Goriot (Balzac), 47
Leveson, Ian, 141
Levinas, Emmanuel, 145, 155, 158n28; Other, concept of, 156, 158–59
Liebermann, Max, 72n29
Life (magazine), 30, 32

Lindqvist, Sven, 66, 67n23, 176–77
linearity, 169
Lisbon earthquake, 15
Lithuania, 41
London, 15–16; *Blitzkrieg* in, 2, 68, 114, 126
Longinus, 11, 11n8
Loyrette, Henri, 180–81
Lustig, Sandra, 141
Lyotard, Jean-François, 89

Mann in Ruinen (Hofer), 62–63, 62–63n15, 68; as allegorical, 64
Marinetti, Filippo Tommaso, 136–37, 137n5, 138–39
Marx, Karl, 75
materiality, 94, 107
Matisse, Henri, 72
McCarthyism, xv
Mein Kampf (Hitler), 70
Memoirs of the Blind (Derrida), 16
memory, 7, 66, 78, 83, 94, 141; and amnesia, 92, 183; as collective, 9, 86; erasing of, 22, 118; and monuments, 86–87; outing of, 25; ruins, comparison to, 12, 16, 90, 132; and self-protection, 25
metahistory, 172
Metropolis (film), 179
Michelet, Jules, 53
Minow, Martha, 133
Mitchell, W. J. T., 94n2; double consciousness, 94n2; image anxiety, 94n2
modernism, 90
Moeller, Robert G., 24n4
morale bombing, 114–15, 118; as humane, 120–21; justification of, 116–17, 121

Winckelmann, Johann Joachim, 9

Winkler, H. A., 181–82

World War I, 49, 62–63n15, 68n25, 86, 91, 114, 137n5, 179

World War II, 1, 5, 8, 17, 24n4, 44, 49, 62, 64, 78, 86, 91, 94, 114, 141, 171–72, 174, 177, 179; prolonging of, 120–21, 121n40

"Writing on the Wall, The" (Attie), 131

Yalta Conference, 150n18

Žižek, Slavoj, 11; "Real Real," 164

Zola, Émile, 48

Zweierlei Untergang (Dual Destruction) (Hillgruber), 144